ARTISTS IN EXILE

ARTISTS IN EXILE

Jane Katz

ſD

STEIN AND DAY / Publishers / New York

First published in 1983
Copyright © 1983 by Jane Katz
All rights reserved, Stein and Day, Incorporated
Designed by Louis Ditizio
Printed in the United States of America
STEIN AND DAY/*Publishers*
Scarborough House
Briarcliff Manor, N.Y. 10510

Library of Congress Cataloging in Publication Data

Katz, Jane B.
 Artists in exile.

 Bibliography: p.
 Includes index.
 1. Artists, Expatriate—United States—Biography.
I. Title.
NX512.2.K3 1982 700'.92'2 [B] 81-48457
ISBN 0-8128-2851-8

I am grateful to the following publishers and publications for permission to reprint material:

Farrar, Straus & Giroux for excerpts from: *A Day of Pleasure* by Isaac Bashevis Singer, copyright © 1963; *A Simple Lust* by Dennis Brutus, originally published by Hill & Wang, copyright © 1963; *A Part of Speech* by Joseph Brodsky, copyright © 1973; *Night* by Elie Wiesel, originally published by Hill & Wang, copyright © 1960; translated from the French by Stella Rodway.

Harcourt Brace Jovanovich for excerpts from *Strange Things Happen Here* by Luisa Valenzuela, copyright © 1979.

Harper & Row Inc., for excerpt from *Selected Poems* by Joseph Brodsky, copyright © 1973.

Holt, Rinehart and Winston for excerpt from *Legends of Our Time* by Elie Wiesel, copyright © 1968.

Pantheon Books for excerpts from *The Dragon's Village* by Yuan-tsung Chen, copyright © 1980.

Three Continents Press for excerpt from *Stubborn Hope* by Dennis Brutus, copyright © 1978.

New York Review of Books for excerpt from "Less Than One" by Joseph Brodsky, copyright © 1979.

To my father and in
memory of my mother

Acknowledgments

My thanks to the many artists who graciously granted interviews, some of which, unfortunately, I was not able to include because they did not fit within the scope of the book.

My father, Harvey J. Bresler, provided inspiration, honest feedback, and invaluable editorial assistance from the beginning to the end of this project. Others read portions of the manuscript: Professor Iraj Bashiri, Department of South Asian and Persian Studies, University of Minnesota; Jim Erickson, Education Department, Science Museum of Minnesota; Nancy Goldstein, Paulina Shur, Judy Vick, Pat Webster, Yasmina Wellinghoff, and, most important, my husband Jack whose support makes this work possible.

Tamin Ansary provided useful background information for Aziz Mujadedy's interview; Yildiz Golonu did the same for her husband's; Birgitte Lingk of the Hill Library answered innumerable questions with intelligence and humor.

Finally I wish to thank editors Jill Neimark and Pat Day for believing in the book.

It isn't easy to turn your back on the past. It isn't something you can decide to do just like that. It is something you have to arm yourself for, or grief will ambush and destroy you . . .

V. S. Naipaul, *A Bend in the River*

Contents

*Date of emigration to the United States.

*Date of emigration to the United States.

*Date of emigration to the United States.

LIST OF ILLUSTRATIONS

Introduction

They have escaped across borders, leaving familiar worlds and loved ones behind. They have scaled the barriers of language and culture to come to America, a land offering immigrants a new beginning. "In my country, I lost everything," says Turkish painter Gunduz Golonu. "In America, I am reborn."

I can hear the voices of the artists now, speaking in their distinctive accents, chronicling their passage from youth to maturity in their homelands. I can see their animated faces, hands gesticulating, as they relive the historic events that dramatically changed their lives. Fervently, they articulate the vision that sustained them as they made the journey from one world to another.

A variety of motives have brought foreign-born artists to our shores. They seek refuge from wars, political and religious persecution; they crave the artistic freedom and unlimited creative horizons which this country offers. They have had far-reaching impact on America's art forms.

The period following World War I was an era of exodus for European artists reacting to political and economic instability at home. In 1924, choreographer George Balanchine left his native Russia and never returned. Resettling here in 1933, he formed an indigenous American ballet company and became a leading creative force in the classical ballet.

Innovative painters Hans Hofmann, Piet Mondrian, William de Kooning, and others arrived from Europe between the two world wars, creating the artistic ferment which led to the Abstract Expres-

sionist movement. Emigrés Walter Gropius and Mies van der Rohe transformed American architecture, blending the ideals of the German Bauhaus with American techological achievements.

The Spanish Civil War drove the world's virtuoso cellist Pablo Casals into self-imposed exile in this country. Andrés Segovia, also in flight from Franco's Spain, lived in temporary exile in New York City. Conductors of immense stature arrived prior to World War II: among them, Toscanini, Monteux, Szell, Walter and Reiner, and performers whose names are legendary: Horowitz, Heifetz, Rubinstein, Milstein, and others.

Among those in flight from Hitler's Holocaust were Wanda Landowska and Arthur Schnabel. Rudolph Serkin established the Marlboro Festival in Vermont as a center for runaway musicians. Emigré composers who changed the direction of American musical composition were Kurt Weill, Paul Hindemith, Bela Bartók, and Arnold Schoenberg, whose "atonal" method and expressionist style led to a revolution in contemporary composition.

Beginning in the 1950s, the Soviet monolith tightened its hold on the nations of Eastern Europe, driving many artists into exile, among them the cellist Janos Starker from Hungary, Czech film-maker Milos Forman and two stage directors: the Romanian André Serban and the Lithuanian Jonas Jurasas. From Russia came the dancer Mikhail Baryshnikov, the pianist Bella Davidovich, and Russia's greatest cellist Mstislav Rostropovich who ran afoul of Soviet officialdom when he sheltered the dissident writer Solzhenitsyn, also now living in this country.

China drove some of her finest artists into exile during the Cultural Revolution. The struggle for control of Southeast Asia resulted in the destruction of most of the arts and material culture of Vietnam, Laos, and Cambodia, and brought surviving artists to our shores. Today, as the political turbulence escalates throughout Europe, the Middle East, Africa, and Latin America, the art forms and culture of many nations are threatened with extinction.

A personal note as to how I became involved with this subject. My

previous work with Native Americans brought me into contact with people who had been uprooted from tribal lands and culture. It became clear to me that the Native Americans' sense of being linked to a meaningful cultural tradition which must be perpetuated has enriched their lives and their art. I wondered if a similar sense of purpose motivated the emigré artist.

Traveling to this country's cultural centers, I sought uniquely talented individuals, with emphasis on the "new wave" of immigrants. The interview process presented immense communication hurdles as recent arrivals struggled to express complex ideas in English, a language with countless linguistic idiosyncrasies. Ironically, some of those with the least facility with English were the ones with whom I developed the deepest rapport. In the many hours we spent together I probed, asked for clarification of ideas and images, assisted in the search for *le mot juste* and thus participated in their voyage of self-discovery. At the artists' requests I corrected flagrant errors in grammar and syntax, while attempting to preserve the flavor and spontaneity of the conversations. Most of my questions I deleted to keep the focus on the interviewees.

As the artists told their stories, I began to perceive of each one as a maverick. Arriving as an impoverished immigrant and unknown, Isaac Bashevis Singer wrote in Yiddish, a language many people considered obsolete. Freed from the limitations imposed by the Bulgarian government bureaucracy, sculptor Christo created a daring new visual statement, challenging existing notions of the artists' role. Worn down by the battle for physical survival, forced to contend with an alien language and culture, Indochinese artists persevered in their unique art forms. I was struck by the explosive energy of the artists and their optimism.

How to see the world through their eyes? Certain key questions began to take shape. In what sense were you molded by your early environment and culture? Did you find that opportunities for artistic growth were limited? Were you at odds with your society? Did the chance to live and work in an open society compensate you for the loss

of your homeland? Did the experience of being uprooted from the land and culture which nourished you affect your art? Do you feel intense pressure to succeed as an artist in this country to justify leaving your homeland?

Common threads link all the displaced artists. Most express a deep attachment to the land of their birth, a need to return to it physically or through the medium of their art. Refugees tend to be obsessed with the holocausts of history, whether in Germany, Hiroshima, Vietnam, or Afghanistan. Having witnessed the irrational slaughter of innocents, they cannot take their survival for granted. Holocaust-survivor Elie Wiesel speaks as a witness for future generations when he says:

We survived by the grace of God. But we are afraid our testimony won't be remembered. If the world forgets, there will be another holocaust, but this time . . . all of humanity will be the victims.[1]

Isaac Bashevis Singer also expresses his fear of mankind's capacity for self-destruction. At the same time, he affirms his faith in the human spirit, a recurring motif in this book.

Whether his exile is voluntary or compelled by political pressures, the uprooted artist must cut himself loose from family and friends, from old and safe roles and assumptions. This is most painful for the displaced writer who feels very deeply the loss of his people's language, visual images, and even the laughter of his homeland.

Russian-born Vladimir Nabokov fled Europe during World War II and resettled in America where he achieved distinction as a "great American writer." In an interview with Herbert Gold he once said, "I am not emotionally involved with Indian dances or pumpkin pie . . . but I am as American as April in Arizona."[2] Nevertheless, Nabokov acknowledged that his loss of Russia was the tragedy of his life.

A recent Russian defector, author Yuri Krotkov, speaks of the trauma of separation from the motherland.

I still feel that I am an alien, stateless. I think America is a beautiful, colossal land but in my dreams, my recollections, my "forever"

remains in Soviet Georgia, where I was born. . . . My only source now is my past.[3]

Writers in exile from Thomas Mann to Czeslaw Milosz have had to come to terms with this profound sense of alienation.

The emigré artist acts as a gadfly in his adopted nation. Often unable to express himself in his homeland, he exercises that prerogative here—he has sacrificed for the right to speak out. The artist's social criticism is an indication of his respect for America—a country with a conscience.

The artist is a free spirit. In a restrictive society, his creativity is stifled, his song unheard.

Transplanted to this country's nurturing environment, he begins again, responding to new stimuli, interacting with American artists, gaining inspiration from them, sharing with them his unique vision and perspective. Ultimately, the emigré's creative voice is reborn, stronger than before, and the process of cross-fertilization enriches all the arts.

The uprooted artist's ties with the past are torn, but not severed—one's ethnic identity is a source of strength. In his creative work, the artist links past and present, perceiving meaning in both. Recapturing his people's spirit through art, he insures them continuity. Thus, art becomes truly redemptive. Knowing this is a source of liberation and hope for the artist in exile.

(Alex Gotfryd)

Isaac Bashevis Singer
Writer from Poland

"I feel that no man should forsake his language."

For his narrative art Isaac Bashevis Singer has won two National Book Awards and, in 1978, the Nobel Prize for literature. In stories such as "Gimpel the Fool" and children's tales, he pokes fun at wise men and fools. In novels such as *Satan in Goray*, *The Magician of Lublin*, and *The Slave*, Singer moves from history to allegory, blending philosophy and folklore, fantasy and reality.

His origins are the Polish *shtetl* and the Warsaw ghetto. His characters are Polish Jews and Jewish immigrants to America, but his themes are universal. He deplores hedonism and life without faith. "I'm an optimist," he says. "I believe in Providence and in God's plan for the Universe."

Critic Irving Howe writes that Singer populates his novels "with imps, with devils, with Satans, with seizures . . . all kinds of strange creatures that a nice Jewish mother wouldn't let into her house . . ."[1]

Interview, November 14, 1981

Isaac Bashevis Singer

For two years I have sought an interview with Isaac Bashevis Singer. At last, in a comfortable apartment on New York's Upper West Side, he materializes. Alma, his wife for forty-one years, ushers me into the living room where, almost hidden behind a mountain of books and papers stacked on the coffee table, he sits on an overstuffed couch. "Sit here beside me, and we will talk," he says in his thick Yiddish accent. Behind the wide-rimmed glasses his blue eyes are tired, but he takes in everything. He interviews me: "Do you have a family? How old are your children?" he queries, more like a loving grandfather than one of the world's literary giants. "You seem to have a special fondness for children," I observe. "Your children's stories contain none of the harshness found in your work for adults."

Well, I'm not going to tell children horror stories. They deserve to be children. You cannot really tell them stories of pogroms and slaughter. They begin life with some belief in human goodness because they see it in their mother and father, and I don't want to disillusion them.

But let me tell you, children are not saints. When they get together with each other in school and on the playground, the same rules are valid there as among adults. The strong are strong, and the weak are weak. There are the tough guys and those who make a career of flattering them. There is always a dictator who manages everybody and tells them what to do. And then there are the timid souls.

Oh, I don't romanticize children. They are little angels only in the eyes of their parents. But still, I love them because the damage they do is seldom as great as the damage adults do. They seldom kill or rob. If they rob, they take away a penny, not a million dollars.

Singer was born in 1904 in Radzymin, Poland. In 1908 the family moved to Warsaw and settled on Krochmalna Street in the Jewish quarter where Jews who had lived through pogroms and fierce repression were segregated. A few found their way into the world of com-

3

merce and the professions; most lived in poverty. Singer wrote in his autobiographical narrative, *A Day of Pleasure:*

> *Most of the people who lived on Krochmalna Street were poor storekeepers and laborers, but there were many scholars among them, as well as idle urchins, criminals, people from the underworld . . .*[2]

Denied access to secular schools, Jews built their own culture in Poland. They had their own language, Yiddish, and their own schools, called "cheder," where boys devoted themselves to prayer and study of the Jewish holy books.

> Our home was a place of learning. Other children had toys, but I played with the books in my father's study. Even before I knew the alphabet, I took my father's pen, dipped it in ink, and scribbled words. The Sabbath was an ordeal for me, for on that day it was forbidden to write.
>
> At the age of four I started going to cheder. It was there that I became a storyteller. I did not take pennies from other children or beat them up. I made myself popular by story-telling. Children love to hear stories. Sometimes I elaborated on Bible stories, sometimes I invented my own. I told them my father was a king. Why they believed me I don't know, I certainly wasn't dressed like a prince. I would boast to the other children that I was going to write a book. I observed children objectively, and I could see in them the character of the whole human race.
>
> I also observed older people and their nonsense. My father was a rabbi—a very scholarly man who sat all day and studied the Talmud. He had a red beard with long black sidelocks. The people of our street came to him for advice or to have him settle disputes. He was a judge, a consultant, a psychoanalyst. People came to our home to get engaged or married, they came to my father to get divorced.

4

I listened to everything that took place in my father's so-called "courtroom." One question I heard my father ask over and over, "Why do you want to get divorced?" It seemed like a simple question. Two people had come to get a divorce. Supposedly they had had plenty of trouble before they made such a decision. But they could only answer in clichés. The man would say, "She's a bitch." "What do you mean?" my father would say. "A bitch is a female dog." But the man would repeat in anger, "She's a bitch." Then the wife would say, "He's a murderer." Well, to me he didn't look like a murderer, he looked like a humble little man. So I understood even then that although people live through many experiences, it is very hard for them to find a language to describe them. I said to myself that when I grew up, I would try to find a language to describe human beings.

My father believed that the world was an evil place inhabited by spirits, demons, and goblins. He told us stories of dead spirits coming back to life, souls returning in the form of animals, demons haunting houses. To strengthen our faith, he also told us stories about angels—for if there were demons there had to be angels—and of the miracles performed by the great rabbis.

My mother, on the other hand, was devoted to reason and logic—always questioning, brooding about the eternal mysteries. As a result, I became both a doubter and a man of faith.

My days and nights were filled with morbid dreams and fearful fantasies. I hardly dared to go outside by myself, and stayed at home reading books from all over the world in translation. I read Tolstoy and Balzac and de Maupassant. I read your Jack London and the Sherlock Holmes stories, and Edgar Allen Poe translated into Yiddish. What a translation that was, better don't ask me!

I found a series of Yiddish detective stories with a hero, Max Spitzkopf, and I wrote my own Max Spitzkopf stories.

Once I followed a man on the street, playing detective. He turned on me, wanting to know why I was following him. After that, I stuck to writing.

I began to write in Hebrew. But Hebrew at that time was a language of the Book. People didn't speak it in their daily lives. I was from a Yiddish-speaking community. I decided that since the characters in my stories spoke Yiddish, I would write in their language.

When I was in my late twenties, a publisher of Yiddish books agreed to publish my first book of stories. It was set in type, and I reread it. I decided it was boring, and withdrew it from publication. The publisher was furious. I waited twenty-eight years before I published another book.

But I was always writing stories, and this caused some conflict in our family. My father was absolutely opposed to secular literature. "Gossip," he called it. "You mock people, you make fun of them," he said. He especially disliked love stories. My brother I. J. Singer had been writing for years, despite my parents' disapproval. Now I was taking up this "vulgar" occupation.

My parents wanted me to be a rabbi, and I did attend the Rabbinical Seminary in Warsaw for a year and a half. But the life of a rabbi was not for me. There were many fights in our house, but we fought with words, not, God forbid, with fists. I tried many times to move out of the house, but I didn't have the means. Finally, I left, and went to work for the Yiddish press.

Well, if you don't quarrel with your father, you quarrel with yourself. You know, there are always disputes in the human mind. Sometimes I felt guilty, sometimes ambitious. Of course, I'm not a Freudian—I don't use often the word guilt. I don't think of guilt as a sickness, as the Freudians do. Without it, the human spirit would become naked. I think a person who doesn't feel any guilt is actually an animal.

6

I saw the conflict mostly in myself. The soul is at war with itself. All kinds of ideas and fears are cooking inside. There is never any rest. Even when you sleep and dream, the struggle continues.

I look at the human spirit as a volcano. Sometimes it erupts, sometimes it keeps quiet, but there is always some turmoil inside. I cannot imagine good literature which is quiet and idyllic. I think even in the Bible, in the book of Genesis there is love, but also anger and violence.

I always felt and I still feel that there are powers which we cannot understand which work in us and influence our lives. To me Satan and the devil are not just words. They express the essence of our subconscious emotional life—our inhibitions, our capacity for destruction and self-destruction.

I was affected by the unrest in the society around me. I saw values changing drastically. I was brought up in a family where marriage was considered a sacred institution—husbands and wives were faithful to each other. There were conflicts, but basically the family stayed together. But as I was growing up, I saw families falling apart, children abandoned, people in the community who didn't know where they belonged.

In the years following the Russian Revolution, it seemed to me that all of Eastern Europe was in a state of upheaval. People were rejecting the old order and traditions. Jews were turning from God, looking for a substitute religion and deceiving themselves. Fascists and Socialists were proclaiming a new tomorrow, but the majority of people still were victims of poverty and prejudice.

I questioned God's justice. I could never forget the millions of people who had lost their lives in epidemics and pogroms, in World War I, in the Bolshevik Revolution. Whole villages starved. People sacrificed their lives, but the fighting didn't solve anything.

7

I had rejected dogma, but I am essentially a religious person. I see the Ten Commandments as a protest against the injustices perpetrated by human nature. People transgress; they are redeemed by a return to the Law. I decided to write about Jews: their sufferings, trials, aspirations, but to write about them as flesh-and-blood creatures with bodies as well as souls, appetites as well as minds.

You have written of the world as "one huge slaughterhouse, one enormous hell," but judging by the sensual scenes in your stories, you seem to have enjoyed yourself.

It's true, I explored. You don't sit down with a microscope like a biologist. You live, you experiment, you explore. You think about it, and if you have a talent for writing, you write about it.

I feel that literature is mostly about human relations, especially love relations, because every human being has a different approach to love and sex. There is greater individuality in love and sex than in any other aspect of human life.

In your novel *Young Man in Search of Love,* you describe a young Polish writer who is tormented by women. Is this book autobiographical?

It is 90 percent me and 10 percent fiction. When I was young, women bothered me. Why not? This is what we are here for, to get a little enjoyment out of life. I always thought two girls were better than one, and three were even better. But I respected each as an individual.

The relationships you were having with women violated the precepts of your orthodox religious community, didn't they?

8

Of course. Our notions were completely different. My mother and father believed that it was decreed in heaven that two people should meet, get married, have children and live together for the rest of their lives. I didn't have this belief. To me it looked like an accident. You happen to go to a party, you meet a person you like and a relationship begins. If you hadn't gone to the party, it wouldn't have begun. To me, the possibilities of what might have happened were infinite. For a writer, this was a gold mine.

I always felt that my writing and my life were deeply connected. In the relationships I had with women, I was able to some extent to stand outside and observe. I could remember things very clearly, I would remember words and expressions and later, I would write them down.

I am interested in the nonsense people speak when they make love, because behind this nonsense, much truth is hidden. Let's say, when a man sleeps with a woman and she says in a moment of ecstasy, "Kill me"—which some women do say—this sounds like nonsense, but there is a reason for this, there is a reason.

What is the reason?

(He chuckles.) God knows what it is, but it's there. People are always saying things which reveal their insights. Actually, our genes are as old as the human race. We are the descendants of good people and thieves and murderers. All this is mixed up in our subconscious, and is expressed in one way or another.

In 1935, Isaac's brother I. J. Singer, then a writer living in New York City, invited him to come there. There was the promise of a job with the Yiddish Press. There was little to hold Isaac in Poland. His father had died, and he had grown apart from his family. The growing

strength of the Nazi movement was casting an ominous shadow all over Europe.

I saw that the Jews were in great danger in Europe. Warsaw was a doomed city. I was thirty-one. I left with two valises of clothing and manuscripts. It was Passover. I sat on the train munching on some matzos. When we reached Germany we could see the Nazi banners celebrating Hitler's birthday. We could see Jews being ridiculed in the streets. I had a sense of foreboding.*

I found my way to my brother's home on Coney Island in New York. I felt really lost. You come to a country, you do not know the language, and you cannot make a living. It was hard, but I knew that life was hard, and I'm not the sort of man who falls easily into despair. I immediately began to study English. Every word I heard or read I wrote down and looked up in the dictionary.

I will tell you, whenever I go to a strange country I take the Bible since I know it quite well, especially the Old Testament, so when I read it in any language, I know more or less what I'm reading. The only danger, people told me, was that after a while I would begin to speak biblical English. It didn't happen. After half a year. I was able to communicate, whether in good English or bad. I'm still learning the language. I speak with an accent—but then, I speak all languages with an accent.

You have said that "a writer needs an address," that he should remain close to his roots. Did you feel alienated from your community?

I wasn't alienated, because I brought it with me. In my memory, the beggars and thieves and scholars of Kroch-

*Only four years later, in 1939, Hitler invaded Poland. Singer's mother and brother, along with others he knew and loved, were deported in cattle trains and perished.

malna Street were very much alive, and I put them all into my stories. Besides, I was living among Yiddish-speaking people in New York and working for a Yiddish newspaper.

When I first came to America I found that the soil for Yiddish was thinning, but I thought, "If I write well, it will one day be translated and people will be interested." And it really happened. There isn't a day which passes, not a day when I don't get letters from all over America, Europe, and Asia from people who know my work. It seems that no language is a barrier when a man has something to say.

I write my first draft in Yiddish, and then it is translated into English and other languages. Yiddish is such a rich language. Now when a Yiddish writer wins the Nobel Prize, the snobs who snubbed Yiddish are impressed—they only respect money and fame. Some say Yiddish is a dying language. Well, I'm not sure it is. I think more people speak it than Icelandic.

I feel that no man should forsake his language. If you forget your mother language, you forget in a way your mother and the generations before you who spoke this language. For a writer to suddenly switch to a language not his own is in a way an act of suicide. Of course, some writers have done it. Nabokov wrote first in Russian and then in English, and I would say he became very self-conscious about language, and tried to write better English than the English themselves. Conrad was a Pole and he wrote his novels in English. I would say he describes better the sea than the people.

As an immigrant, I had to adjust to the temper of American life. At first, I had a feeling that I could not understand Americans. They seemed to me like people of another planet. But I learned to understand their motivation, and to see them as part of the human race.

I cannot forget that almost all my work was created here in America. Although the move to America bewildered me,

it enhanced my creativity. I began to see the world in a new way. From everything we do, we learn something. The spirit is never tranquil. America allowed me to express what is in me.

Here the State does not tell you what to write. And if one publisher turns you down, you can go to another. If you cannot find a publisher, either you belong to the future or you have no merit.

There is the belief in America that if something is wrong, you can do something to correct it. This is the secret of American success.

Are the devils afoot in this country?

The devils are here but they are different. In Europe, the devils ponder and lament and brood and do little. "This has to be," they say. "There is no remedy." In America, you have devils of deeds. The typical enlightened American believes any problem can be solved. Now it's true that you cure one illness and another pops up, but at least you go on striving. There is a fighting spirit in this country. Americans don't fight among themselves. They fight conditions.

Your devils sound very constructive.

Yes, of course. (He laughs.) God would not have created any force which is all negative. You know that when I speak of devils and demons I am speaking of the emotions. I don't know why God has made us millionaires of emotions, why he has given us so many. We live with them, we fight them, we make peace with them. It seems that the human spirit is made of a little logic and a lot of emotions.

In your first novel *Satan in Goray,* you picture a community going berserk over a cult figure, a so-called religious messiah.

12

Since I wrote this book, many communities have gone crazy—in Poland, in Germany, in Russia. Even in America we had this man, Jones, who killed all his followers.

Devils come out in all disguises. There are many threatening forces today. There are millions of people walking around this world whose only desire is to do damage. So many people, especially men, think you can correct the human condition by killing, destroying, turning one group against another.

When I was young I had nightmares, and I still have. In this respect, I am young. My nights are so full of dreams and visions. I cannot really describe my dreams. I don't think anybody can—dreams and amnesia go together.

In my case, I'm dreaming while I'm awake. Many times I have decided to put an end to my daydreams, but I cannot get rid of them. They are with me all the time. Whenever something happens, I get involved. If I read that an innocent man is killed, in my fantasy I immediately catch the killer and bring him to justice. I would say that in this respect I am still the little boy I was at the age of six.

Artists really in a way remain children. To me, Dostoevsky was a grown-up child to the end of his life. His character Raskolnikov has all the qualities we all have. He does things without knowing why he does them. He says things which are both clever and full of contradictions. There is a Raskolnikov in all of us—the capacity for doing things we cannot control or explain, the need to boast about what we have done, to regret it and do it again.

You seem to take delight in shocking your readers.

You know the play which I co-authored, *Teibele and Her Demon?* When it opened in 1977, some people were shocked by the idea that a religious woman is seduced by a demon. They called it erotic. I describe the female sexual

13

desire, the woman's dream of adventure. But then many women called me up and said, "I would like to have a demon like that."

I think a little shock is not bad for literature. And suspense is an element of shock. But I wouldn't say that my writing is "shock treatment." In the final analysis, literature has to entertain. The great tragedy of modern literature is that it has forgotten this and tries to solve problems. Writers today try to be psychiatrists, psychologists, and sociologists. I prefer nineteenth-century literature. Balzac was a great storyteller; so was Tolstoi. Even when Tolstoi was preaching, he was entertaining.

A real writer doesn't rely on a message as a crutch. He isn't obscure, he doesn't create riddles, he can reach almost anyone with his words. You don't have to sigh and struggle and force yourself to read. He hypnotizes you, draws you into his world so you want to go on reading.

Has success brought me peace of mind? Well, I don't go around being happy all the time. But I rather enjoy the fact that I speak to people better than if I were to speak to no one.

What is your hope for the world?

I'll tell you, I don't have any personal hopes. I'm not going to live long enough to see it, but I think that humanity may, in ten thousand years from now, learn that wars don't help anyone.

But it's a long process. It seems that the powers that created man have a lot of time and patience. They can wait. We cannot. In the meantime, I will go on writing as long as I can. I am getting older, my eyes are not so good, I have my inhibitions, but I try my best.

14

Visibly tired, Singer removes his glasses and wipes his eyes. Alma looks into the room: "Isaac, you really must rest now," she says. "Okay, okay, we will finish soon," he replies. Then to me: "Wonderful woman, Alma. She takes care of me," and he goes on talking.

(Daniel Chu)

Yuan-tsung Chen
Novelist from China

"I burned all my manuscripts."

A young woman from the privileged middle class in postrevolutionary China, Yuan-tsung Chen devoted herself to easing the deprivation of the Chinese peasants. But Ms. Chen was one of the many victims of the excesses of the "Cultural Revolution." Unable to speak out or pursue her career as a writer, her very survival threatened, she emigrated to the United States with her husband and son in 1972, and has dedicated her life since then to writing about her homeland. *The Dragon's Village,* her historical novel about her experiences in China's land reform movement, was published to critical acclaim in 1980.

A diminutive woman, Yuan-tsung Chen seems very genteel. But as she gets emotionally involved in conversation, she becomes disarmingly candid. "This is my day and I will have my say," she says, punctuating her comments with a hearty laugh. But her sense of delight is never far removed from her memories of the tragic events she witnessed.

<div align="right">Interview, July 16, 1980</div>

Our people never liked to bow down to foreigners. But from the time of the Opium Wars in China, we were controlled by the British, then the Japanese. They brought their armies and police, they controlled the railway and the waters. If you disobeyed an order, they shot you, and the Chinese government was powerless. We were a subjugated people. This was humiliating.

All during my life in China, there was either war, civil war, or revolution. I saw so much suffering.

As a child, I loved to read and I loved to dream. I was a headstrong girl, intense, a perfectionist. I studied so hard I made myself sick. My mother had a hard time with me. If she didn't let me do whatever I wanted, I would lock myself in the bedroom and cut things up with a scissors. I would refuse to come out and would go without food for two or three days. Mother was modern and not very superstitious, but sometimes she wondered if I was possessed.

Little things made me angry, no big deal. One day my mother defended my brother in an argument and said I was wrong. I threw a china spoon at him. Mother was mad and said, "You might have hurt him." I was furious. I stayed in my room and planned to run away. I thought she loved my brother more than me because he was a better child, gentler and well behaved.

When I was thirteen or fourteen, still very emotional, my father said, "You are hurting yourself and your parents." The Buddhist influence was very strong. They thought if a child did something wrong, the parents would be punished. So I restrained myself, and tried not to hurt anyone. I knew very early that I wanted to be a writer, and I tried to express my emotions in my writing. This became the most important thing for me.

We were always taught to do something for the people. That was instilled in us from the time we were very young.

And to think of our parents before ourselves. Even today, this is a part of our culture. I just read in a Chinese newspaper that three brothers from a peasant family were accused of neglecting their parents. The old people felt abandoned and committed suicide, and now the brothers are on trial. So you see, the Chinese tradition of fulfilling your social responsibility is still very strong.

We always had a strong democratic element in our society, at least as far as men were concerned. We were taught to win respect for our people by being educated. All during the thousands of years we were a feudal society, poor boys were educated alongside sons of the rich. Confucius had 3,000 students, boys from all classes; one was even an outlaw.

For girls, it was different. When I was young, most Chinese wouldn't even think of educating a girl. But my parents were very cosmopolitan. They encouraged me to read the great Chinese classics. And they sent me to the best girl's school in Shanghai run by Protestant missionaries. In school I was exposed to Western ideas and literature. Your culture touched my soul.

We saw American movies: *Camille* with Garbo, Hitchcock Films, *Gaslight* with Ingrid Bergman, and I loved them. Americans seemed so rich and carefree, especially the women. But I really didn't envy your way of life. I wasn't hungry for material comforts. I thought, if I'm going to be a writer, I'd better stay in my own country.

As I grew up, I was observant and critical. I noticed that women in our social set seemed to have very little control over their own lives. They were pushed into marriages which had little to do with love, often just to bring the family prestige. The women in my mother's circle wasted all their time and talents just being wives, fulfilling their husband's expectations. Their only achievement in life was being mothers, but they couldn't even take credit for that,

for the children were raised by a wet nurse and servants. Right up until the time of the revolution, many upper class men had concubines, and they used this as a threat to keep their wives servile: "If you don't produce a son, I'll get a concubine."

The women didn't seem at all happy. A friend of my mother's was very rich. She spent all her time buying beautiful clothes and making herself up so that her husband wouldn't leave her. What a futile existence. These women feared living, feared getting old. That life, I decided, wasn't for me.

At the beginning of the Second World War Japan invaded China. My family left Shanghai, and we went inland to escape from the fighting. We traveled on highways, through smaller cities and villages. It was a long, hard trip, and it opened my eyes to the life of the Chinese peasants. We saw whole families fleeing from the Japanese, their meager possessions piled high on carts, the old walking with the young, looking cold, hungry, and frightened. The poorest people stayed in their villages, either too frightened to risk everything in flight, or unaware that there was a world outside their village.

In 1949, the Communists established the People's Republic of China, and began the redistribution of land to the peasants. For centuries these people had been part of a feudal system which left them without land and without any means of supporting themselves. The promise of land reform brought hope to millions of Chinese peasants.

When the Communists advanced on Peking where I was living in 1949, many people I knew fled to Hong Kong, but I felt that I could deal with them. I got caught up in the revolutionary ardor. Two years later, I was nineteen and I had my first job as translator at the Film Bureau in Peking. Along with many other city workers, I joined the move-

ment to carry out land reform in the countryside. We were not Marxists. We didn't understand what it was all about. Most of us were from educated, middle-class families. It had always been a dream of the Chinese intellectuals to relieve the suffering of the poor. We were sent to Gansu Province in a remote area of Northwest China. Our task was to take land from the landlords and divide it equitably among the peasants. We traveled on ox carts across bleak lands to the village, a walled town which was to be our new home:

> *. . . Ancient, crumbling, feudal, the half-awake town still dominated the parched land around it. When I looked back I thought how much the battlemented walls looked like stage props now, and yet two thousand years ago generals of the Han dynasty had fought great wars here. . . . The village was nothing more than a sorry collection of cottages built of rammed earth, loose soil mixed with puddled clay and chopped straw, and roofed with the same adobe. The roadway between the cottages was deeply rutted and eroded by the rain-wash from their roofs. . . . In the peasants' homes, too poor for oil lights, they groped around in the dusk. It was too dark for work, too early for bed; immobile, obscure shadows, they stood or squatted at their front doors. Tiny dots of flame in their pipes flickered red in the twilight. A stray dog sniffed and licked at the roots of a leafless tree. Some ragged children, still stuffing their evening meal of porridge into their mouths, ran after our cart.*[1]

We lived in the peasants' houses and shared their deprivation. We had to stand by helplessly while a peasant couple mortgaged their land for a few bushels of grain. Everyone went to bed hungry. I used to dream of steamed fish and roasted Peking duck. That year of hunger haunted me when I returned to Peking, and haunts me still. When I sit and gorge myself on an ice cream sundae, I feel guilty. When I write, it eases my conscience because then I'm not just sitting here and enjoying myself.

After I was married, I left my husband and son many times over the next 20 years to return to the countryside. We

were part of a women's cadre helping to set up communes. The people were fearful and superstitious, and it was hard to win them over. They lived in such squalid conditions. They had to battle poverty and the elements:

> *... In just a few hours the weather turns cold; a chill wind blows, the dragon's breath; black clouds fill the sky; and the rain comes down in torrents. If the harvest isn't stacked but lies out in the fields or on the threshing floor, a farmer can be ruined in a day.*[2]

Their customs were really feudal. I felt for the women. There was no protection for them against rape by landlords, or from physical cruelty by their fathers and husbands. They remained in the kitchen, subservient, believing that this was their destiny.

We saw the people take title to their own land. We formed a women's association to hear the women's complaints. We exposed them to new ideas. But there was so much we could not change. Many times, during those years in the countryside, I struggled with myself. I wanted to return to my family, to lead a normal life. But I knew that if I could stick it out I would have a unique experience, and that one day I would write about it.

You had to be a bit of a maneuverer in China if you were a writer, for you were taking a risk. From the time the Communists took over in 1949, they said openly that literature and art should be propaganda for the party and the government. I could not accept that. At first we could disagree with the policy and we could read what we wanted. Then later, during the Cultural Revolution, they put pressure on us to read only literature approved by the party. I read in secret. They insisted that we write only what was useful to the state.

"Let a hundred flowers bloom, let a hundred schools of thought contend," decreed a Chinese Communist Party spokesman in 1956.

23

But within a decade, the flowers of creativity had withered as Mao Tse-tung's Cultural Revolution stifled the arts by forcing them to conform to the "Socialist realism" mold.

You were supposed to glorify the Communist society. If you wrote a poem about how beautiful the moon is, you would be attacked—they'd say you were decadent. Even those who tried to conform were under attack. Almost any subject was sensitive. You'd write a story praising the communes and the system, for example. But along with praising the cows you'd try to express some sort of human feeling, so you'd write: "She cried because she was criticized in a meeting." Just that was enough. They would pick it up and say, "You distorted our society." It was like a witch-hunt, they had to find scapegoats, and you never knew when you'd be singled out for attack by Mao's wife and her cohorts.

My family urged me to be cautious, but I wasn't naive. When I saw what was happening, I just shut up, and I made people think that I had given up on my writing, while I went on writing in secret. Always when I spoke to others I talked about my baby, how difficult it was to take care of the baby, and how rewarding it was. Anything trivial, right? Nothing about writing. More and more, I saw that there was no hope of getting my work published in China. We applied for an exit visa in 1966, but the Cultural Revolution made leaving impossible. We were under attack. There were searches. There was no law. So many people were persecuted and were destroyed. Many of them were my friends. I saw my friends who were writers go to prison and die there. Those who survived had to write in the official manner. I felt so defeated. I was paralyzed with fear. I burned all my manuscripts. I thought I was finished as a writer, and I said to myself, "This is my fate."

I could not go on that way. I was determined to make something of my life.

In the early 1970s, the People's Republic was admitted to the United Nations, the U.S. and China established diplomatic relations, and China's emigration policy was liberalized. With her family, Ms. Chen was able to emigrate to the United States.

We hated to be uprooted. We had to leave my mother in Shanghai. But this was an opportunity to move to a more stable society, one ruled by law. In America, you can talk and sing about what you believe in.

I went to work as a writer to tell about what I had experienced in China. A human story, not propaganda. I had written the first version of *The Dragon's Village* while I was still in China. I wanted to rewrite it to make it accessible to Americans.

American writing is so different from Chinese. Your novelists are so submerged in themselves. They are narcissists. They suffer, but they don't really seem to care about the suffering of others. For example, I read Saul Bellows' *Herzog*. He complains about his empty life. He walks out on his wife and sleeps with other women, but they don't satisfy him. He doesn't care about their needs, he just makes use of them. And he says *he* is suffering.

Then I read *Fear of Flying*. Now look at this woman. She has more than one lover, but she wants the men to be faithful to her. You know, this is so funny to me as a Chinese woman because we were always told what you don't want others to do to you, you don't do. That goes back to Confucius and the Manchu Dynasty.

Another book I read is *Looking for Mister Goodbar*. It's about an educated young woman who sleeps around, then is murdered by one of her "lovers." I don't think that

promiscuity is liberation, because you're then the captive of your sexual desires. The author tells us that she is careless because of some childhood operation or deformity which left her with a poor image of herself. Well I really don't think that's motivation. I want to know something of the history, the social problems which influenced her, led her to throw away her life.

In China, it's just the opposite. The writers are too involved with history and social problems, too little with the individual, so their works are didactic. I thought I would find a point in between, and this would be a breakthrough.

I worked for many years rewriting *The Dragon's Village* in English. I could find the right English words, but friends would read it and they'd say they didn't know what I was talking about. I was heartbroken. I realized I was writing English as a Chinese—it was Chinglish.

Back to work. Everything had to be explained for American audiences, things the Chinese would take for granted. If a character told a joke, it had to be explained. If you start explaining, no joke. I had to learn to think in English. It was so hard. I revised the book 15 times. During all those years I didn't think I'd ever find a publisher.

People said "Why don't you write something commercial." But I thought, I don't like to go to nightclubs, I don't enjoy gorging myself in restaurants, what would I do with the money? I'd rather write something lasting. Of course, nothing is really lasting. One day, everything will sink into oblivion, and new things will come forward. I thought I would keep on experimenting. I want to leave something behind.

I'm a little superstitious. Sometimes I would look out the window at a bird in a tree and I'd think if the bird doesn't fly away, he will bring me good news. I was lucky. I met the great journalist Harrison Salisbury, and he was interested

in my book. He found a publisher for it. The reviewers were very kind. You know, Americans are accustomed to reading Pearl Buck's romanticized view of the Chinese peasants. Well, she was a missionary, an outsider, and she didn't get really close to the people. Her peasants are loyal, kind, and passive. But they're not really like that. In my book, the peasants are brutalized, they clean themselves by picking lice off their bodies. But they are flesh and blood.

The Chinese government hasn't criticized me for writing the book. Now they're becoming more liberal and enlightened. But they haven't published it in China. I feel sad that I had to cross the Pacific to get my book about China published. But it's the truth. Chinese literature is not progressive today. I can be more creative in this country.

I'm a little crazy, and I have a plan. One day, when I get old, I think I will again write a book in Chinese. A more complex book about human relationships. More lyrical, with some subtlety.

I'm an adventurous person—when it comes to improving myself, not when it comes to experimenting with men. It's not that I'm so moral or proper. But one just has so much time in this life; you have to figure out what's important. What I want most is to do something meaningful for my people.

So many times in my life, the world outside has almost collapsed. That has left its mark on me. I still have that awareness that it may all end at any time. So I like to withdraw into myself as if there were another world inside me. There, I can do whatever I like—cry, yell, vent my emotions, because this is my world, one I create.

There were opportunities in the past when a transition to decency could have been peaceful, but I think we have reached a point where we have just squandered all of the incredible patience, tolerance and goodwill of the black people in the country. There's nothing left of that now.

South African Playwright, Athol Fugard (Interview), The New York Times, *November 16, 1980*

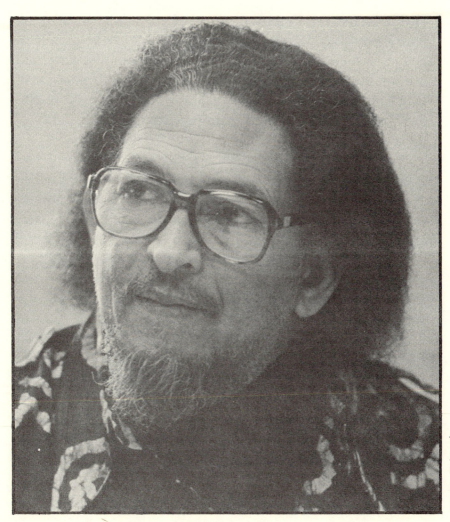

(Jackie Kalmes)

Dennis Brutus
Poet from South Africa

"For the unsung brave"

He has been called "a third world prophet." His body and mind have been scarred by experiences in South Africa's black ghettos and jails. A graduate of a black college, a journalist, poet, and teacher, Brutus actively fought the practice of apartheid, a system which denies the most basic freedoms and dignity to blacks. Persecuted in his homeland, imprisoned, given the choice of perpetual "detention" or exile, he chose freedom.

In the United States, Brutus serves as visiting professor of English at Northwestern University and Amherst College, while continuing to work for the abolition of white supremacy in South Africa and elsewhere in the world. Believing that his life is in danger if he returns to his country, he has sought permanent political asylum here; his status is under review by the Department of Immigration and Naturalization.

In his books of poetry: *Letters to Martha*, 1968; *A Simple Lust*, 1972; *A Stubborn Hope*, 1978; and others, he evokes the wailing of police sirens, the tramping of the oppressors' boots. At the same time, he sings passionately about his love affair with the land he has left behind.

Interview, February 13, 1981

Dennis Brutus

Nightsong: City
Sleep well, my love, sleep well:
the harbour lights glaze over restless docks,
police cars cockroach through the tunnel streets . . .[1]

I was born in Port Elizabeth, South Africa, a coastal city, a big industrial city, the Detroit of Africa. I grew up there, went to school there, and to prison, so I established myself there. (Laughs). My parents were what the government terms "coloreds," that is, they were of mixed racial heritage. We lived in the township where blacks were forced to live. "Colored" is just a shade of black. The predicament for all blacks is the same in South Africa.

My parents taught black children in the ghetto. Growing up there was like living in a cocoon, a warm companionable neighborhood, an extended family. You're really not aware of the degree of discrimination in the rest of the world. Everyone around you is black. Now and then you'd see a white policeman, or someone who came to fix a water main. Occasionally you'd see a white man directing a gang of handcuffed, barefooted black convicts, but there was no open conflict.

There was one incident when I was ten or eleven years old. Coming home from school, my friends and I encountered a group of white kids whom we felt engaged in unprovoked hostility. They threw stones at us, and we responded with stones. The policeman comes up to us and says "What are you doing?" My friend answers, "It's those white kids, they started it." The cop slaps him, knocks him down. The implication was that when attacked by whites, we were supposed to run, not fight.

Adjoining our ghetto was a township for white workers. Living conditions a little better than ours. Two rows of fences and a hedge separated the communities. At the age of seven, I had an injury. For a few years, my mother kept me

33

home from school most of the time. A very solitary child. I discovered that across the hedge there was a little white boy around my age. Like me, he spoke English. He called me "darky," but I didn't see that as offensive. Then one day, my older brother said, "He calls you 'darky.' That's an insult."

Once, when I was in my twenties, I went to a bookstore to buy an English magazine. The woman behind the counter said, "Tell your master it's not in yet." I said, "No, it's for me." "Why, he reads English," she said to her colleague, absolutely astonished.

Another time, I remember going into a shop to buy a Beethoven Violin Concerto, and waiting to be served. Finally, after all the white people were served, the proprietor said, "What can I do for you, boy?" And I replied, "Pass me that Beethoven record, boy." His face turned purple. I simply never accepted their arrogance, their assumptions of our inferiority.

When I was teaching in a black ghetto school, I'd go and drink tea with a white friend. The students would say, "But he's white." They were programmed to be fearful. It was illegal to enter a white area. If you were caught, you'd go to prison. But it wasn't illegal to drink tea with a white man. I explained to them that a society that punished you for this was unnatural.

I must tell you one amusing story. The cinemas and theaters are all white or black. My students were studying *King Lear* and it was playing at the white theater. I bought the tickets in advance, and arrived at the theater with my twenty black students in tow. They refused us entry, summoned the manager, and were in a state of panic because black kids wanted to see the show. "I'm sorry, I can't let you in," the manager said. I'm glad to say there were whites in the line behind us who tore up their tickets and went home.

I went to a black college run by the churches, Fort Hare University, and got a good education, majored in English

34

and Psychology. Then the State took over the school, decided the place was dangerous—turned out too many educated blacks.

In school, and in my home town, I saw talented black athletes. Some of the best athletes in the country were black, and the South African Olympic team was entirely white. I had been brought up in the British tradition of fair play, and this seemed unfair. I discovered that the Olympic Charter says that any country which practices racial discrimination must be excluded. So I bombarded the International Olympic Committee with letters of protest. I gave copies of my letters to the South African press—so nothing was done in secret, no one could say I was a subversive. I gave them evidence—a black athlete who lifted 650 pounds while the best white athlete lifted 450—absurd discrepancies like that. It wasn't an overt political stand. But still there was harassment from the secret police.

They opened my letters. At around three o'clock in the morning, they'd arrive at my home, get the whole family including my mother and seven children out of bed, and ransack the apartment searching for subversive material. They'd carry out my typewriter, all my paper. I'd go to the head of the Secret Police to demand the return of my stuff. He'd be apoplectic—that I had the nerve to come and demand my rights. Normally, one wouldn't go near them, one would be terrified into submission. But here I was, asking to see his commander, and he'd say, "I'm investigating Communism." I'd say, "What does Communism have to do with the Olympics?" with an innocent air, and it would drive him through the roof. "I'll ask the questions," he'd say.

Well, we won support worldwide, and eventually, in 1964, the South African team was excluded from the Olympics. They've not taken part since. As a result of this exposé of South African racism in sports, I was served with a series

of orders making it a crime for me to teach—I was fired; I was forbidden to attend any meetings, belong to any organizations, or go to church, the cinema, or a football game. Then later, there was a banning order making it a crime for me to write. I had published very little up to then, preferring to act—words are sometimes a substitute for action—but I was so angry at this restriction of my freedom that I started publishing my poems under an assumed name.

So I went to Johannesburg. I formed the South African Non-Racial Olympic Committee. We mobilized around 60,000 blacks to demand admission to the Olympic Committee, and to demand integrated teams. At one of our meetings, two members of the Secret Police jumped out of a cupboard in the wall and arrested me. I was released on bail, but there was a law which permitted the government to detain you for life even if you had not committed a crime—"preventive detention"—so I fled the country. A friend drove me across the border heavily guarded by the military. We timed it for 4 P.M. on a Sunday afternoon, for we were told that at that time, the guards were often too lazy to come out and inspect your papers. Well, that's what happened. They waved us through.

I got no further than Mozambique. A doctor "friend" of mine offered to drive me to Kenya, but he turned out to be a policeman and delivered me into the hands of the police. People were celebrating my escape, and I was returning home in shackles, and landed in jail.

I tried to escape from prison through a gap in the barbed wire, but I was caught and taken to court. The guards who drove me to Johannesburg for the court appearance said "We won't handcuff you, because we're hoping you'll try to escape. Then we'll kill you." I was afraid I would be left to die on the side of the road and no one would know. It had happened to others.

Rush hour in Johannesburg. Commuters, shoppers, and

workers all heading for busses and trains. I tried making a dash for it in the crowd. I had played football, and was pretty nifty with my footwork, so I started weaving through the crowd. I covered four blocks, then boarded a crowded bus from the back, not realizing that it was heading back toward my pursuers. One of the cops chasing me tries to board the bus. I push him off, and he goes sprawling on the sidewalk. Then the conductor heaves me off the bus, and I fall across a parked car. I pick myself up and start running, but the cop catches up with me. I hear a noise and keep running. I look down and see this red stain on my shirt. No pain at all. I stopped, thinking it would be stupid to run myself to death. A crowd gathered. An ambulance arrived, but they took one look at me, saw that I was black and drove off.

Eventually the black ambulance came. I learned that the bullet had entered my back and had come out through my chest. The cops followed me into the operating room, hoping I would make a statement under anesthetic. All I said was "I don't regret anything."

I was sentenced by a commander who had supported the Nazis during World War II. Eighteen months in prison in Pretoria. About 60 of us were kept in a single cell built for 30—terribly crowded, dark, dirty. Occasionally, a warden came and asked if we had any complaints. Elected as spokesman, I said, "We need to get out of here." So they'd let us out to run, until we collapsed. My bullet wound hadn't healed. I protested to the prison doctor. His reply was really quite memorable. "But Brutus, you're so interested in the Olympics. You should be pleased that we give you so much exercise."

I was moved to another prison on Robben Island near Capetown. This was once a leper colony, and was now a prison for the most dangerous political prisoners, a sort of Devil's Island, highly fortified.

How does one survive the indignity of prison? It helps to have a sense of humor. While I was out working, breaking rocks into gravel, I'd fantasize about a helicopter appearing overhead, a rope dangling down, a dramatic escape. I'd fantasize about the resistance, and about revenge. I wasn't particularly angry with individuals. I wanted to see the system destroyed.

They beat me—I suppose for my offenses before entering prison. There was a time when my body was so covered with bruises, that I felt rather like a tatooed lady in a circus.

Convicts serving time for murder and rape ran the prison. They could beat us, lock us up, impose sentences. In exchange for "keeping order," they were rewarded by the white wardens with food, cigarettes, pot, or sexual favors.

We were not allowed any reading matter. No paper, no pencils. Once every six months I was permitted a letter. I would get paper and a stub of pencil and was told to write 300 words. If you wrote 301, the letter was torn up. Otherwise, no pencil. But I did write, of course. There were always things you had to communicate. You found you could remove a portion of the graphite, a quarter of an inch or so, and hide that under your mat. And you'd use it to scribble messages on toilet paper which you'd attempt to pass to other prisoners.

In solitary, I began reevaluating my life, and I concluded that much of it had been wasted. I reevaluated the poetry I had written before going to prison, influenced by John Donne, T. S. Eliot, Hopkins, and Pound: highly ordered, reasoned, and ornamental. I decided it was contemptible. Rather than be reduced to despair, I altered my approach, devising very simple, unadorned poetry, concentrating on the immediacy of communication without trying to show how clever I am at manipulating words.

I tried writing poems on toilet paper, but shortly before I left prison, my cell was searched, and the fragments which I

had stashed away were found and destroyed. So I came out with nothing. A few poems I was able to recreate from memory.

> *... but now our pride-dumbed mouths are wide*
> *in wordless supplication*
> *are grateful for the least relief from pain*
> *—like this sun on this debris after rain.*[2]

I came out of prison in 1965. A year later, I was allowed to leave Africa with my family on an "exit permit," a document which I signed permitting me to travel—although travel was a crime—with the understanding that I would be prosecuted on my return. It was a sort of Alice in Wonderland situation to be signing an admission of guilt with the police assisting you in committing the crime—an amusing piece of paper. I said I'd like to keep it as a souvenir. But they said, "No, no. If you come back, we will want it to prosecute you." Of course, I'm in no hurry to return.

I went to Britain intending to organize opposition to apartheid, but I found that powerful elements were bolstering the government; the large corporations were perpetuating the system, as they do here, by investing in the South African gold mines. So the South African struggle for human rights had to be carried on in Britain.

Then I came to Northwestern University to find that this university has $18 million invested in South Africa, and is making a handsome profit from black labor. So I find myself conducting the fight once again, and becoming equally unpopular.

I'm a gadfly. I have to say that this is blood money made from 22 million black South Africans who have no votes, who have no political rights, who are in semislavery. That's why it's so profitable. Without the support the

minority government receives in money, arms, and technology, apartheid will disappear.

I began to see that the poverty in the American ghetto is often reinforced by the same economic and corporate structure which derives profits from blacks in South Africa. Here, you meet blacks who have been fired from the Ford plant, shut out of U.S. Steel. You go to the South Side in Chicago, and you see the deadbeats and the addicts and the pimps and the houses that look as if they'd been hit by a bomb, bulldozed to make way for highrises, the blacks shunted from one ghetto into another—this is called "urban renewal."

I felt that I could be of some use trying to reach blacks on the cultural level. We formed an organization in Chicago called the Black Arts Celebration. We encourage young writers, dramatists, musicians. We have performances in schools, supermarkets, churches, and parks in the black areas. It is an assertion of cultural values in a society where black peoples' needs are not recognized, their humanity is often crushed.

Once I spoke at a community center on the South Side on the anniversary of "Sharpeville Day." That's a city, a ghetto like Watts outside Johannesburg, where 79 black Africans were massacred by police for taking part in a peaceful protest against apartheid. The center was in a rough area of Chicago, with gangs fighting for control of the drug traffic. In the middle of my speech there was some kind of rumpus in the back of the hall, people punching each other. I didn't know what was going on, and then two young black men came onto the stage with drawn guns. I expected the worst—an assassination, but they turned to the audience and said, "Let the brother speak." It was quiet after that. I learned later that the Black Peacestone Nation, Chicago's most powerful gang at that time, was running that part of town, and was "maintaining order." I had experienced that

in South Africa. There are enormous "locations" there where police do not go because there's no guarantee they'll come out alive. Black vigilantes run the town.

You know, the black struggle for liberation began as peaceful, nonviolent protest. But in the aftermath of the Sharpeville massacre in the late 60s when blacks were gunned down, it turned into an armed liberation force, and now it's escalating. The oppression of blacks in South Africa is worse today than when I was there. Any changes are only cosmetic.

For whites, it's a desert. You can't dare to be humane in South Africa. To be humane would be to recognize that every day, hundreds of blacks die of starvation. The society is carved up into ghettos. Black people are torn apart from each other, torn up by the roots. To live in South Africa, whites must insulate themselves against this reality.

Black leaders are coming forward, although few are allowed to speak out. Steve Biko was an inspiration—they murdered him, kicked his head in. But I have no doubt there will be others.

> . . . *for the unsung brave*
> *who sing in the dark*
> *who defy the colonels*
> *and who know*
> *a new world stirs.*[3]

Certainly the younger generation of blacks in South Africa are determined to wrest their freedom from the white minority if they can't get it in any other way. They are prepared to confront the armed might of both the police and the army in an ongoing struggle.

My poems are not the great stirring call to action some of my admirers and some of my critics wish they were. They convey my love of country. You don't stop loving because

the object of your love has become ugly and disfigured. I envision a time when ownership of my books in South Africa will no longer be a crime, when I will be able to go home.

> . . . the long day's anger pants from sand and rocks;
> but for this breathing night at least,
> my land, my love, sleep well.[4]

Although passionately devoted to their culture and language, most of Russia's post Revolutionary poets lived in spiritual exile, pariahs in their own land. Their work was unpublished. They faced banishment, imprisonment, annihilation. Osip Mandelstam died in the labor camps. Vladimir Mayakovsky committed suicide. His name anathema, Nobel Prize winner Boris Pasternak died in isolation. Marina Tsvetaeva hanged herself in Russia after 20 years in exile. Anna Akhmatova survived to write anguished poetry after her husband, also a poet, was shot by a firing squad. "Poetry is respected only in Russia," Mandelstam said. "People are killed for it."*

*Stalin is reported to have executed more than 100 poets and writers in one day.

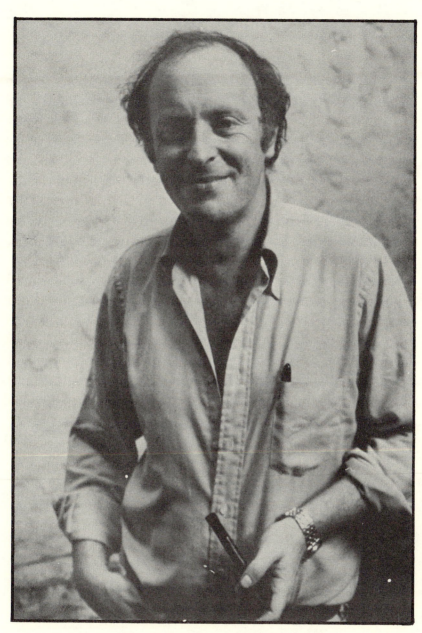

Joseph Brodsky
Poet from Russia

"I have too many memories"

Leaving school at the age of fifteen, Leningrad-born Joseph Brodsky worked at a series of jobs, from milling-machine operator to assistant in a morgue. Within a few years, he was working as a translator and writing the poems which endeared him to the Russian intelligentsia.* But this was not considered "socially useful work" in post-Stalinist Russia, and at the age of twenty-four, Brodsky was tried and convicted in a Russian court of "parasitism." When prison, mental institutions, and "internal exile" failed to squelch his independent spirit, he was asked to leave the Soviet Union in 1972.

Now an internationally acclaimed poet living in New York City, Brodsky is involved in the reconstruction and translation of his poetic manuscripts, most of which he was forced to leave behind him in the Soviet Union. Published here in *Selected Poems, A Part of Speech,* and other volumes, his poetry is emotional and subjective, enriched by literary and religious allusions, evoking the landscape of his native land in rich, visual imagery.

<div align="right">Interview, March 1, 1980</div>

*His poems were widely circulated in the Soviet Union, but not published.

Joseph Brodsky

A crowd has gathered at the University of Minnesota to hear Joseph Brodsky read his poetry. Uniformed policemen clear the room, and conduct a meticulous search. The audience returns; enter Brodsky—tall, slender, hair-thinning, with an air of vulnerability. Hand over his heart, glancing out the window, he reads his poetry passionately in the musical Russian language. In an interview the next morning, Brodsky speaks in heavily-accented English, his humor laced with self-mockery. Asked about the police search, he dismisses it. "It's nonsense." "It certainly enhanced your stature as a controversial international figure," I observe. "I wasn't aware that I had any," he replies.

I asked Brodsky what it was like to be a child in Stalinist Russia.

My childhood, I don't know how to tell about that. For that I need a drink; it's too early in the morning. I'm not a narcissist. One can't talk about oneself. Besides, I hate to be a parrot. I hate to repeat what I've said. I think everything I could say in one way or another I put into my writing.

I don't believe for a moment that all the clues to character are to be found in childhood. For about three generations Russians have been living in communal apartments and cramped rooms, and our parents made love while we pretended to be asleep. Then there was a war, starvation, absent or mutilated fathers, horny mothers, official lies at school and unofficial ones at home. Hard winters, ugly clothes, public exposé of our wet sheets in summer camps and citations of such matters in front of others. Then the red flag would flutter on the mast of the camp. So what? All this militarization of childhood, all the menacing idiocy, erotic tension (at ten we all lusted for our female teachers) had not affected our ethics much, or our aesthetic—or our ability to love and suffer . . .[1]

Rather early in life, I was made aware of my Jewishness. My family didn't have any affiliation with Judaism, none whatsoever. But the system has a way of making you aware

of your ethnic identity. In the Soviet Union, you carry an identity card, an internal passport. First there is your name, your family name, place of birth, nationality. Failure to do so can be punished by law. In Russia, a considerable amount of anti-Semitism is pedaled by the state.

In school, being "a Jew" was something you had to defend. They called me the Russian equivalent of "kike." I engaged in fist fights. I was silly enough to take the "jokes" as a personal affront. That was silly, because I am a Jew. Now I don't think there's anything offensive in being called what you are, but that awareness came later.

In school, I questioned the conformity. You rebel against all that. I remained apart, more an observer than a participant. This separation had to do with certain traits of my character. Moodiness, not buying the preconceived notions, being affected by the weather, I don't really know. People differ, especially when they are young. They are more obstinate, demanding. It's an accident of your personal development, of your genes. It just so happens that I was a little more demanding, less ready to excuse banality, stupidity, or redundancy. These sentiments set you apart from others.

There were others who were more rebellious. All kinds of nasty things happened to them. Actually, the bulk of my class ended up in criminal court. At one point, I remember, I had the idea of writing an anthology about my class and I traced their whereabouts. And a good half of them for one reason or another went through prison.

I too went to prison, so in that respect, I fit in. (Laughs.) Why was I imprisoned? I really don't know why, and it doesn't really matter. They had their reasons. Ostensibly because you're a poet. One day you find yourself in the van, being taken inside, you are searched, installed in a cell, and on it goes. It's pretty bad, initially. You are scared, because your routine is altered. But I think you can adjust to that.

Prison is after all a shortage of space and an abundance of time. It's unpleasant and yet to a certain extent it's a simple thing. You are operating on a small, graspable scale. You know who your boss is, who your friend is, who your enemy is.

In prison, you find yourself psychologically comfortable, because the distribution of good and bad is simplified. And you know where to go to find someone to lean on, to provide support. You get to know your cellmates. You're in the same boat. The lot is shared.

How did you preserve your humanity?

Perhaps I didn't have that much to preserve. Prison doesn't dehumanize you. It just reduces your sphere of operation, which is in a way quite convenient. Basically, prison is in miniature a reflection of the entire system, so there's nothing new to learn.

The only thing is that you can't write because you don't have pen and paper. But I was writing in my head. I was memorizing things. You go on doing what you know, what you like to do. I was lucky I was a poet. A novelist has to write everything down, but a poet can memorize.

Were you angry?

Actually I wasn't. I didn't accept the system. Therefore, they had a right to put me behind bars. This is their system. It is inevitable. Insofar as you manifest your dislike for it, they have a right to do whatever they like with you, since their goal is to perpetuate their system.

Why this persecution of a nonpolitical poet?

One isn't really nonpolitical. I didn't write in the official

manner because it was tedious. Insofar as one doesn't do the things expected of him, he is considered an enemy of the state.

One should be sober. I don't think one should delude himself. Those guys are in charge. I'm weaker than they are. I don't have the power. I don't really know how I would behave if the roles were reversed. I just thought everything would be all right, one way or another.

I was in prison three times. First, I was nineteen, then I was twenty-one, then twenty-four. The first time, my poems circulated in some kind of publication, what you call in this country "samizdat" (underground publications). The second time, I don't remember for what.

In 1961, when Brodsky was twenty-one, the Supreme Soviet of the USSR issued a decree calling for "the intensification of the struggle against individuals who evade socially useful work." Brodsky—one of Russia's most admired poets, heir to the tradition of the great modernist Russian poets Osip Mandelstam, Anna Akhmatova and Marina Tsvetaeva—found himself the target of journalists and party officials. His apartment was searched, his journals confiscated. In 1964, Brodsky was brought to trial.

They charged me with vagrancy. Although I was writing poetry and working as a translator, I was accused by the prosecution of not holding a stable job. I had refused to join the government writer's union. There were sixteen charges against me. I said, "If all those charges are correct, I should get capital punishment. If not, I should be released."

Excerpt from unofficial transcript of the trial of Joseph Brodsky, January 18, 1964, Dzherzhinsky Region Court of the City of Leningrad.*

*Trial proceedings, recorded by a Russian journalist and translated by Carl Proffer, were smuggled to the Western press.

Joseph Brodsky

Judge: *Citizen Brodsky, since 1956 you have changed jobs thir-*
teen times. . . . Explain to the court why you did not work
in the intervals (between jobs) and you led a parasitical
kind of life.

Brodsky: I began working at fifteen. Everything interested me. I
changed jobs because I wanted to learn as much as possi-
ble about life and people.

Judge: *And what did you do that was useful to the fatherland?*

Brodsky: I wrote poetry. That is my work. I am convinced . . . I
believe that what I wrote will do a service to people, and
not only now, but to future generations . . .

Judge: *Who is it that said you were a poet? Who included you*
among the ranks of poets?

Brodsky: No one. . . . Who included me among the human race?

Judge: *And you went to school for this?*

Brodsky: I don't think one achieves it by going to school.

Judge: *Where does it come from then?*

Brodsky: I think it's . . . from God.

The sentence—five years of forced labor—produced an outcry from
Russian and Western intellectuals, and was commuted to eighteen
months on a collective farm in the North, the Archangel region of the
USSR. In the village with its wooden peasant huts, Brodsky chopped
wood, shoveled manure, and in the evenings, read and wrote poetry.

I hear no words, and the moon burns steadily
at no more than twenty watts. I will not set
my course across the sky between the stars
and raindrops. The woods will echo
not with my songs, but only with my coughs.[2]

The peasants are like anybody else, no better or worse. I
liked their capacity to cherish what they had. I liked it there
because there was less interference, less of that nonsense
from the state. If there was any oppression, it came from the
elements.

After his return from "internal exile" in 1965, the official harassment

of Brodsky continued. On two occasions, he was confined to mental hospitals.

> This was the most horrendous thing I have been through. There's really nothing worse. They tried lots of things— recantation, change of character. They grab you out of bed in the middle of the night wrap you in your sheets, plunge you in cold water. And they stuff you with injections, all kinds of debilitating medicines.

In 1972, Brodsky received an official "invitation," accompanied by intimidation, to leave the Soviet Union permanently.

> When they asked me to leave the country, I felt terrible. This was my home. How do you say goodbye to your family? You simply can't imagine any forever. I went to Vienna and London first, then to the United States. I didn't experience any culture shock, but lots of things irritated my eye and ear.

> *Life is a drag, Evgeny mine. Wherever you go,*
> *everywhere dumbness and cruelty come up and say, Hello."*[3]

> I had an image of America prior to coming to this country. I had thought that this was the only realm where ethics matter. It isn't.
> The freedom in this country meant a lot to me. I began to realize the possibilities open to me. I experienced a terrific sense of exhilaration at being left alone.
> At the same time, in the seven years since I have been here, there has been a universe of complications and hurdles. I don't know what to ascribe it to: the fact that I am in a foreign country, or that I am getting older. My parents are still in the Soviet Union. They are quite old. I've been trying to get them to come here all these years to no avail.

The government will not allow them to leave, despite the Helsinski accords.* They are like hostages.

Brodsky disavows the term "exile" preferring to think of himself as "living abroad." But he returns frequently in his poetry to the motif of exile. In a poem written in Russia and published in the U.S., Odysseus speaks to his son.

> *I don't know where I am or what this place*
> *can be. It would appear some filthy island,*
> *with bushes, buildings, and great grunting pigs.*
> *A garden choked with weeds . . . Telemachus, my son!*
> *To a wanderer the faces of all islands*
> *resemble one another . . .*[4]

Brodsky has a keen sense of history. Asked if Russian writers of the late nineteenth and early twentieth centuries created the ferment which led to the revolution, he replied,

> I would say that they created a psychological climate in which political demagoguery found its audience. Russia has always been a centralized nation. Politically active elements capitalized on the people's tendency to follow sheepishly. Some were manipulated. Some put up a struggle. As in any civil war, there is bloodshed. If you're smart, you think it will pass. You don't want to kill anybody. But it doesn't go away.

What is the role of the writer in times of political upheaval?

The writer has only one role, to write well.

*International agreements calling for the reuniting of families, especially in cases of illness. Brodsky has a severe heart condition.

Is poetry stifled by political repression?

I wouldn't say that it is. On the contrary, it blossoms considerably. However, the flowers are not really visible in the Soviet Union, because the best there is is not in print.

Art, like the poor, provides for itself. It's bound to develop, like any natural phenomenon. Actually, art and adultery are the only forms of free enterprise left in Russia.

I really don't know what influenced me. One grows up hearing the language. It's a part of you, like your blood. We have a literary tradition that is three hundred years old. Every writer bounces off the previous linguistic and stylistic idiom. Russian, this is such a language that poetry is inevitable.

Is your writing a way of reaching out to people?

Writing is essentially a very private affair. I write to clarify certain things for myself. If the same thing happens for readers, I'm very pleased. But it's certainly not my main purpose. I became a poet because of circumstances. To call oneself a good poet is almost as indecent as calling oneself a good man.

Do I trust people? Yes, stupidly, I do. I find it hard to get close to people, but once in a while, if I'm lucky, I do.

> So long had life together been that now
> the second of January fell again
> on Tuesday, making her astonished brow
> lift like a windshield wiper in the rain,
>> so that her misty sadness cleared, and showed
>> a cloudless distance waiting up the road.

> So long had life together been that once
> the snow began to fall, it seemed unending,

54

that, lest the flakes should make her eyelids wince,
I'd shield them with my hand, and they, pretending
not to believe that cherishing of eyes,
would beat against my palm like butterflies . . .[5]

I have too many memories. The more one remembers, the closer one is to dying. The room is full. One cannot handle any more. Still, remembering the past is more satisfying than contemplating the future. There is an awareness that death may come before I'm ready for it, not on my terms. I'm not concerned about an afterlife. That's not on my agenda.

There is an urgency about creating.

. . . Life, that no one dares
to appraise, like that gift horse's mouth,
bares its teeth in a grin at each
encounter. What gets left of a man amounts
to a part. To his spoken part. To a part of speech.[6]

Perhaps very little of what happens in Argentina is really news, because there is no movement forward; nothing is being resolved. The nation appears to be playing a game with itself; and Argentine political life is like the life of an ant community or an African forest tribe: full of events, full of crises and deaths, but life is only cyclical, and the year always ends as it begins . . .

V. S. Naipaul, The Return of Eva Peron

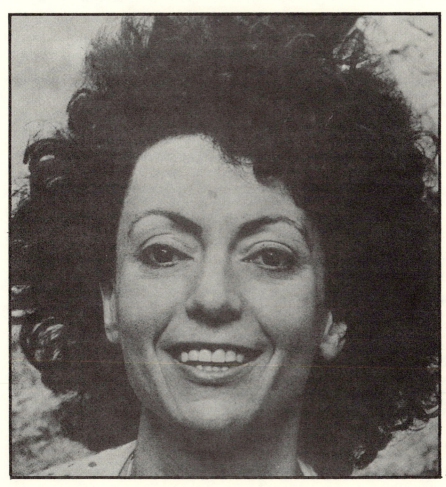

Luisa Valenzuela
Writer from Argentina

"I was always a bit of a rebel."

A prominent Argentine journalist, Valenzuela has worked for the newspaper *La Nación* and has contributed to national magazines in her native land. She is the author of novels and short stories published in the Spanish language, an award-winning film script, and two books published in this country: *Clara,* 1976 and *Strange Things Happen Here,* 1979.

When she speaks in the colorful cadences of her British-Argentine acent, Valenzuela reveals the many facets of her personality. There is her puckish sense of humor. There is her literary persona, her affinity with those Latin American writers forced by tyranny to come to terms in their writing with the daily reality of oppression. And there is the pensive and compassionate woman haunted by the memory of fear in her homeland.

<div align="right">Interview, November 12, 1980</div>

American Indian tribes used to send boys into the forest for days in search of a vision. I have been living in the forest called New York for three years, and I still don't perceive my vision too clearly. Nor do I really understand the meaning of the word exile. I don't pretend to be a political exile to benefit from the prestige this status has among many intellectuals. I'm here by choice. I do go home to Argentina. But go back home to what? The country I knew and loved so much is not there anymore. The military regime has choked her to death—through murder and torture and harassment and censorship.

Sometimes I call myself an expatriate and forget the pain of being away from my land and language. I tell myself it's good for a writer to be away from home—sharpens your perspective. And it gives you a chance to say what has to be said. True, but in a way I'm kidding myself. Those of us who exile ourselves from our homeland are participating in the conspiracy of silence that permeates the land, and that gives the dictator free reign.

When I do go home to Argentina, I notice that few people want to talk about the political horrors we have lived through. They've succumbed to the semantic tricks of the government which hired a Madison Avenue advertising agency to convince the people that speaking out against the government is unpatriotic.

Besides, speaking out is *dangerous*. When I return home, I'm very careful. I don't speak pointedly about the abuses of the Argentine government the way I do here. If I did, do you think I would be alive? I've seen too many of my friends sent to prison for that, tortured, and then disappear, just as if they had never existed.

Despite the conspiracy of silence, on Thursdays in Buenos Aires you will see a band of desperate mothers parading in front of the Government House, the Pink House, hoping for a chance to inquire about the where-

abouts of their sons and daughters who have disappeared. There are countless other bereaved mothers who do not join them, perhaps afraid to find out the truth. The pain is too strong to bear, and fear closes their mouths.

It is difficult to make rational conversation out of the irrationality that is Argentina today. There's something nightmarish about the life there. We have always believed ourselves to be the most cultivated, the most civilized people in Latin America. And yet we have come to the point where 30,000 people have disappeared. "Desaparecido"—a term invented by the underworld of the military and police in their systematic campaign to wipe out any opposition to the regime. And the most frightening thing is that we don't resist. We acquiesce.

People don't speak openly of their fears—they consume huge quantities of sedatives. And you find them on the psychiatrists' couches. There is a fashionable area of Buenos Aires that has so many psychologists and psychiatrists, it is known as "Villa Freud.," The bars there are named "Freud" and "Sigmund." The most popular comic strip character in Argentina is a duck-like bird named Clemente who undergoes psychoanalysis.

I grew up in safer times in Buenos Aires, in a beautiful, secluded neighborhood with tree-lined streets, and mysterious mansions. I explored an abandoned house that turned into a castle or a dungeon, depending on my whim. In the summers, we went to the estancias, the ranches, where we roamed the wastelands, rode horses, and played gaucho. The gauchos in Argentina are different from your cowboys. They're a wise and philosophical people. I wore colorful neckerchiefs, baggy trousers, and espadrilles. No saddle. I was always a bit of a rebel. I wasn't going to be a nice little girl in a beautiful dress. I climbed trees all the time—quite a tomboy. Life was an adventure.

I really didn't intend to be a writer. I went to an English

school. When I was in the sixth grade, the teacher called my mother and she said, "Luisa is very bright, she's a fine mathematician, but her compositions are terrible. Why don't you write them for her?" Well, my mother is a famous and respected writer in Argentina. So she wrote a paper for me on a very appropriate subject, the making of the Argentine flag. She wrote of this man lying out under the blue sky and dreaming of the flag and independence. And I thought it so horribly corny that I decided to write. So you see I tumbled into a family tradition.

By the time I was fifteen I was working for a magazine. At seventeen, I was working for newspapers. All my friends were painters and writers. We lived a Bohemian life, sitting in the cafés and talking very late at night, putting on plays, taking part in festivals. There was censorship under the Peronist regimes and intellectuals were harassed, but we were young and felt invulnerable. A time of innocence.

My mother is not political. She's conservative. A society lady. But she thinks of herself as an anarchist. As time went on, there was increased persecution of writers and intellectuals. They couldn't find work, and they were starving. My mother gathered together a group at her home. Brilliant and outspoken writers like Borges and Sabato came to give talks and poetry readings. And we went to dissident parties in Sabato's fantastic, old, crumbling house.

I became a sports reporter for a popular magazine. I was the first person in the locker rooms after the football games. I remember, after our national team won the world championship, the whole country went out into the streets, celebrating as if it were Bastille Day. The whole event was manipulated by the media. I'm sure the government hired American press agents to whip up the populace. It all seemed rather stupid to me. Had we liberated ourselves from dictatorship, there would have been something to celebrate.

Juan Peron headed a government from 1946 to 1955 notorious for the weakening of the country's once flourishing economy, and suppression of dissidents. Forced into exile by a military junta, he was recalled and elected President in 1973.

Ideologies in Argentina are so confused. Peron was an enemy of the Left. But the Leftists, with their powerful underground army, brought him back from exile thinking that they could manipulate him into supporting their cause. Wishful thinking. Peron used the Left to regain power, and then repudiated it. Peron never had a program for social reform, although his second wife Eva had at least attempted some reforms during his first regime. The second Peronist regime was even more corrupt than the first. He appointed Lopez Rega, a witch doctor known for his writings on the love charms of Venus and Saturn, as Minister of Social Welfare. We felt as if we were in the hands of madmen.

At Peron's death in 1974, his third wife Isabel succeeded him as President. Under Isabel, the security forces became all-powerful, abducting, torturing, murdering in a whirlwind of paranoia, always denying responsibility for their crimes. Their victims were left-wing extremists, but plenty of innocent people got caught up in the violence. On an ordinary day, you could hear police sirens shrieking. If you saw a package lying on the sidewalk you'd have to cross the street for it might be a bomb. The para-police force struck at the populace, seeking subversion everywhere. It was a reign of terror.

It's true that a number of bombs have gone off in the neighborhood, but what can they be searching for in the grocery store? Imagine: they started by cautiously picking up each piece of fruit, holding it up to the light, and examining it, listening to it with a stethoscope. Then their fury mounted till it finally found its natural form of

expression, which is kicking. They kicked first the fruit and then us a few times, until they realized that we had no hidden arms there, no gunpowder cache, nor were we digging secret tunnels or hiding terrorists or maintaining a people's jail behind a mountain of potatoes.[1]

To restore "order" the military junta deposed Isabel, and everybody cheered—at last we would have peace. Wishful thinking again. The military are trained for war. The kidnapping and killings continued. Press censorship grew more insidious. They stopped professionals from speaking out and from functioning. A psychoanalyst, a friend of mine, was tortured because one of his former patients was a Leftist. Whole clinics were closed down because they had a patient who was a Leftist. If you associated with a dissident, you could disappear at any time. Good friends of mine were tortured for writing in opposition to the government, others, simply because they were writers. The country could not breathe.

I was writing in secret during this time.

Though I'm quiet these days, I go on jotting it all down in bold strokes (and at great risk) because it's the only form of freedom left ... to preserve my sanity. I write in the dark without being able to reread what I've written . . .[2]

Most people in Argentina carried on their daily activities in a kind of stupor. I had this feeling that most of the people were blind.

People irrevocably condemned to darkness to whom all clarity has been denied. And to compensate . . . they make candles and that's maybe the only chance they have to laugh. They also make coffins, the women embroider shrouds as they weep and it's only during the frequent burials, when candles and shrouds come together, that laughter and tears become one and it's as if they were alive.[3]

Actually, I've never been politically active, and I don't consider myself a political writer. But one does have to express one's concerns. It's the only way to live. All this discussion of art, whether or not it has to have a message, this is very Latin American. But art, if you can use such a pretentious word, is what it is. It's not political discourse, but it doesn't deny political realities either, for it's about our lives. The idea of the ivory tower artist—that's a romantic idea.

I lived abroad for two years, in Mexico and the United States. I had to get some distance from the situation in Argentina. When I returned, nothing had really changed politically, and I had this sense of futility. One of my books was published in the United States, and in 1979 I received an invitation to become writer-in-residence at Columbia University. It seemed as if New York was my destiny. Or my damnation?

In New York, I missed old friends and family. I missed my favorite books and the old familiar terrain. But I had this wonderful sense of mental space. It's true there is violence in New York. Instead of being afraid of the cops you're afraid of the people on the streets. But I went out at night, I rode the subways, and I wrote. Actually, in the midst of all the violence, New York is a quiet city.

My writing . . . sometimes it emerges spontaneously. Most of the time I have to fight for it. I personally don't want to write. I'd much rather roam around, or join a safari. To sit down and write, that's too big an adventure. I think you don't want to face yourself, to put yourself on paper. It's like seeing the face on the other side of the mirror. All those unconscious movements that appear on paper are very threatening. I like some threatening things, but then I get frightened and run away and invent all kinds of excuses not to write. It's like jumping into a swimming pool—you

jump to see if there's water in it. Not a good tactic, but at least it's not the paralyzing terror—not writing, I mean.

My characters have a life of their own. Words have a life of their own. What is said is more important than the characters themselves. I don't care so much for psychological truth but for profound truth of the word, of language. It's strange, but sometimes a word or a pun will turn everything around. Many of my short stories start with just a line which in itself is not significant. But the whole story springs to life, the words grow and have children, and a coherent story develops. Evidently, the story was somewhere in my unconscious.

Now in my new novel the central character is a witch doctor who becomes a powerful government minister in an unnamed country. I tell the story in the first person; I'm the protagonist who enjoys devising methods of torture and repression. Certain words this character uses evoke grotesque images. I'm sadistic to the point of absurdity. The horrible thing about this novel is that I'm treating the political realities of Argentina as a big joke. Horrible because there's nothing funny about it. But it's the only way I know to tell about the terror. If I wrote a drama, it would be so melodramatic it would be unbelievable.

When you live under oppression, you have to have a sense of humor to survive. It's like wearing dark glasses to look at the sun. You can't bear to focus on it directly. So many people I know have been destroyed. My inner censorship would not allow me to even think about these things without humor. Black humor, I suppose you'd call it.

It's my Latin American mentality. We deal in subtlety. You translate ideas and experiences into metaphors and symbols. Where does the material come from? If you're alert, you find it everywhere. After Peron died, the country was in turmoil. Emotions were running wild. People's

wishes for peace were flying around as if they were doves. I wrote this book of short stories *Strange Things Happen Here.* It was a way of coping with what was bewildering. I went to the cafes and wrote and wrote. Every image, things I overheard, I put in the stories. For example, I was riding a bus in Buenos Aires, and near me was this guy—very well-dressed and dapper. Every time we passed a church, he'd make the sign of the cross. And then I watched him put his hand on a woman's ass. And I wrote this feminist story. In my story, the woman retaliates by putting her hand on his ass, and taking his wallet. You're surprised, you're on her side. Men think they can do anything to women. Some people think it's funny, some think it has a political message.

Women are repressed in Argentina, but it's not as bad as in most other Latin American countries. But that's one reason why I left Argentina. Women are always forced to use the words of men, to accept their image of the world. There are still some archaic laws: there's no divorce, so when parents get separated, the father controls the children, like property. The mother doesn't count.

I was married to a Frenchman, and for a while we lived in Paris. But it was boring. Marriages usually are. I wanted to live in Argentina, but, to a Frenchman, that was an insult. When we separated, I couldn't remarry by Argentine laws. For many years I lived with a man who was more of a father to my daughter than her father was.

We Argentines love to laugh. The government can't kill that in us. Like America, we are a nation of immigrants, and very cosmopolitan. There's a saying that an Argentine is a Spaniard who believes himself British, who speaks some French, and actually is Italian. That's typical Argentine humor. And we're always playing with words. A new bill of paper money was issued and, because of inflation, it

was worth a lot of money. People called it "the baby" because you had to change it all the time.

I guess it's because I have this sense of the absurd that I like New York City. Especially Greenwich Village. Here, artists, writers, all kinds of strange people are acting out their dreams in the streets. I mean, there is this guy who roller-skates in Washington Square Park; he roller-skates wearing his warmups and earphones, and he does ballet. And you know he's thinking of something beautiful while he's doing his pliés. People really live out their fantasies here.

I think that it's the other side of the coin from Argentina, where people can't live out their fantasies. They dream, but everything goes wrong. People deny the reality of the oppression, they shut it out. That's how they survive. They don't speak of the fact that the rich are getting richer and the poor poorer. When they do talk of the bloody purges by the junta they say, "Well it was like a war. People get killed in war." You cannot justify the excesses of those in power, whoever they are.

Here in Greenwich Village, horrible and beautiful things are going on all the time. Reality is always giving the writer presents. Once, I was chatting with a friend on a corner in the East Village near the Bowery. It was a cold evening. This drunkard, an older man, approached me, babbling. He looked like a nice guy, so I gave him some coins, maybe seventy-five cents. He started thanking me, very moved. He had a crushed cigarette which he wanted to give me. I don't smoke, so I said, "No, no, keep it please." I wanted to get rid of him so we could go on talking. "Really," I said, "I don't smoke." Well, he backed away a little and he started crying. And I felt so bad. The only thing he could offer me was his crumpled cigarette. So I put a hand on his shoulder and said, "Look, please don't worry."

He wanted to hug me and to cry on my shoulder, and I ran away. That's what one so often does. One gets half-involved, but is afraid to get really involved.

Another time, I was writing something really difficult about Argentina. I went out for a walk to get away from it, and I heard a voice yelling from behind the church up the block. "What can I do to be saved?" I thought, oh my goodness, I can't even go to the corner without hearing the voice of my conscience.

When I was living in Argentina and in other countries, I was never completely happy. I always thought I wanted to be somewhere else, there must be a better place. But New York is a world in itself. Everything comes to you. I think that it's the only place that is everyplace at the same time. It's the center of nowhere, and everywhere, a wonderful, eerie city of the mind. I love that sensation.

William Gass on the contemporary Latin American novel.

They come from everywhere, these massive, burning books . . . (One) dreams of a place where prose might loosen its pants; and now, indeed, it has sprung up at us; it has come back to us in a series of powerful orgasmic bursts . . . in the guise of symbol and allegory, transmogrified history, felt fact and passionate observation, colorful tapestry, subtle arrangement and thunderous rhetoric . . . as exuberant, exact and angry poetry. It is a literature of exile . . . The Spanish-speaking people have objectified themselves and their carefully duenna'd inner life by driving out their artists . . .
William H. Gass, *"A Fiesta for the Form,"*
The New Republic, *October 25, 1980.*

71

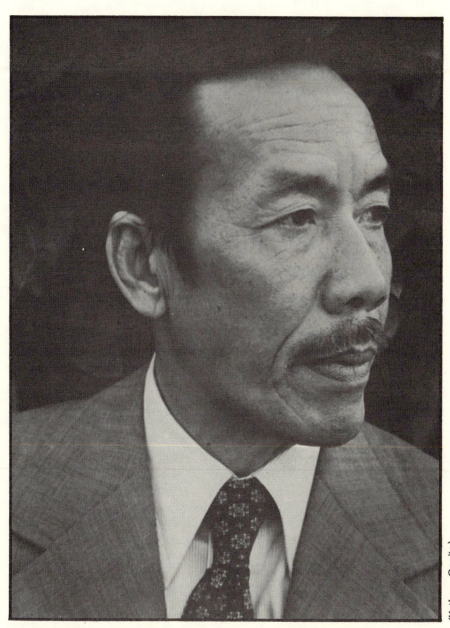

(Kathryn Oneita)

Mai Thao
Writer from Vietnam

"The sea was calm, and the people began to sing."

Since the fall of Saigon to the Communists in 1975, the South China Sea has been strewn with refugees, people from all segments of Vietnamese society who are willing to risk their lives in small boats on the high seas, rather than endure food shortages, forced resettlement, and political repression in their native land.

One of these "boat people" is Mai Thao, a journalist and popular novelist in Vietnam, author of 42 books in the Vietnamese language before he was forced underground by the Communist takeover.

Mai Thao escaped by boat to Malaysia in 1977, and from there came to Seattle, where he is editor of *Dat Moi*, a Vietnamese language newspaper, and is president of the Washington-based Vietnamese Cultural Association. All of his books can be found in the Cornell University collection.

He speaks with quiet dignity, and with the restraint which years of privation have taught him. His friend Tony Nguyen, an earlier emigré from Vietnam, serves as translator.

Interview, July 10, 1980

Mai Thao

I was born in 1930 in Nam Dinh Province in North Vietnam. My father was a successful rice farmer. He had honor from people in the village. He was the head of our family. My mother was in the house with servants. My brothers and I, we obeyed our father in everything.

After Westerners infiltrated our country, then there was conflict between young and old people. But outsiders could not tear apart the foundation of our country-family life. This was the old order which no system could destroy.

My father managed the farm. I was not allowed to do farm work because my father was a rich man. It would not be accepted. I had to go to school and study. But after school, I roamed around the farm. Buffaloes pulled the plow across the flat delta near the Son Hong Ha River. The meadows were green and fertile. Some of the village people worked for my father; some had their own land. Our people love the land. They believe it contains the spirits of their ancestors. Whole families worked together in the fields. No one starved.

When I was ten years old my father lost his farm and my family moved to Hanoi. So hard for my father to leave behind the land of his ancestors and his village. In the village he had a connection with all the people. He had an identity which he could not find in the city.

In Hanoi, you could see forts and old pagodas from the Royal Kingdom of the eighth and tenth centuries. One pagoda was named Island of Jade, another the Temple of the Dark Warrior. At the center of the city was a lake where working people met after the long day. In the summer, we went to the seashore.

Although we were living in the city, we held on to our traditions. We honored old people, and observed the holidays in the old way.

Nationalism is part of the Vietnamese tradition. For a thousand years, the Vietnamese were ruled by the Chinese who influenced their

thinking and educational system, but never won total submission. Then in the nineteenth century the French took control of many of the country's provinces, establishing French authority in the schools, the civil service and local government.

> I was sixteen years old when I joined the resistance movement against the French. We put on musical programs in the villages to arouse the people's patriotism. We wrote stories about our history and love of freedom. I left the resistance four years later when I realized that the Communists were using the movement to stir up opposition to the old order in our society, to encourage the class struggle.
>
> The war between the Vietnamese and the French ended in 1954, and the country was partitioned. The Communists allowed people to migrate, so my family moved to Saigon. That was a protest against the Communists. My father didn't trust them, and they didn't trust him. Under Communist rule, our people lost interest in art. How can you paint pictures when you have to struggle for food, for the essentials of daily life? Intellectuals were hounded, and often forced to fight in the army.

Hostilities broke out in 1958 between the Communist regime in the North, backed by Communist China and the Soviet Union, and the non-Communist government in the South, supported by the United States and its allies.

> There was constant propaganda from both sides. The North claimed they were liberating the South against United States imperialists. The South Vietnamese government said they were trying to liberate the people from domination by Communist China and the Soviet Union. The Communists fought a hide-and-seek guerilla war to clear the jungle. American airplanes sprayed poison to

force the enemy out of the jungle. They poisoned our forests, our plants and animals, our food supply.

My memories of those years of war are still vivid. I can still see the bombed houses, trees with burned leaves and bare branches, an old Temple burning, children with big bellies missing an eye or a leg, a homeless old woman wandering as if she had lost her soul . . .

Since 1950, I was writing. To be a writer or a scholar was much respected in my country. My books were published by small private companies in South Vietnam. Even though they were very popular—some were best-sellers, to make a living as a writer was very hard. I kept on writing, many novels and stories. We did not have many translators, and my books were not translated into other languages. Also I edited journals and literary magazines.

I read some American writers I really liked: Henry Miller, Hemingway, John Steinbeck—these were translated into French. They did not influence my writing. Our literature is so different. We have our own literary traditions which go back thousands of years. Our literature is very formal. It has a purpose: to improve the society.

A story I wrote that is my favorite is called "The Testament on the Highest Peak." A man and a woman live together in a small house near a stream. She does not understand why he leaves her. He travels to the highest peak in the Orient. He must know how high it is; he is in search of absolute truth, happiness. When he reaches the mountain's summit he is desperate, for he realizes that absolute truth is unattainable. His beloved searches for him, and finds him lying beside a stream. No one knows how he died. She takes the body back to the village asking herself why he died. She realizes that he had to pursue the truth; for this, he was willing to die.

I pose a human problem as a writer; I do not attempt to

find resolution. Most of my books and stories are based on my own experiences, or on those of people I have known. Remembered events blend with fantasy. Style is important.

> *At the end of the beach, a jagged ridge of rocks partly hides the fishing village of Merang which sits at the foot of a naked mountain stretching from nearby rows of palm trees weeping their leaves to the waves . . .*[1]

The Americans withdrew from Saigon in 1975. Because I had protested the Communist takeover in my articles, I was on the blacklist of writers considered to be a threat to the government. Most of the other writers on that list went to jail; many died there because they did not have enough food or medical care.

I was fortunate. The people took care of me and protected me. They kept me alive. Without the love of his people, a writer could not survive in Vietnam.

The Communists issued a paper stating that anyone who helped a blacklisted writer would be arrested. Their security system was well organized. They assigned neighbors to watch each other and report to the government. But many many people risked their lives to help me. They hid me in eight different houses over a period of two years. I lived in basements in the dark. If any light or activity was noticed in the neighborhood, it would be dangerous for the family. Whenever they were afraid that I might be found, they moved me to another house. Homes without children, for the Vietnamese would not teach a child to lie. The Communists searched some of the homes, but they were not very efficient, and I was not found.

I lived like an animal in my dark, underground hideouts for two years. There were sleepless nights, days of monotony. A friend brought me Chinese Chess, and I played both positions. Sometimes I desperately needed to get out; this

had to be done in secret in the darkness. Sometimes it is inconceivable to me that I lived under those conditions. There were times when I felt I was on the edge, when I could imagine the possibility of taking a long sleep and just passing on. But the Vietnamese people are accustomed to suffering, and to overcoming it. I felt very deeply that a writer belongs to his society, to his people. With so many people cooperating to save my life, I felt that I had to be courageous, to deserve the help that I received.

I am not really a Buddhist, although my family is Buddhist. But as a writer and thinker I felt that a person should look back on his life and try to find out what it all means. So I spent many hours meditating. Especially in those circumstances, one should seek to find the truth, the significance of one's life. I had the opportunity. I believe that each of us has his God within himself. A man can save his life by himself, by what he does and thinks. This awareness was always with me.

By the end of 1977, a private organization of Vietnamese was making a major effort to help people escape. They contacted me and told me to wait in my hideout. I knew that escaping was expensive, and I didn't have a cent. There was no way to contact my family without endangering them. I waited. One very dark night, a man wearing a black shirt arrived on a Honda and parked in the back of the house under a tree. Following instructions I had received, I got onto the bike and we rode in silence to the Saigon River where a small fishing boat was waiting. I was advised to row, to pretend to be a fisherman. After two or three hours I was transferred at sea to a motor boat. Now the woman operating the boat said that I could smoke. I took one final look at Saigon, and I cried because I knew that I would not see it again. The South Vietnamese people, we give all our loyalty to one city, Saigon. I felt that I was turning my back on my heritage.

Out on the ocean, I had a sense of release. I was a free man.

It was a dark, moonless night. We reached the ocean, but a storm came from the Philippines, whipping our little boat, forcing us to return to shore. Back to my hiding place. A few days later, I received word that my father had died at the age of eighty-two. In Asian countries a child is expected to attend a parent's funeral or face condemnation. But my brothers said I was not to come, for the house was watched and I would be arrested. Fortunately, I was able to visit his grave in secret and say a prayer in his memory, and this eased the pain.

Then, another motorcycle on a dark night. The second escape was even more dangerous than the first. A small fishing boat took me to a cove and I had to hide there in a swamp hidden by trees for two days. Finally, a boat arrived and took me out on the high seas where we searched in the dark for a larger fishing vessel. There was a signal, a sudden flash of light, no sound. It took careful calculation and much luck. The boat I boarded was built for 20 people, and it held 58. We had to ration water and rice, for there was hardly any room for food. Everyone had just a little every day, and no one died.

On the boat there were political refugees, students, old people, families, with young children. We traveled for six days and nights. People were hungry and thirsty, some were sick. When we came near to Malaysia, the sea was calm, the day clear, and the people began to sing. They asked me to recite a poem. I recited one by a Vietnamese friend about a man who leaves home without anyone to say goodbye.

We reached Malaysia, but we were not wanted there. The officials were unfriendly, for so many refugee boats had come there; it is a poor country, and they cannot afford to take care of all of them. Every time we tried to land they chased us away. Finally, a Malaysian fisherman signaled to

us; he said to ram the boat against the dock. If our boat was destroyed, they would have to take us in. We did this and it worked. The boat that had brought us so far split apart. We helped the children, the sick people, and the old ones wade to shore. Relief officials from the United Nations met us, and gave us money for food. The first thing that I bought was a pack of cigarettes. They took us to the refugee camp. It was very crowded, but there was food and shelter and we were free. We were not confined to the camp. I came to love the Malaysian people. There was a radio broadcast in the camp, and I was asked to write programs and to give talks. I served as president of the refugee court.

I came to the United States because two of my brothers were here, and I knew Vietnamese writers who came before. Now I am writing about my experience. I am hoping to have my novels translated into English. I am working for the release of artists and writers who are still in prison in Vietnam. There are so few left. I am afraid our arts will die.

I send money to my mother. I want her to come here, but she doesn't want to be a burden to her children in the United States. And she does not want to die away from home.

I say to the world that twenty years of warfare have destroyed my country. Buildings and roads you can rebuild, but not the beauty of the land, or the morale of the people. While we are talking here, the destruction continues under Communism.

Perhaps one day Vietnam will be free and I will be able to return. I am happy to be here, but inside I am very sad. Sad for my people. I do not know if we have a future. Separated from our land, it is hard to preserve our traditions. We feel as if we have lost our soul.

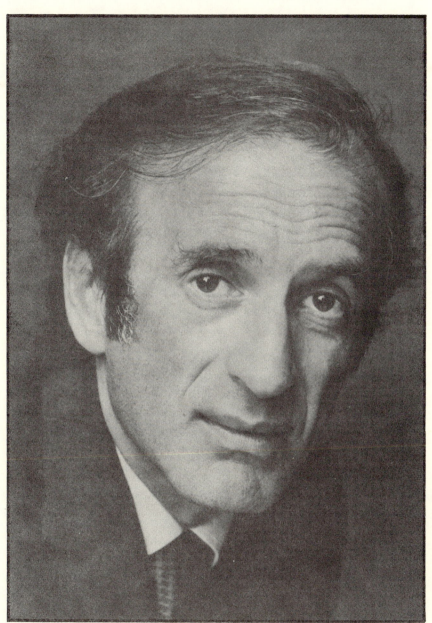

Elie Wiesel
Writer from Hungary

"How many candles must one light for mankind?"

And who is he? He is a Jew. He is Job, of course. But he is also one of the Last of the Just—a man 4,000 years old who has absorbed the spirit of a People and transmits it through his very existence. But he is non-Jew, too, because he is Man and speaks for all of us and to all of us . . .[1]

My conversation with Elie Wiesel takes place in his study lined with books in many languages, overlooking New York's Central Park. The shadows in the room highlight the deep caverns in the face of this man who has lived through mankind's darkest hour and survived. He speaks in a gentle, melodic voice, choosing his words carefully, living out his role as witness to the Holocaust of World War II, a reality that is never far from his thoughts.

A philosopher-poet for all times, Wiesel teaches, lectures, and writes continually: novels, tales, parables, nonfiction studies. In his many books: *Night, Dawn, Legends of Our Time, Souls on Fire, The Testament,* and others, he puts his visions into words, words that rivet our attention forcing us to reexamine our history and our humanity. He calls on us to remember the dead, for the sake of the living.

<div align="right">Interview, November 13, 1981</div>

Elie Wiesel

In the beginning, the end: All the world's roads, all the outcries of mankind, lead to this haunted place unlike any other. Here is the kingdom of night, where God's face is hidden and a flaming sky becomes an accursed graveyard for a vanished people.[2]

Ghosts from the past haunt Elie Wiesel and will not let him rest. His mission, one he seems driven to fulfill, is to recapture a past filled with both horror and beauty. So the world will not forget and immolate itself. So the people he once knew and loved will live again.

I was born on Simchat Torah, a Jewish holiday which celebrates the Law. The year was 1928. My little town, Sighet, was in Rumania; then in 1939 it was taken over by Hungary. In my mind's eye, it is vibrant and colorful. I can still see the low gray houses, the church and butcher shop and, at the corner of the market square, our synagogue.

I grew up among compassionate, gentle people who had a lofty view of God. The community was spiritually rich. My memories of those early years are filled with longing and nostalgia. The world was pure and beautiful. Probably it wasn't, but in my mind it was so. The rich were rich, the poor were poor, but there was no real hate between them, or at least that's what I thought because the rich loved to give, and the poor loved to receive. The scholars loved to teach, the students loved to study. Even the workers worked from early morning till night for a little food and a roof over their heads. It was almost idyllic. I know it was a child's vision of the world, but that was my vision of the world.

The town isn't there any more, but in my memory it remains beautiful. I'm not ashamed of glorifying it. Sometimes I'm stretching the truth a little. (Laughs.) So what? So many people belittle that old life, so many people besmirch it, let there be one person who takes up its defense.

After the war, I learned the truth about Sighet—that there were many divisions and tensions in the town. One reli-

85

gious sect hated the other. But that knowledge came much later. In my time, I was so involved in the life of our Hasidic* community that I saw only the harmony.

I grew up in a loving home. Because of the pressures from outside, the families were extremely tightly knit. My father was a storekeeper, and my mother helped him in the store. He was also involved in community affairs, always raising money to help Jews who had medical problems, who were in trouble with the authorities, who had to flee the country. Busy as he was, on Shabbat our family spent the whole day together.

My mother—I rarely speak of her—was a strong, gentle, and pious woman. She read books in many languages— German, Hungarian, Yiddish, and Hebrew, all self-taught. I think my passion for reading comes from her. Even though she worked in the store all day and kept a religious home, she was surprisingly well informed about modern secular movements.

My grandfather lived on a farm. We went there by horse and carriage. He had a small house, a vegetable garden, a goat, a horse, a cow. Oh, he was a poor man, but he didn't know it. I used to love to sing with him and to listen to his stories of the lives of the Hasidic masters, of the wonderful miracles that befell them. Whatever I received, it was from him. I have written three books on Hasidism. Now I try to write more scholarly books—but it is still my grandfather's voice that comes through.

There were many communities like Sighet in Eastern Europe at that time. I was too young to have known the intricacies of the way communities function. I was both an outsider and an insider as all children are. People don't talk of certain things in the presence of children. Still I saw the

*A religious movement that flourished in the ghettos of Eastern Europe; it centers on compassion, love of scholarship, and joyful worship.

people struggling from early morning to late at night. I saw how they managed to nurture their children. They put them through school, gave them a sense of commitment to learning, and dignity. Even in the deepest of exiles, in the darkest of times, there was a place for education. This was the priority.

At six in the morning I used to get up to go to cheder. We studied the Scriptures, the Talmud, and commentaries. We learned whole passages by heart. When I was twelve I began the study of the cabbala* with a man who did odd jobs at our synagogue. "Moshe the Madman" he was called. "Be kind to him, he's mad," people warned me. He had the strange, deep-set eyes of a visionary. He found me praying at the synagogue and undertook to introduce me to the forbidden books. One was not supposed to explore these mysteries till one was thirty, but my father did not intervene. He thought any study was valid.

Moshe introduced me to the unknown, the impenetrable, the other side of life, the other side of death. I was challenged. I asked questions about God. Moshe said, "Seek, Eliezer, but you will find the answers only within yourself." This began a process of searching that has gone on all my life.

When the Germans entered Hungary in 1944, we Jews were forced to register and wear the yellow badge which identified us as Jews. Jews were beaten in the schools and on the streets. There were restrictions preventing us from entering universities, traveling, doing commerce, attending synagogue.

Among the first to be deported were foreigners, forced into cattle trains by Hungarian police, and among them was Moshe the Madman. Miraculously he escaped, and

*Body of Jewish mystical doctrine and philosophy formulated primarily in the Middle Ages.

returned to tell his tale of horror—of being transported to Polish territory and turned over to the Gestapo, of Jews forced to dig their own graves. He had been wounded and left for dead, but managed to crawl out of the pit and find his way back to warn us of the danger. Nobody believed him. Some truths cannot be believed. "He is mad," the people said.

> *Moshe had changed. There was no longer any joy in his eyes. He no longer sang. He no longer talked to me of God or the cabbala, but only of what he had seen. People refused not only to believe his stories, but even to listen to them . . .*[3]

Who is sane and who is mad, I wonder.

I had two very close friends. We wanted to live so intensely that we would bring the Messiah. The mystical theory proclaims that every individual, if he strives hard enough, can redeem mankind. The three of us were going to bring the Messiah, as simple as that. After a few months, one of my friends went mad. And then the other. They wouldn't speak, couldn't speak. A psychiatrist diagnosed it as aphasia. But I understand now: they were just terribly sad that they couldn't bring the Messiah.

We were transported to the ghetto. Fifteen thousand Jews guarded by Hungarian soldiers, forced to live on four streets in the center of town enclosed by barbed wire. We set up our own government: a Jewish Council, a Jewish police, and social services. I think that at that time, if we had known what was ahead, we might have been able to escape. But where would we have escaped to? No one wanted us. In the Spring of 1944, there was news from the Russian front that the defeat of Germany was imminent. We felt sure we would soon be more secure. We continued our studies, our prayer, our daily lives. Moshe remained silent.

Three months before Normandy, 600,000 Jews in Hun-

gary didn't know there was an Auschwitz. We were so isolated. The world knew, but no one cared to tell us. Then the Germans announced that within twenty-four hours we were to be deported to a labor camp. The last thing they did before we left, they came and took our passports and tore them up. We had worked so hard to be recognized as Hungarian citizens, and they tore up our papers. This hurt deeply. The sense of being homeless and rootless has stayed with me.

There were a few in the town who tried to help us. Our servant offered to take us in. But very few opened their doors to give shelter to Jews. The townspeople watched us go. They perceived us as strangers. Strangers should come, strangers should go, most of the time dispossessed of homes and worldly goods. That's what happened. People stood and watched in silence.

We were ejected, expelled, spit out. It's not only true of my town. It happened all over Europe. The Jews were expendable. Four or five or six centuries of coexistence went down the drain. Had we known where we were going, many of us would have fled to the mountains, but no one told us.

My parents and three sisters and I were herded into a cattle train. There were 80 of us in each car; the cars were sealed. After three days, as we approached our destination, Madame Schachter, a woman who had been deranged by the separation from her husband and sons cried out:

"Fire! I can see a fire! I can see a fire! . . ."

She continued to scream, breathless, her voice broken by sobs. "Jews, listen to me! I can see a fire! There are huge flames! It is a furnace! . . ."

Our flesh was creeping. It was as though madness were taking possession of us all. We could stand it no longer. Some of the young men . . . put a gag in her mouth . . .[4]

> When we arrived at Auschwitz, fire illuminated the sky. Thousands of Jews were assembled there. I thought to myself, "All the Jews have come to welcome the Messiah." The first day there, I was walking with my father and a man came up to tell us what was going on, and I remember saying to my father, "It is impossible. We live in the twentieth century, not the Middle Ages."

Wiesel was fifteen years old when he arrived at Auschwitz. He was more fortunate than some; he and his father remained together and clung to each other for strength. But Wiesel had to watch while a sadistic guard smashed his dying father's head in, and could do nothing. Like the biblical Job, the young Wiesel's faith in a just God and a beneficent universe was severely tested. His father, his mother, and one of his sisters were exterminated in the ovens of Auschwitz. He saw a truckload of babies dumped into a fire. He watched while Nazi soldiers played with babies as targets, throwing them up in the air and shooting them. He saw a soldier tear a baby from his mother's arms and then tear him to pieces, alive. One million children were killed, massacred, burned alive.

> When I saw this, I couldn't believe it, and I recorded it almost as a nightmare. Then I located the documents corroborating these atrocities. I know people who spent five or six years in prison camps. What did they learn? The Germans taught them that only strength survives, that morality doesn't count. And yet I saw people who remained human. While others were pouncing on each other for a crust of bread, there were Jews in the camps who resisted the killer's law and refused to turn against their fellow man. They preferred to die.
>
> What of those who escaped, or managed to survive? I was one. I somehow "lived" through Auschwitz, Birkenau, Buna, and Buchenwald. Why didn't we who survived seek vengeance? We had a right to accuse the whole world. But a

peculiar thing happens. Instead of accusing others, we accuse ourselves. Why did I survive, and not another? I once made a survey of the 400 child survivors of Buchenwald. Most of them led constructive lives after the war, choosing philanthropic careers that enabled them to be of service to others. That must mean something.

Why did we not fight back—that question recurs. If we had been a normal people, we might have. During the war there were many instances of armed revolt in the ghettos. It's a miracle that it happened, without weapons, without support. Everything is a miracle. I say it again and again. I don't understand. It defies imagination. In the chronicles of ghetto life, on the prison walls you find these words: "Avenge our blood!" This was the testament the dead left us. Yet we didn't do it because we don't believe in vengeance. Something in our tradition keeps us from hating those who oppress us. Suffering is unjust, but it never justifies murder.

Whoever kills, kills God.[5]

I never rejected God. But I was angry with Him. It doesn't matter. He can take it. My Jewish tradition allows me to be angry with God if it is on behalf of mankind. Since the time of Abraham, our sages have commanded us to argue with God and everybody else on behalf of justice.

Despair was not the solution. I knew that well. But then, what was the solution? If I survived, it must be for some reason. I must do something with my life. It is too serious to play games with, because in my place someone else could have been saved. And so I knew I must speak for that person. On the other hand, I knew I could not. The war, the experience transcends language. It is impossible to transmit to those who have not been there. When we left that war. when we left the camps, we did not talk about it; it is

91

too personal, too intimate. And yet it is always present. From that time, everything I did, whatever I wrote was against the background of that event.

After his liberation from Buchenwald, Wiesel worked as a journalist in France and Israel. For ten years he maintained his silence about the Holocaust. Then he wrote the autobiographical novel *Night* and, with the encouragement of his friend François Mauriac, published it in France in 1958.

> *Never shall I forget that night, the first night in camp, which has turned my life into one long night, seven times cursed and seven times sealed. Never shall I forget that smoke. Never shall I forget the little faces of the children, whose bodies I saw turned into wreaths of smoke beneath a silent blue sky.*
>
> *Never shall I forget those flames which consumed my faith forever.*
>
> *Never shall I forget that nocturnal silence which deprived me, for all eternity, of the desire to live . . .*[6]

It was difficult to find an American publisher for *Night*. No one wanted to publish anything dealing with that dark era. People didn't want to know. But we found a small publisher, Hill and Wang, and when the book came out, young people in schools began reading it and taking it home to their parents.

I wrote the book in French, and it was translated into English. Why French? My native language was Hungarian, my family spoke Yiddish, and I studied modern Hebrew. But I had put everything Hungarian behind me. The language reminded me of the brutality of the Hungarian gendarmes. Living and working in France was a new beginning for me. French is the language of reason, it is nonmystical, precise.

In 1964, twenty years after my deportation from Sighet, I

made a pilgrimage back to the town of my birth. It was a strange encounter. The town had not changed, but I had changed. I was afraid of seeing too much, of understanding too much.

It is a town like many others, and yet it is not like any other. Quiet, withdrawn, resigned, it seems almost petrified in its own forgetfulness; and in the shame that springs from that forgetfulness. It has denied its past; it is condemned to live outside of time; it breathes only in the memory of those who have left it . . .

Anyone at all may leave from anywhere at all and arrive at Sighet, by way of Bucharest . . . in less than seventy-two hours. But not I. For me the journey was longer. It was to take me back to where everything began, where the world lost its innocence and God lost his mask.

"We're coming near," said the driver. . . . His words sounded like a threat. He was taking me to a rendezvous. With whom? With death? With myself? . . .[7]

In 1975 I came to the United States as a United Nations correspondent on a French passport valid for only one year. After a couple of weeks here I had an accident and spent a year in and out of hospitals, so I couldn't return to France to validate my passport. In my wheelchair, I went to the French consulate and asked for an extension. "No, you must return to France to arrange it." "I cannot," I explained. "I am in a wheelchair." But he would not bend the rules. On another occasion, the answer was the same. Finally, an American immigration officer said, "Why not become an American citizen?" "Why not," I said, and I did. The American bureaucratic system seemed to have a human element, and I was grateful.

Of course, I still felt a profound sense of alienation. There were certain subjects that were taboo. There still are. Those who haven't lived through the madness cannot

understand. Of course, survivors would talk to survivors.
We had shared something, we had a code. But how could
outsiders understand? The full story is beyond language.

Having this feeling about the irrevocability of the event,
and then about the impossibility of communicating it, of
course you don't speak. It doesn't matter. I'm not a social
person. I like to be alone with my books, my writing, my
studies.

I had my job as a correspondent, but still I was poor.
Eventually I accepted speaking engagements. For my
speaking and writing on the Holocaust I do not accept
money for myself. There is a man in Brooklyn who runs a
Yeshiva, a Jewish school. I was with him all the time in the
camps. Whatever I get, it goes to him. I cannot capitalize on
what happened. I cannot take anything.

You know, in our tradition, a writer was not very much
respected. He was someone who had nothing else to do. To
be a scholar, yes, that was something! But who writes
books? Now today in America it's different because litera-
ture has become big business. One can be an affluent writer.
This doesn't interest me.

I like to teach. But what do I say to the young people
today, so many of whom are contemplating suicide? They
tell me there is no future for them, the world will blow itself
up. They tell me it's wrong to bring children into the
world. I tell them I have hope in a world where hope is
impossible.

Wiesel's nine-year-old son Elisha enters the room carrying some
treasure he has discovered. "Is this yours, Daddy?" he asks. "Yes, but
now it's yours," Wiesel replies, smiling. And then softly: "Close the
door, please. Boom!" And this 53-year-old man who witnessed his
own father's death in a concentration camp is redeemed by this child
of love.

I tell Elisha stories. He is a descendant of Abraham and

94

Isaac. I teach him to be a good Jew and a good human being. Children give the world a new innocence.

Are you ever surprised by what you write?

Oh, always. Every line I write surprises me. It comes from the subconscious. Suddenly you see it on the page. Then what you do is confront it, work on it, chisel it, then you are surprised again.

One is moved by the austerity of your writing, by what is left unsaid.

When I reread those chronicles of ghetto historians, I noticed that they too felt the need to be witnesses for future generations, so the experience would not be wasted. I was amazed by the compression of their writing; it was as if one sentence had to contain everything, for you never knew if you'd live to complete the work. It was then that I understood the economy of my own writing.

The horror of the camps casts a shadow over all other events of modern life. We circle around it, trying to understand, but in the end the message cannot be shared. I write books, I tell stories. But ultimately, images are inadequate. The experience of the last war was so powerful, no words can contain it. I go on writing, but I feel I have just begun.

We thought the Nazi madness was the last madness. But the killing continued and continues in Africa, in Vietnam and Cambodia, in Afghanistan, in Ireland. I feel profound empathy for all those who suffer. What can one do? I shout, I shake my fist at God over the injustices of the world. This won't stop the madness, but you never know the destiny of one shout.

We are responsible for one another. Judaism is humanistic. The accent is on Man, not God. My teacher told me, "Imagine God at Sinai, giving the Law. You'd expect a lecture on theology. After all, it's His field. Instead He

spoke of the most mundane things: do not steal, do not lie, honor your parents. He was concerned with human relations."

How is it that we who have given the world such a dimension were abandoned by humanity? Thousands of years ago, Eretz Israel, a little nation, was at the crossroads of the Holy Land. All the armies of hostile nations passed through, occupied us, and subdued us with their swords. During the Crusades, we were massacred. For centuries, the enemy has tried to wipe us out. They have employed every possible method to extinguish us: seduction, conversion, torture, force of arms, exile—yet here we are. We are stubborn in our will to survive as Jews. We drive the enemy crazy.

We survived by the grace of God. But we are afraid our testimony won't be remembered. If the world forgets, there will be another holocaust, but this time a nuclear holocaust and all of humanity will be the victims.

How many prayers can one say for an entire world? How man
candles must one light for mankind?[8]

Once upon a time, I was convinced it must be possible to change the world. Now I am satisfied with small miracles: a good friendship, a good concert. Maybe a few people will be changed by my writing.

As a boy, when I went out with a girl, I would talk to her about Kant and generally never see her again. The truth was so important to me. In America these days, it's hard to believe in anything with such conviction. I am somewhat pessimistic because I don't trust history. Out of despair, one creates. What else can one do?

As Camus said, in a world of unhappiness, you must create happiness. We must answer hate with an affirmation of life.

96

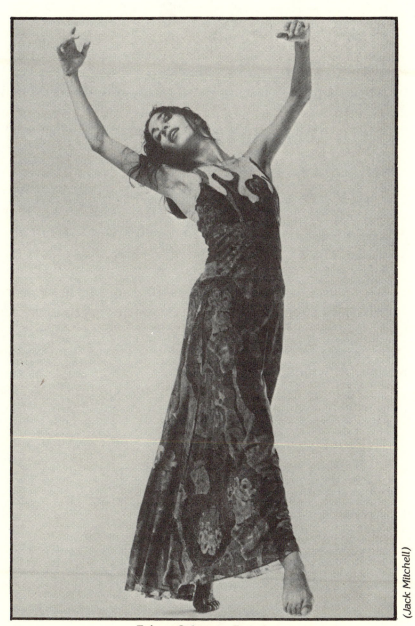

(Jack Mitchell)

Ze'eva Cohen in *Rooms*

Ze'eva Cohen
Dancer from Israel

"A celebration of life."

Post-World War II Israel—a time of austerity for the young nation struggling to absorb the war's refugees. Occupied with the issue of survival, Israel could not provide the opportunities for artistic growth available to a dancer in the United States.

Coming as a student in 1963, Cohen remained to build her dance career, performing with the companies of Anna Sokolow, Pearl Lang, The American Dance Theater, Dance Theater Workshop and the New York Shakespeare Festival. Her solo dance program, inaugurated in 1971, has been seen throughout the world.

Cohen's dance repertoire is eclectic, featuring the work of the world's great choreographers, as well as her own unique creations. Whether improvising to an Indian raga or dancing to a virtuoso piece by Beethoven, Cohen draws viewers into a private world where emotions are deeply felt.

Interview, April 13-14, 1980

Ze'eva Cohen

When Solo dancer Ze'eva Cohen performs her tour de force *Mothers of Israel*, the first four Hebrew matriarchs step out of the pages of the Old Testament. Carrying a lantern, to the accompaniment of drums and the chanting of a Yemenite woman, Sarah, Abraham's aged wife, enters a darkened stage.

The stage is empty, suggesting the barrenness of the Yemenite desert. Sarah is ninety years old, and she can barely move. I hobble, I stoop, I dance close to the earth to suggest her age and her closeness to the earth. When Sarah finds out that she is to bear Abraham's child, there is joy mixed with disbelief and irony. She cackles at the thought of being pregnant. She blabs away in a sort of free association. She has a premonition that her son Isaac will be sacrificed. She struggles with herself and conducts a dialog with God.

Then Rebecca struts onstage with a water jug on her head. That's an important touch—it has to do with fertility, with giving life. I see her as a thirteen or fourteen-year-old chick, wild, sensual, noisy, and clever too. The music is playful; we call it the Yemenite rock and roll. When I move from the elderly Sarah to Rebecca, I feel as if I'm shedding my skin.

Next comes Leah, Rebecca's older sister, and she's a shrew. Leah is jealous of Rebecca because she is beautiful and Jacob loves her. Leah feels guilty because she knows that custom requires her to marry first, and her father will make Jacob marry her in place of Rebecca. She knows it's ugly, competing with a sister. Her vulgarity is a kind of defense. I have to scream and shout in Arabic, which I don't understand, and do obscene gestures to convey all this.

When Rachel enters the stage the mood is tragic. She has lost her child, and she dances a stylized rite of mourning. With her black shroud covering her from head to toe, she is the classic figure of mystery, the unquenchable flame of Israel, the sorrow, yet the hope and endurance.

99

What I love about *Mothers* is that these women are not saints, but down-to-earth real people.

The work is by the Israeli choreographer Margalit Oved, and working on it with her was really something. She wanted me to paint the images for the audience so they'd grasp the concept. We started with large stylized movements. She said, "You're not believable. You're too much like a dancer onstage. You have to be a woman on the street." Then we reduced the movements. Everyday we did it differently. We reduced everything to the vernacular. I had to express ideas in earthy terms. Once, in total frustration, I sat down and scratched my head. "Now," Margalit said, "you're believable."

People try to pin down my style—is it modern, or ballet, ethnic dance, or Martha Graham? I refuse to be put in a box. It's all of those but none of them. I am myself. I feel very universal. When you trace it back, though, Yemenite folklore is my starting point. I feel the movement, I feel a connection with the soil, with the desert. That's a part of me.

I was born in Tel Aviv before Israel became a state, into a chaotic environment with a clash of cultures. My grandparents had emigrated to Israel from Yemen around World War I. They had somehow felt a calling to move toward the Holy Land. They traveled mostly on foot with their food and pots and pans piled onto donkeys, and settled in what was then a very primitive land. They never liked to talk about those early days in Israel. For them, nothing was rational until Israel became a state in 1948. But when I prodded my grandmother, she'd say, "Well, the Turks were on one side, the English were on the other and the French . . . and we ran off to the mountains." She only recalled bits and pieces and I never knew what was myth or what was real. She remembered a community of people living wild in the mountains, finding wheat in the fields, digging holes in

100

the earth to make ovens to bake their bread. That was how they survived, just like Ruth in biblical times. Then, when the fighting stopped they would return to their homes. My grandma didn't understand the political implications. She just knew they had to dodge the bullets.

My grandparents came to Israel when they were very young and grew up in a community of Yemenite immigrants. These people brought their old ways into a new society. When my mother became "marriageable" they tried to marry her off to a wealthy uncle. She ran off and joined a kibbutz, and found her own husband, my father.

My parents broke away from the old world atmosphere, and we moved into a European neighborhood. Everything Western was supposed to be progressive and cultured. Our Yemenite relatives came to visit us. My grandfather would walk up to our house wearing his red "fez" and a long, narrow dress, looking very Arabic. My grandmother wore dark colors and kept her head covered with a kerchief. I thought they looked funny, and I was embarrassed. By the time I became curious about their traditions, they had died.

I grew up in Tel Aviv. The name of the city means "Hill of Spring." At that time it was a desert town, with hills and sand dunes, eucalyptus trees, narrow streets with concrete buildings bleached white by the sun. The houses had terraces and balconies with big pots of herbs and flowers. Such wonderful smells, I remember. We used to shop in the flea markets—I still love to do that when I go back to visit. You could buy anything. You'd hear the fish sellers crying out, "Buy my fish, mine is the best." There were watermelon stands, you could have your knives sharpened, your windowpanes repaired. You know, the immigrants came to Israel from all over the world. They had lost everything and had to start again, and they used their ingenuity to find work.

In our neighborhood, you could hear people shouting at

101

each other from their balconies in different languages, very volatile and emotional. Everyone knew everyone else, you didn't lock your doors, and if your parents were away, there was always someone to take care of you. Our apartments were so small, we spent all our time in the streets, swinging from the trees, playing war games in the sand. There was my street gang and the other street gang, all Jewish, of course. (Laughs). We had our camp and they had theirs. We used the fruit of the eucalyptus trees as ammunition. We were wild.

One of the delights of childhood was building campfires in the sandlots, and roasting potatoes over open fires. In winter, everything blossomed. There were whole fields of dandelions and red anemones.

But those were troubled times in Israel before statehood. You could feel the tension in the air.

The British, carrying out their United Nations mandate for supervision of Palestine, were particularly rigid with regard to the Jewish population.

Sometimes we couldn't go out at night because of the curfew imposed by the British, but we'd sneak out and play hide and seek and count how many tanks went by that day. Once, the British assembled all the inhabitants of the city in a big empty lot to count us, just like cattle.

There were attacks by Arabs on the Jewish settlements, attacks by the Jewish underground organizations. I was very young. I didn't understand all the complex political issues. I just knew there was turmoil. Wherever you went, you saw soldiers carrying guns and barbed wire. As a child, you come to accept this. It's only later it hits you—wow, that was a really scary time.

My parents were activists. They worked for the establishment of a Jewish state—their dream. As members of one

of the underground organizations, they took part in espionage and kept illegal weapons at home. My father was arrested by the British and was imprisoned in Africa for five years. My mother went to work as a nurse to support the family. I remember how those "evil British soldiers" used to come and get her in her nurse's uniform and take her on her rounds during the curfew. I used to wonder if they'd bring her back.

When I was in school, there was a movement to go back to the Bible, to discover the roots of what is uniquely Israeli. Many of the immigrants had come from countries in the Diaspora where they were not wanted, and they appeared meek, afraid, apologetic. Whereas we Sabras (native-born Israelis) were arrogant, proud, sure of ourselves, just one big scream, "I'm here, I'm alive and free." So artists looked to the Bible as a source of Jewish folklore (they studied Arabic music as well), and created music and dance forms which reflected the Israeli spirit. A song popular in those days was "I'm En Ani Li." Rough translation:

If I'm not for myself, who is for me.
If not now, when.

People sang it and sang it on the radio and everywhere. The idea was—here I am and I'm going to take care of myself!

Judaism was implanted in us, not in a religious sense (for many of the very influential East European Jews were socialists and not religious at all) but in terms of absorbing Jewish culture. On holidays, public transportation would shut down, and people would walk in the streets all dressed up. You could feel the holiday spirit in the streets. There was some ceremony and ritual, but mostly a sense of belonging. It was lovely and warm, something we shared. And yet, sometimes in school it got to be too much for me, because the Bible was fed to us year after year. We wanted to

know other things too, to be part of the world. I read everything—Zola, Dickens, Dostoevsky, Chekhov.

We were poor, but my parents wanted to be sure we grew up nice and cultured. We went to concerts. There was always money for music and dance lessons. From the time I was three, I danced. I danced when I was alone, to give vent to my emotions. I danced when I felt joy. Whenever I heard music, I melted. It was an absolutely overpowering sensation, and I had to dance. In my teens I studied with Gertrud Kraus who was then Israel's leading choreographer. She taught us to improvise to a musical score by Stravinsky or Bach, or even in response to a painting. She gave me a sense of dance as a visual art, and a sense of controlling space. She remains for me a symbol of forever daring.

Whenever a dance company came to Israel, we'd go and see it, and then for months we'd imitate their style and spirit. We would become Danish dancers, Spanish dancers, and African. By the time I was sixteen, I was studying ballet and jazz dance, and was touring Israel with a professional company. We played in the cities, and in the kibbutzim—in the open with the cows mooing, and in dining halls with tables tied together to make a stage. I remember doing a beautiful tragic solo on one of those makeshift "stages," and knowing exactly what they had had for dinner.

When I turned eighteen I did my military service, two years in the army. Then returned to study dance. My parents didn't want me to be a dancer. They thought it would be a struggle in Israel; too few opportunities for dancers. Israel is a push-and-shove society, with a sort of nervous energy. Maybe it's the mentality of immigrants who were always on the run—you can't afford leisure. You have to fight, if not for your life then for economic survival.

The American choreographer Anna Sokolow started a company in Israel in the early '60s and I danced with her for three years. One day she said, "How would you like to go to

the United States?" I jumped—what an opportunity! She arranged for an audition for me at the Julliard School in New York City, saw to it that I got an airline ticket and financial support, and there I was. An immigrant in New York.

I worked with Anna Sokolow in New York, I studied with Erick Hawkins, I studied Martha Graham and José Limon technique—all those wonderful teachers. I had to disengage from a particular style, to develop a sort of neutrally trained body that could adapt to various choreographic styles. Sure, your temperament and heritage lead you toward a certain style, but you don't want to get locked into it. I started performing works by choreographers from all over the world.

When I began solo dancing, people said it was old-fashioned, wouldn't work. But it was what I wanted to do. I probably couldn't have made it in Israel, but in America, anything is possible. At first you feel you're alone against a hostile world, then you win support and you're on your way. It's a sort of coming of age artistically. As a solo dancer you have total artistic control, and that's beautiful.

I can't imagine not dancing. The movement comes from deep within me. From the time I do my first demi-plié in the morning, I breathe organically from the center of the body. It's not just how high can you kick but the sense of being in tune with the source of positive energy in your body.

Maybe I'm not trendy. Some of the avant-garde dancers onstage seem noncommittal to me. As if they're just minds on top of bodies. Sometimes you see a dancer who is so esoteric it's sickening. There's no heart in it, no earth beneath, no roots. Dance from the beginning was a physical connection with something spiritual. Merce Cunningham is cerebral, but he never loses contact with living things. He's a sensualist, almost like an animal onstage.

When I'm onstage, I'm not just performing steps, it's not

just a show. It's something I have to do. It's joyful, but life isn't always fun, "ha ha." It's also "oy vey." I'm emotional, I'm committed.

Dance for me is a celebration of life.

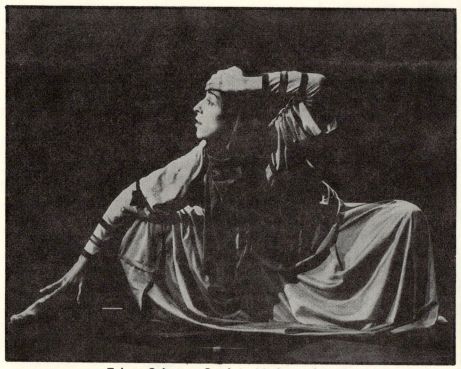

Ze'eva Cohen as Sarah in *Mothers of Israel*

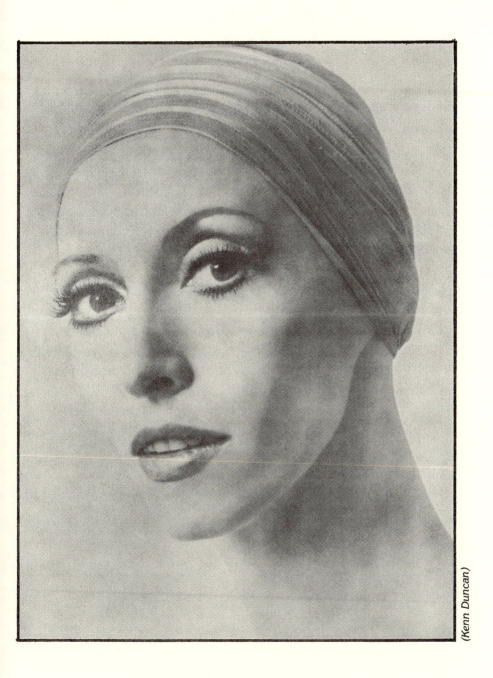

Natalia Makarova
Dancer from Russia

"I couldn't live with myself."

In 1965, Natalia Makarova, a star of Leningrad's Kirov Ballet, won a Gold Medal in the International Ballet Competition in Varna, Bulgaria. In 1969 she was awarded the title Honorary Artist of the Russian Federation. She was about to be named People's Artist of the Soviet Union when, in 1970 during a London tour, she decided to defect to the West. In that year she made her debut with New York's American Ballet Theater, dazzling audiences with her technical brilliance and sensitive characterizations.

Makarova has been called the foremost ballerina of her generation. Her appearances with Ivan Nagy, Rudolph Nureyev, Mikhail Baryshnikov, and Anthony Dowell have made dance history. Her choreographic efforts—restagings of traditional ballets —pay tribute to the Russian classical style and demonstrate the diverse talents of this consummate artist.

<div align="right">Interview, November 18, 1981</div>

Natalia Makarova

We meet in the coffee shop of the Harkness Ballet School in New York City where she has been rehearsing all morning. With a purple scarf encircling her fragile head, attired in white coat and white boots, her face alive and radiant, she is elegant. Over a cup of tea she catches her breath, and I comment on the frenetic pace of her life.

I move from one place to another. I make myself keep going.

What drives Natalia Makarova?

I suppose it's just that I want to dance, to do something worthwhile, to do the best I can do, to use what God gave me. You cannot do that if you do not devote all your energy to what you are doing.

So you and God are working as a team?

(She laughs, animated.) Oh, I hope so.

Are you religious?

In Russia they don't encourage you to think of religion, but I suppose I am religious. I believe in something, some indescribable force. I'm not sure what it is.

I love challenge and adventure. I love my new life here in the West. I am working on several projects at once. Now I am rehearsing for a new season with American Ballet Theater. At the same time I am working on a Stravinsky Festival for the Metropolitan Opera. I will dance the nightingale in *Le Rossignol*, choreographed by Ashton.

In 1980 Makarova starred as Nikiya, the Hindu Temple dancer in her three-act version of *La Bayadère* which combined her original choreography with that of Pepita, the giant of the nineteenth century Russian ballet world.

109

Looking back, that was a tremendous job to choreograph, supervise all the staging, acting, costumes, and music, and dance as well. This was the most difficult thing I have ever undertaken, and it absorbed me for many months. By the time we opened, I was exhausted. The production was televised. I was excited and keyed up. But in the second act, I injured my foot and could not finish the performance. Of course it was very disappointing. I had to face the fact that there are some human limitations. I didn't make big drama about it. I felt in two days it will get better. Well, weeks went by, and it didn't. I had an important season at Convent Garden, which I could not give up. I danced through the season, although the foot was very painful. Then I had an operation.

I can't remember a time when I didn't dance, except when I was pregnant awaiting the birth of my son Andrushka. That was a peaceful time. It was as if I was preparing myself for another big performance, and I had to do my best. I took care of myself. You do what you can; the rest is not up to you.

Andrushka is certainly the most beautiful thing I have created. My husband and I have been blessed by God. What's he like? He's adorable! He's very clever like his father, and stubborn too. That's from his father. And he has an artistic spirit. Since his birth I have felt a sense of calmness, which has improved my dancing.

I don't plan his future. He can be whatever he wants. We always had this opportunity, even in Russia.

Were you totally unpressured in your choice of career?

Well, I always had this big fight with my parents. I didn't know my real father—he was killed during World War II, and my mother remarried. My stepfather was a musician, and I lived for music. We lived on Tschaikovsky Street in

110

Leningrad, near the River Neva. My parents wanted me to be a doctor or an architect.

When I was very young I wanted to be an actress. I would dress up in my mother's long dresses, use a tablecloth for a scarf, and practice different expressions and gestures in front of the mirror. I was double-jointed and a bit of an acrobat too. Sometimes my mother would come in and find me on the floor, with my legs tucked around my shoulders.

During the war we were evacuated from Leningrad and lived in a little village in the heart of Russia. I wandered deep into the woods, picking berries and wild mushrooms. I loved taking risks, and was never afraid. I love to be alone. Some people cannot live with themselves, but I was always happy with myself.

As a child, I was temperamental and stubborn, and very absent-minded. I was bored by anything routine or easy. I thought of myself as very plain, with my thin hair, one long braid down my back, angular features, long neck and long limbs. In school they called me "the giraffe."

At twelve I decided I wanted to enter the Vaganova Choreographic School. My parents were opposed. I cried and stormed until I had my way. This was the training school for the Kirov Ballet, and had produced the great Russian dancers Pavlova, Nijinsky, Ulanova, and Nureyev. This is the school that trained Baryshnikov.

I was bored in school. I could figure out all the math problems very quickly; then I would bury myself in a book. I read like crazy—Tolstoi, Turgenev, and especially Dostoevsky. I was intrigued by his questioning and mysticism, and his psychological insights.

In addition to our regular studies, we had many hours of ballet training. A long day. A concentration-camp atmosphere. My teacher pushed me so hard, sometimes I thought, "If I have to do one more leap I will die."

When I was nineteen, they took me into the corps de

ballet of the Kirov Company. I didn't like it at all. I could not see why everyone had to do the same thing at the same time, and my absent-mindedness caused problems. When all the girls moved left, I turned right. I could not remember the steps. Finally, they made me soloist—I don't know why. Maybe because I was so eccentric. (Laughs.) At last I had a chance to develop my own interpretations. For my graduation exercises I danced *Giselle*. There were flowers, good reviews in the newspapers, and I was famous.

I played Odette-Odile in *Swan Lake*. I always loved this ballet. It represents the eternal symbols of life—white magic and black magic—and I was fascinated by the complexity of the characterization. Odette is an enchanted swan-maiden who longs for love. Then you must transform yourself into Odile, the seductress. She is passionate, she blazes like a fire. This role reflects the many sides of my nature.

You never know how many qualities you have inside you. Some are hiding. (her smile is disarming.) Every day I discover a little bit more about myself.

I am proud of my training at the Kirov Ballet. They taught us to push ourselves. Always you go a little farther, you stretch yourself. They inspired me to seek the meaning of a character, her inner life. Dancing is a spiritual experience. Without soul, without emotional force, you are not a ballerina.

But it was very sad. In the Stalin years, artistic standards at the Kirov began to deteriorate. There were the "Soviet ballets." I had to perform in "Leningrad Symphony" with music by Shostakovich. Young men in tights represented German soldiers. I had to get down on one knee and aim a rifle. I did not like this. I thought it was commonplace and false.

The basis of ballet is poetry or legend. It takes hundreds of years for an event to grow into a legend. You need

distance, perspective. A ballet about the construction of a hydroelectric plant? This is not poetry, not art. Under the Soviets, the arts stood still. Fortunately, they preserved the best of the traditional classical ballet—thank you for that. But it was very conservative. They didn't allow it to grow.

I was supposed to be in the Soviet film *Swan Lake,* but I disagreed with the director about the interpretation. It was a matter of style. "You have to dance more seductively," he told me. Well, I walked out and refused to go on. Soon I heard from the Communist party officials. I was to dance, not to give my opinions. I did not give in, and I did not perform in this film.

At the Kirov, we did a new interpretation of Berlioz's symphonic poem *Romeo and Juliet.* I was Juliet. Baryshnikov was Mercutio. I always loved this story of passionate, despairing lovers. It was a marvelous production. We had to hold a preview for Communist officials to get their approval to perform it. They attacked the ballet, they said it was influenced by the West, it was erotic, "the flower of evil." The production was canceled. I was crushed, and retreated to my own private world.

I was thirty years old. I felt bored, and hemmed in. I couldn't live with myself. Not long after that, we left to go on tour to London.

On September 4, 1970, Ms. Makarova applied to the British Home Office for permission to remain in Britain. She wrote in an article in the *London Sunday Telegraph*:

> *Why did I choose to make this leap into the West—into if not the unknown, at any rate, into a great deal of uncertainty? The simple answer is: Because I wanted to be free—free to dance as I please, free to develop my art, free to work with whom I want to work, free to make the maximum use of all the talents nature has provided me with . . .*

I knew that if I wanted to go further, develop my art, and to reach
new heights—if I was capable of them—I would have to leave my
own country. So long as I stayed there, I would be up against a brick
wall. I would dance the old, classical roles to the end of my dancing
years, and that would be that. Some ballerinas are ready to accept
that fate. For me, it was artistic death . . .

We continue our conversation in an automobile. Ms. Makarova has
permitted me to accompany her on the trip downtown to the studios
of American Ballet Theater, where she will rehearse in the afternoon.
The honking of car horns produces a disturbing cacophony, making
concentration difficult.

At first, New York seemed so immense and overwhelming,
and I had to get used to the pace. I am not a practical person
and I knew very little English, so everything was big
struggle. I could not handle money very well. I could not
make a call from a phone booth. In interviews, I did not
understand the questions and often gave answers which
seemed foolish. I was very much alone, and I lost myself in
dance.

I was invited to dance with many European companies.
In 1978 I was performing with Rudolph Nureyev in Paris.
You know, he was the first to defect from the Kirov, in 1961.
We went to a performance of the Kirov Ballet at the Palais
de Congres. It was wonderful to see this beautiful company
which had formed me. It made me wistful for the past.
Afterwards, we greeted the dancers, they hugged us, we
laughed and exchanged memories. But suddenly members
of the KGB approached. The dancers left us, just vanished.
Rudi and I stood there feeling very sad. All the old fears
returned. We felt relieved that all that was behind us.

Another time, Nureyev and I were dancing in *La Syl-*
phide in Paris. There is always this sense of exhilaration
when we dance together, and the audience was very respon-

114

sive. I finished my performance and exited off into the wings. I couldn't believe it—there was a fire. People were shouting and pouring water on the flames—and Rudi was still onstage dancing. Later I asked him, "How could you go on dancing? Didn't you see the fire?" He answered, "Yes, but I wanted to finish my variation."

Last year, I produced my own show, *Makarova and Company*, on Broadway. I wanted to present the best of Russian ballet tradition—I still think Russian ballet is the best in the world. Russian dancing is soul-inspired. I want to pass that on to young dancers, to teach them the value of tradition. This is where you begin. You train your body to be a responsive instrument. You work hard to achieve purity of style and technique. Then you can move on to new choreography.

For this production, I chose all the repertory. I learned all the ballets myself. I tried on every costume to see how the dancer would feel in it. I had complete artistic control. I am difficult and demanding. I suppose I want to be Diaghilev.

I like experimenting with new styles. I like the modern ballets, especially Jerome Robbins, Balanchine, and Antony Tudor. I feel the real work of my life is ahead of me. I am waiting for a ballet to be created for me. I want to dance Nastasia Filipovna in the ballet *The Idiot* based on the Dostoevsky book. This is a woman with many sides to her character. The role excites me.

As an emigré, what has America given you?

The consciousness that nobody will choose for me. The feeling of beginning life all over again. I'm a new person. I say what I want, I go where I want, I dance what I like. It's good for your health.

Before a performance, I am very nervous. But when I am dancing, I enter the atmosphere of the ballet, I take on the

personality of the character and express feeling in a direct way. I express my personal vision.

God gave me a good instrument. I'm happiest when I'm onstage. There is this sense of being at one with the music and the movement.

I'm a chameleon. I'm spontaneous. This of course explains my defection. I bring Americans my spirit from the woods. If you have a free spirit, you must go with it.

After I decided to stay in the West, I talked to my mother on the telephone. She was lonely for me, but she understood the reasons for my defection. "Listen, Natasha," she said. "You must let the whole world see the quality of our Russian art."

This is what I am trying to do.

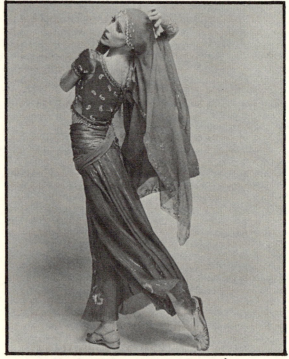

(Dina Makarova)

Natalia Makarova in *La Bayadère*

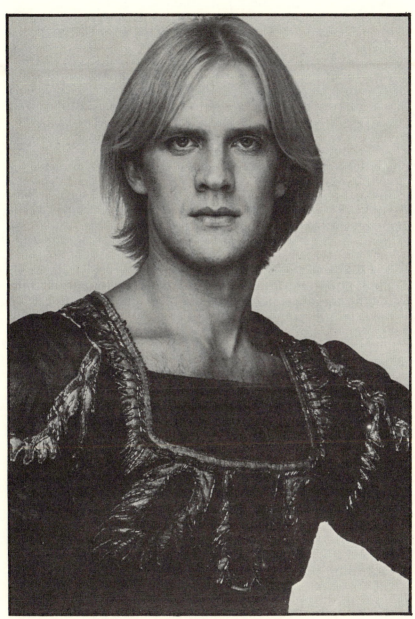

(Stan Fellerman)

Alexsandr Godunov
Dancer from Russia

"It is forever."

He made his debut with the Moiseyev Young Classical Ballet at the age of seventeen, with the Bolshoi Ballet at twenty-two, and won a first prize gold medal at Moscow's International Ballet Competition. In 1979 he stunned the dance world by defecting to the West, the first renegade from the prestigious Moscow-based Bolshoi Ballet. While his wife Ludmilla Vlasova was on an airplane returning to Russia, Godunov said that he could not resist this chance for greater artistic freedom, although he feared that his defection might end his marriage.

Since joining American Ballet Theater, Godunov has performed the romantic, heroic roles in which he excelled in Russia. He has been hailed by American audiences for his charisma, overwhelming stage presence, and phenomenal speed.

Interview, January 13, 1981

Alexsandr Godunov

On August 23, 1979, Alexsandr Godunov, twenty-nine year old star
of Russia's Bolshoi Ballet then on tour in New York City, walked into
the office of the Immigration and Naturalization Service and
requested politcal asylum in the United States. His wife Ludmilla
Vlasova, also a soloist with the ballet, was not with him. Facing a
barrage of questions from the press, he issued a statement.

> My decision to remain in the United States was entirely by
> free choice and was based on my desire for greater artistic
> possibilities. I agreed voluntarily to meet with the Soviet
> authorities so they would have the information directly
> from me rather than from other sources.

Briefly, he retraced for reporters the events leading to his decision.

> I was absent from the hotel for such a long time that I
> passed the curfew hour established. If I returned to the hotel
> it could be most likely I could lose the opportunity to do
> what I wanted to do. That is, defect.
> In the life of every artist, a moment comes when he has to
> decide that he either stops to achieve, or proceeds on in
> quest of artistic development.

Among those listening to Godunov was Iona Andronov, a corres-
pondent for the Soviet weekly *Literaturnaya Gazeta*. Shaking his
head, speaking in a loud voice, he conveyed his disapproval: "Why,
why, Mr. Godunov? Very strange." In the next issue of his newspaper,
Andronov charged that Godunov had been "besieged by a whole
crowd of instigators who promised him mountains of gold and a sea
of whiskey free of charge," and that when this was ineffective, "the
catchers of human souls decided to apply psychological pressure by
spreading dirty, slanderous rumors about Vlasova to the press." The
United States government accused the Soviets of "fabrications and
distortions."

Next episode: while Godunov was trying to avoid further press

119

attention, his wife Ludmilla Vlasova was detained incommunicado for three days on a Soviet airliner in Kennedy International Airport while American officials sought to determine whether or not she had been coerced into leaving. "Nyet," the ballerina replied confirming her desire to return to her homeland, bringing this dramatic international incident to an end. A few days later, asked by reporters why his wife had decided to return to the Soviet Union, Godunov replied,

> I would like myself to ask her this question. I think that if we had the chance to meet at that time we wouldn't have separated.

Asked if he thought his wife had wanted to defect, he answered,

> I do not want to answer this question since she is in Moscow. . . . I don't think there are words in any language that would be adequate to express my feelings. I would like passed on to her my desire to see her again.

Now, fifteen months later Godunov steps out of the pages of history and meets with me in his Minneapolis hotel room during American Ballet Theater's midwest tour. Ballet's newest superstar lives up to his "Greek God" image. He is tall and virile, his long, usually unruly blond hair is carefully combed, he dresses with style. Belying reports that he is a reluctant interviewee, he is gracious and charming. We discuss the relative freedom of his life in the United States. He seems to be thriving. I ask if his phone calls to Russia are monitored.

> I don't know. I don't worry about it.

He has a puckish sense of humor, and is a born mime. As I play back a portion of the discussion, he points to the tape recorder, playfully putting his finger to his mouth,

> Shh. Is too loud. (Pointing to the walls.) Spies! They will hear.

Alexsandr Godunov

About press coverage of his defection he is candid. He does not view
the experience as a media event. He has lived it, and will not relive it to
satisfy those who would make colorful copy out of his personal pain.

> Why should I speak about this? That word "defection."
> That means to be a traitor to your homeland. I did not
> betray anyone. Why should I explain anything? I dance.

There have been rumors that his wife has expressed a desire to come to
this country. On this subject, his lips are sealed.

> I cannot speak of this while my wife is in Moscow.

His emotions are intense. His right to privacy must be respected.

> You know, at 2:00 A.M. this morning, there was a phone call
> from Los Angeles. A woman newspaper reporter asked if
> she could interview me when I am in Los Angeles with
> ballet next week. I said "O.K." She said, "May I call you at
> your hotel in LA?" I said, "If you can call me in Minneapo-
> lis, why not in Los Angeles?" She apologized for waking
> me, and hung up.
> I remember last year in Chicago, it was my first appear-
> ance with ballet in this country, a man and a woman came
> to interview me. After my performance, they came to my
> dressing room. I said, "Come in." They sat down and we
> started to talk. They asked me about my wife. I said, "I'm
> sorry, I don't want to answer." "OK. Thank you," they said,
> and they left. Next day there was a big article in the paper. It
> says "Godunov comes in smoking, he doesn't answer any
> questions, he says, 'Go away, I don't wanna talk.'"
> People ask me, "Is it true?" I said, "If you want to believe
> it, you will." Always more reporters asking the same things.
> "Do you love your wife? Why did she leave? What do you do
> with your wife?" I said, "I sleep with her in the bed. What
> more do you want to know?" They don't want to know

121

anything else. Nothing about dance, nothing else. Of course I am angry with them.

Wherever I travel, people follow me. One man tries to get me to write with him a book about my life. For a month last year he followed me everywhere. I said, "No. I will not explain in the right way some things. I will tell my view; not everybody will understand. When you tell about leaving your country, when you put things on paper, you better be sure you say what you really think. You cannot take it back."

Of course, I have many thoughts. I could give you material for a book.

Why not begin now? I ask, tantalized.

It is too soon. You need years for this. The events have to filter. I am too young for autobiography. Now I store up material. Some day I will make nice book.

I explain that I see this interview as a sort of self-exploration, a process of self-discovery. (He smiles with self-assurance.)

I know who I am.
I give many interviews. People interrogate me. Then they write what they want. They invent stories about me.

Cautiously now, treading in dangerous waters, I broach the subject of his 1974 visit to New York City with the Bolshoi. He was reported to have angered Russian authorities by frequent party going and mingling with Americans. His right to travel was revoked, so the story goes, for the next four years. I ask for clarification. His response is guarded.

I don't remember. I have a bad memory.

Stubbornly, I persist. "You must have had strong feelings about this experience."

I have lots of feelings. My feelings.

Whenever Godunov dances with the ballet, women rush up and throw bouquets at him. Asked how it feels to receive all this adulation from American women, he responds,

> How do you think I would feel, with my wife still in Moscow?*

A playboy image surrounds Godunov, but he refuses to step into the myth.

> Parties? I don't go very much. They smoke and drink, maybe dance, stay up late. You sleep all the next morning. When you wake up it hits you—my God, what a waste.

Many questions—about his political views, about the experiences of an independent young man growing up in a restrictive society—must remain unanswered. He has granted the interview out of courtesy. But he will keep the private world of his thoughts and feelings inviolate. We move on to the subject of his early life and training in the dance.

> I was born in Sakhalin in 1949, a little island north of Japan. My father was a shipyard engineer. My mother worked as engineer for transportation. When I was one year old, my mother took my brother and me to live in Riga, Latvia. My father was supposed to come, but he never did. They were divorced.
> My family was not artistic, but my mother liked music and ballet. You know in Russia, everyone who has a college

*In March 1982, Godunov and his wife, Ludmilla Vlasova, were divorced.

education is interested in the arts. Mother was working, and after school I ran in the street with a bunch of boys. Nobody can control me. So she took me to the Riga Ballet School to make me busy. We studied music history, art history, classical dance, character dancing, pantomime, makeup, and acting—a very long day. When you come home, you don't want to go outside and play. You are too tired.

I was not lonely. I had friends. But I worried about being very short. Someone told me that tomato juice makes you grow, so I drink lots of it, but still at sixteen I was small. I went to the doctor and he said, "Don't worry." Soon I start growing and growing. All the muscles stretch and ache. No more tomato juice.

The training in the ballet school was wonderful. We danced to the music of all the great classical composers. We saw performances of the whole classical dance repertoire. I left Riga and went to Moscow and danced with the Moiseyev Ballet for eight years. Moscow, this is such a beautiful city with so many talented people. I went to art museums and saw wonderful painters. I went to poetry readings.

In 1970, Godunov was dancing with the Moiseyev Ballet in Mexico City when two members of the company, Filipov and Vostrokov, sought political asylum in the United States. A year later, Godunov was invited to join the Bolshoi Ballet in Moscow.

I was very lucky. I worked only one month in the corps de ballet, and then I did my first performance as Siegfried in *Swan Lake*. After that, I was principal dancer. I had good position in the Bolshoi, good money, nice apartment. But when we went on tour to the West, I saw the modern ballets, and I was excited by them. You want to try new things in your life. But in Russia, we did only the classical works.

In 1974, Godunov's childhood friend from Riga, Mikhail Baryshnikov, defected to the West while on tour with the Kirov Ballet.

124

Alexsandr Godunov

Mischa was a very popular dancer in Russia. But he was always searching for something—I don't know what. I was shocked when he left Russia, but I knew that in the United States he would have a good artistic life.

I knew many talented people who left Russia, not only dancers. It is a tragedy for Russia.

You can't really imagine what it's like to leave friends, family, and country behind. When you emigrate, it's such a big thing. You feel a great sense of loss. Some people stay crazy for a year. You have to face the fact that you can never return. Never. You in this country, you can leave any time and you are free to return. But for me, no. It is forever.

You get over the pain. I'm OK now. You decide to leave your country, and you adapt. You make friends. Life in America is fantastic.

Not confining himself to traditional ballets in the West, Godunov has appeared in contemporary works such as Alvin Ailey's *Spells*, which blends ballet vocabulary and jazz idiom.

I like to dance the modern ballets. In Russia, I felt shut off from the rest of the dance world. It's good for dancers to try different styles. It is like growing up in your life.

When you dance, you give all you have in a performance. It's not just technique—the pas de deux to impress audience. You speak to the audience, tell them a story in dance, you involve them, lift them up. You want the audience to say, "Thank you. That's good." When you have the synthesis of acting and technique, then you're on top.

You bring something new to each performance. Sometimes you make the audience laugh, sometimes they are crying. After each performance, you check with yourself and your teacher. You find out, "This step doesn't work, this is the wrong direction," and you try to make it better each time. The work never stops. Even when I'm here

talking to you, I'm thinking, "I have to practice new ballet today. I have to rehearse." Or you go to a party after performance. You laugh, you talk, you drink. But you are thinking, "I will do it differently next time." "Ya, ya, ya, hello. How are you? Yes, of course." But the dialog inside you goes on.

You must have dedication to your art. In life, one day you are full of energy, you want to fly, jump, and next day you are sad. But you've got to go on stage and smile and dance. Some gifts are given by God. Stars have the power to hypnotize an audience. When Mischa is onstage, people say they see no one else. He has this power. This is a star.

But to keep on looking good, this is a problem. I am thirty-one. You begin to face the fact that you cannot dance forever. You start very young; if you are lucky and have good training, you can dance till you are forty or forty-five. The audience turns to younger stars. That's life.

Some dancers continue onstage too long. They won't leave the stage. It's very difficult. I understand this. Because you dance your whole life. Then one day you have to say, "That's it, I have to leave now. Goodbye, I'm finished." It's very hard. You have to cut off half of yourself.

You have to have the energy and confidence to believe there's another life for you. I will go to Hollywood and study acting. Maybe I will do choreography. If it comes from within me, I will do it.

All life is some kind of risk. I am full of energy and hope. I take chances. I explore. Voilá.

126

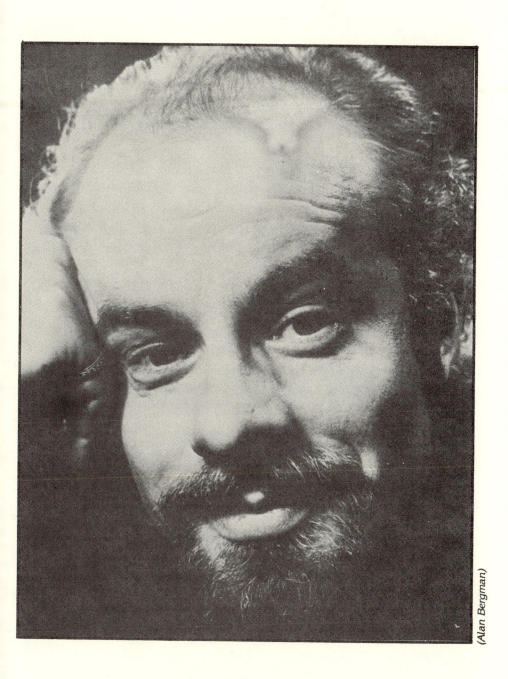

(Alan Bergman)

Alexander Minz
Dancer, actor from Russia

"From the darkness to the light."

"I lived in Russia thirty-two years, but I have no feeling for Russia." Of his arrival in the West in 1972 Alexander Minz says, "It was like moving from the darkness to the light."

Known as Sasha by his friends, he has a dancer's lithe body, an actor's mobile face. He was born in Minsk, Russia, in 1940 and grew up in Leningrad where he attended the Vaganova School for gifted children along with Rudolph Nureyev and Natalia Makarova. After graduation, he joined Leningrad's Maly Theater, and subsequently the Kirov Ballet.

He emigrated first to Italy in 1972, then to New York City. As a character dancer for six years with American Ballet Theater, he performed major roles such as Rothbart in *Swan Lake*. He played Drosselmeyer in *The Nutcracker*, and the High Priest in Makarova's production of *La Bayadère*, both of which were filmed for national television. In the Hollywood movie *The Turning Point*, Minz played the role of balletmaster, and staged a ballet. Currently, he is pursuing an acting career.

Interview, February 7, 1980

I love to travel. If I don't travel, I go crazy. In Russia when I was with the Kirov Ballet, they never took me on tour. I missed so much, the whole world. Then in 1969—I don't know how it happened—all of a sudden they took me on tour to Vienna.

We started drinking already on the airplane. The kids in the ballet joked: "Well, Sasha, we go through Budapest. Maybe they will leave you there." When we passed Budapest, the whole company was screaming with joy. It was marvelous.

When we arrived in Vienna there was sunshine, birds, flowers. My room faced on this beautiful Belvedere Park. I almost lost my mind. We didn't have a performance that first day, so we just drank like crazy.

Then, I remember, we had free tickets to Alwin Nickolais Dance Company, a big festival of the arts. Lots of people and very small theater, and we were in the balcony, and it was very warm and we were in a daze. And then starts the ballet with all this electronic music—lights flashing on stage, and everybody running and jumping. We could not stand it. We left, and went to a cafe with Arabian Nights— fantastic belly dancers—and then back to the hotel at five in the morning. When we returned to Russia, all I could think of was to leave and go to the West.

I'm from Minsk. It is near Vitebsk, the town the painter Chagall was born in. I was one year old when World War II started. During the war, Minsk was bombed by Germans, and was completely destroyed. This lovely city, destroyed. I never knew my father. He disappeared during the war. My mother and I were evacuated to a village in the Tartar Republic. No trains, no electricity. In Russia, we say this is a dead village. This evacuation, it was like exile.

We had a farm, some cows, fresh wild flowers, beautiful flowers. My mother did the farmwork. Also, she worked as a bookkeeper. I remember one evening in winter, my mother

had to deliver some papers to a client. We had to ride in our horse-drawn carriage through the woods to get to the town. It was dark and cold, so cold. We pulled our fur robes up to our chins. I looked back, and saw a pack of maybe 50 wolves following us. Ah, it's so scary. You look back, and they are following. My mother had prepared torches with oil and benzine. We held them up and rode fast through the woods, and the wolves disappeared.

The war ended in 1945 and we moved back to Leningrad. Mother worked, my aunts helped, but we had barely enough food, no money, nothing. All the clothes that I wore—jackets, pants, everything, my mother sewed by hand. She worked so hard to support me.

I went to public school. We learned about Lenin and Stalin, how "Stalin is your father." In the morning first thing you say is "Good morning, father" to his picture. Oh, how I cried when Stalin died. Students, teachers, everyone cried. My relatives never said to me a word against Stalin. If I repeated something bad, I would go to jail. They wanted me to be safe and happy.

I went to drama school from the time I was seven. It was free to everyone. For this and for the ballet school you had to audition. At ten, I went to the Vaganova School in Leningrad. I was excited by dance. Our teacher was Alexander Pushkin, teacher of Mischa—Mikhail Baryshnikov. In my class was Natalia Makarova. She was the best student. Friendly. Nice to people.

About her, about Natasha, I could talk for hours. Oi, what she did for me. We are friends since I was ten, she was thirteen. In school, she was special, she was a very juicy girl. She had a round face, with long curly hair. She was buxom, her legs like triangles. But when she first appeared on stage—we had an hour of theater in the school—she was incredible. Her body was like jello. She moved with harmony and expressed so much.

Alexander Minz

When Natasha first joined the Kirov Ballet, she had no technique. She couldn't do a pirouette, and yet she was remarkable. She danced *Lisztiana* to music by Franz Liszt, and *Liebestraum*—you know this? Da de ya da de ya. . . . After that, everybody compared her with Ulanova and with Isadora Duncan who had danced in Russia earlier in the century.

Ballet was always a cult in Russia. Especially in the Bolshoi in Moscow, dancers have money and privilege. They have connections in the Kremlin. But for us in the Kirov Ballet, it was different. The Leningrad government reports to Moscow. There is much repression. You can't speak out—you will be reported. The KGB watches everything you do. They have a dossier on everyone. That's why so many defections from the Kirov. It's like a private jail inside a big jail.

Lots of dancers in Russia work for the KGB. They report on each other. If someone likes the West too much, usually they do not take him on tour. Once they came to me and asked me to be an agent for the KGB in the Kirov Ballet. I went home and told my mother. She said, "Just tell them that you have a very long tongue, you cannot keep a secret." I told them that, and they did not ask me again.

You have no idea how many great actors there are in Russia—top class, to compare with Olivier and Marlon Brando. But the plays—Pushkin, Gorky, the great classics from the past, every word has to be checked. They cut and cut. Young people might get ideas. If you are lucky, they will let you do modern plays: Albee, maybe Ionesco, but these have to be translated. Some translation! They rewrite the play to make it conform to the Soviet point of view.

Many plays they do not produce: Tennessee Williams— all about sexual relations. In Russia, you do not talk about this onstage. There are only brothers and sisters. Comrades. Homosexuality, sexual problems do not exist—nobody

131

talks. The plays are about working, family, farming, production. So much talent in Russia, but so little opportunity for self-expression. If an actor finds some good material, he is so excited he goes wild.

If you make money in Russia, there's no opportunity to spend, there's almost nothing to buy. If you have a special paper, you wait one year and wait in long lines, and finally you will get a car. If you have enough money to go to Italy or some other Capitalist country, forget it. They will never let you go.

There is persecution against all religions in Russia, but not so much against old people. A few synagogues are still open. The KGB is stationed there, and they photograph everybody who goes in. We have a beautiful synagogue in Leningrad. I was in it once after the Second World War. My mother wanted me to know what it was.

I think Jews in Russia hunger for something. Because life there is so terrible, there is the hope that something spiritual can exist. When everything is broken, you know, you have to have something to hold on to. To save your mind, your spirit, your personality.

This new generation wants to go to church and synagogue, I think, like kids all over the world. Just to be contrary, maybe. They challenge the system. I'm not sure, but I think it is to prove themselves, to be macho, strong. They take a risk, for they can lose their job, lose everything.

Homosexuals have a struggle in Russia. If your boss guesses you're a homosexual, forget about your career. I remember in 1970, there was an open letter against persecution of homosexuals signed by many of the leading intellectuals: the pianist Stanislav Richter, Shostakovich, Sakharov, and Maya Plisetskaya, the star of the Bolshoi. When I got married the KGB came to me and said, "You're just getting married to cover your homosexuality." I said to them, "But if I didn't marry, you'd say I was homosexual

for sure. So there's no way I can win." When I was divorced, I suppose they thought that proved their point.

Minz applied for an exit visa to leave Russia. In the 1970s, a limited number of Jews were permitted to emigrate to Israel, but only if they could prove that they had family there. Unwilling to admit that Russian citizens were choosing to renounce their homeland, the government claimed that it was "reuniting families."

When I applied to leave Russia, they threw me out of the ballet company. I was given official permission to leave. Why? They cleaned the country. They let go all the garbage from the streets: hooligans, thieves, people in black market, drug addicts—and Jews. Jews and hoodlums. So if a Russian boy wanted to leave, he found himself an available Jewish girl to marry. And Russian girls found a Jewish boy. And they let them go, go, go.

I went to Rome, and my mother went to Israel to visit her uncle. I decided not to settle in Israel because they had no classical ballet company. Then mother came to me in Italy. It was hard on her. She had left behind her home, her sisters, everything she knew. I was her last-born child—one she lost at birth, another died in infancy, so she hung on to me. Her life was my life. In Italy, the freedom. She wandered the streets. She ate ice cream and chocolate. Oi, she never did that in Russia. But she was lost in this new country. She lost her mind, and had to go to a hospital. She never recovered.

For Russia, I never had a moment of nostalgia. But Italy, when you walk down the street, all the stones, the antiques, the art speak to you. And the people are so warm. So much spirit. I worked all night as a garcon in a pizzeria, and I picked up Italian. To stay in Italy, I was ready to sweep the streets.

But Minz didn't have to sweep the streets. Through an old friend

encountered by chance, he was invited to teach character dancing at the Ballet of Rome. Then, Natalia Makarova arranged for him to meet the director of La Scala, and he went to Milan to teach ballet. Rudolph Nureyev, who had defected from the Kirov Ballet in 1961, and soon became a legend in the West, was at La Scala in 1973. When Minz arrived, Nureyev was onstage, rehearsing a scene from *Giselle*.

He looked at me, screamed "Minz" and let out a stream of Russian words. You know, we were never friends in Russia, but suddenly we were like brothers reunited, and we didn't stop talking for three days. When he heard that my mother was in the hospital, he said. "You must take her to America." With Natasha, he arranged everything. Natasha talked to Lucia Chase at American Ballet Theater and there was a job for me. Rudi arranged for papers, paid for my mother's hospital, doctors, travel for both of us. All that he did.

Everybody says of Nureyev that he is rude. He never lets people get close to him. But I think he suffered so much in Russia. There he was a great star, but he could not speak his mind, had to hold everything back. So when he became somebody here, he found his power. He could speak out, and he let out all the anger seething inside him. Like a hunting dog, he smells out people's phoniness. He hates when people fawn all over him.

What he did for me, I will never forget.

When I first came to America, to the airport in New York (whistles) it was amazing. All nationalities, all different colors and accents. People moving so fast. I liked it. People live as they want here.

Still, when I hear that white people are against people of other colors, this I can't believe can happen in America. That you still have the Ku Klux Klan here, that today there are powerful groups that would put a muzzle on anyone who speaks ideas they do not agree with, this is frightening.

134

With Ballet Theater, my favorite role is Drosselmeyer in *The Nutcracker.* You want pictures for your book? Here is one with Mischa in a scene from *The Nutcracker.* You like! Go ahead, forget about me. (Laughs.) They all want him.

I play *Don Quixote* wearing a long cloak, white collar, and cuffs. The high boots for this role do not fit, and I have to hobble onstage. Mischa staged this ballet. I said to him, "This is not Don Quixote, this is Falstaff." But he just laughed.

My first years in the West, I could not understand the modern ballets. I was like ice. Now I like Paul Taylor and Glen Tetley ballets. But sometimes I think it's all technique, no spirit. It's difficult for me to catch feeling. Sometimes I would like a moment of just moving softly onstage, not one pirouette after another. I love to see people onstage show love for each other.

Kids in Russia want the new art forms. They grow tired of same sauce for breakfast, lunch, and dinner. They go on tour, their eyes are opened, they come back ready to experiment. But today in Russia it is impossible.

Soon I will go to California to work in television and theater. I would like to have romantic roles, also to play complex personalities. I would like to move people, to make them feel what I feel. Who knows if I can succeed, but I will try.

Since my mother died, I am not afraid of anything. I believe there is something, not God so much, but destiny. I have a feeling that I will survive. I love people, I do. I am very lucky because they trust me. I have fantastic friends.

That's something to live for.

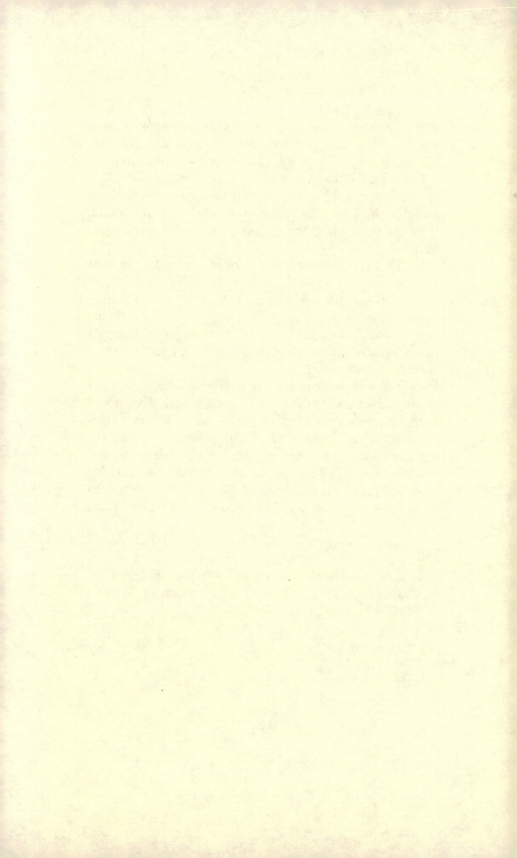

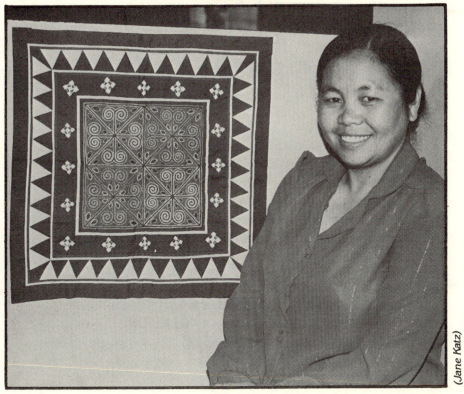

(Jane Katz)

Choua Thoa
Textile artist from Laos

"There is no more country for the Hmong."

They fled from China, where they had been considered barbarians, and settled in the fertile hill country of Laos. They called themselves "Hmong" which means "free people." They were farmers, independent people, self-sufficient, and proud.

The Vietnamese War which spilled over into Laos in the 1960s decimated their population and ravaged their country. Hmong guerilla troops assisted the CIA in their secret military operations against Communist-backed forces in Laos. When their allies pulled out in 1975, the Hmong remained to face Communist retribution. Many fled for their lives to refugee camps in Thailand and were airlifted to safety in the United States.

Coping with the disruption of the traditional way of life as their people adapt to an alien, technological environment, the older Hmong women seek to perpetuate their artistic heritage: the intricate cross-stitch embroidery, batik, and fabric appliqué they learned from their mothers. Choua Thao is highly skilled in this folk art tradition which is winning wide acceptance in the United States.

<div align="right">Interview, September 24-25, 1981</div>

Choua Thoa

She is a small woman, energetic, buoyant. She talks and laughs easily, withholding little. Her English is fluent.

Hello. My name is Choua Thao. I am Hmong. I was born in 1943 in the village of Phou Kabo in Laos. All the people in our village were farmers before the Communists came.

Our people came to Laos from China around one hundred and fifty years ago. In China, they had a written language. The Chinese made trouble for our people, and they escaped. They could take nothing, only their clothing. The symbols and designs they carried in their heads, so they stitched these into their clothing, like a secret language.

Many of the Hmong do not know the meaning of these ancient symbols. They cannot read or write, although we are using the Laotian alphabet to create a written language. But all the women of my generation do the traditional embroidery. It helps us remember our history.

I learned to sew when I was five years old. In our country when we were little our parents gave us a needle and thread just the way in America they give you a book and pencil. I made my clothing with my mother and my grandmother. We made special dresses for festivals. There was a plant which we harvested, and used the fiber for stitching.

Here is some of my embroidery. We use many colored threads on a black background. We love to use gold thread. We learn the patterns from the older women, but we make up our own designs, and we each have our own style. Many of our designs come from nature. My favorite is the snail pattern. Some of the designs are based on old Hmong stories. We like geometric designs. One is called "Getting Lost." It is a maze with no opening. Another pattern is called "Enough." It is a woman's message to her husband that she has had enough children. I do the work freehand, very slowly and carefully. I don't like to have any loose threads. Always I try to be neat in my life.

This piece is a covering. Every Hmong girl used to make these as gifts for her parents. It was supposed to cover them when they died. You would make two to decorate the arms, and one to cover the pillow, for each parent. Then people would come and see the body and admire the daughter's work. They would say, "Oh, she is so good to her parents. She does such beautiful work. She will be a good wife."

This big piece, it has many pieces of fabric sewn on the background. On the fabric I have embroidered flowers. Sometimes in our work you will see animals from the Hmong religion. If you see a cross, that is because the Christian missionaries had much influence in Laos. They taught me to speak English. Now they are publishing a Bible in the Laotian language.

In Laos, my father was leader of a group of 30 villages. So many people, 20 or 30 families in each village. Once I rode a horse around the area, and it took me fifteen days.

My grandfather was leader before my father. When my father became leader we had a big party and many Laotian officials came to our home. My father and the other men cooked the vegetables and roasted the animals for all the people. The women cooked the rice, but the men thought they were too weak to do the heavy cooking. Even today in the United States, Hmong men do most of the cooking.

My father had three wives. I remember how my mother cried when he took a second wife. There is a trick that the Hmong men used to play on their wives. If the wife had a few children, the husband would say, "Oh, I have to get somebody to help you." Usually the wife would say, "I'm happy to have all the work and not have to fight with another woman." He'd say, "No, no. She will help you. She will work with me in the fields, and you can stay home and take care of the children." She'd refuse. He'd say, "Okay, no is no." Then the next week, if she refused again, he'd bring his older relatives over, even the wife's parents, to persuade

her. A husband was supposed to have his way. The woman would cry and cry, but finally she'd give in. My father had so much power. Many young girls wanted to marry him.

In Hmong society, the man is in control. If a woman doesn't obey her husband, people will say she's no good. If she runs around with another man, the whole community will look down on her. Her husband will beat her badly, maybe even kill her. Our people lived in the mountains so far from the Laotian government, the law could not reach them.

Sometimes if a marriage didn't work, the elders of both families would talk it over, and agree to let them get a divorce. There were three young divorced women living in our home. My father agreed to be responsible for them when they got divorced. They were like his adopted daughters. They had more freedom than we did. My parents used to say, "Treat them better than your own sisters because they have suffered enough."

My mother had twelve children. They were born at home. Six died a few days after birth. I had malaria when I was two years old, but my mother took me into town, the doctor gave me an injection of quinine, and I survived. I was lucky.

While Christian missionaries have had some impact on Hmong religious life, most Hmong believe in the presence of ubiquitous spirits called "tlan," both harmful and benign. Although Choua is a Christian, Hmong religion and folklore are a part of her upbringing.

The people used to say that when you are sick, evil spirits are calling the soul to leave the body. The shaman would perform a ceremony and advise the soul to rejoin relatives in death. People would say that if a bird flies into your house and roosts, it is a warning to move. I didn't know if I should believe all that.

But then I saw a spirit. Really, I saw one. I was quite small. My sister and I were staying in a house in the fields because she had to watch over the animals. I missed my mother so much, I cried and cried at night. There was a full moon. I looked up at the window, and there was a hand hanging on the wall. I saw it! I pulled the blanket over my head. The next morning, I told my sister and she told me to be quiet. But I thought it was the spirit of my dead relatives. In our culture, the people say the spirits of those who have died watch over you. I think they were reassuring me not to be lonely.

When I was very young, my grandfather looked at me and said, "Oh, such a little girl. Such small fingers. I hope some day when you grow up you will be able to write." I wish he had lived and could see that I can read and write, and besides Hmong and Laotian, I know French and English. He would be very proud.

My father went into the city to meet with Laotian officials and saw some of the Laotian girls going to school. He said, "I think I'll send my little girl to school." I was just six years old. I was the first girl from the Hmong mountain villages to go to school. I felt very lucky. But the whole community was upset. They said, "If she goes to school, she won't know how to do anything. She won't know how to sew or to work in the fields. She will be lazy, and will be no good to the community."

But my father wanted this for me. So when I was six years old I started riding a horse with my brother to the school in the city. I was so small, my brother had to push me onto the horse. When it stormed, we wore our raincoats. We rode five miles through the jungle. Nothing bothered me. I loved horses.

What the people said was true. I was lazy. I didn't know how to chop the wood or take care of the animals. When I was supposed to help on the farm, I just played.

142

Choua Thoa

In school I was very shy. I didn't know a word of Laotian, but I could understand when they made fun of me. After a while, the people in our village saw that I was speaking and reading and writing Laotian, and they wanted to send their children to the school. So pretty soon there was a whole group of Hmong children walking through the jungle to school.

Because I was my father's oldest daughter and I could read and write, I was respected in the community. The Hmong men did not ask me to marry them because they could not read or write. I married a Laotian man who was educated. We lived in the city, Xiengkhouang.

I was sixteen years old when we were married. My uncle told me about all the things a married woman has to do: care for the children, obey your husband, take care of his relatives. I couldn't go anywhere—just to the market—without my husband or one of his relatives. I couldn't even go home alone to visit my family, and I was very lonely. Still, I was lucky to marry a Laotian. I had more freedom than the wives of Hmong men. I could go to work.

The Hmong found themselves pawns in the fourteen-year struggle for control of Laos. Some joined the Pathet Lao, a formidable army supplied and reinforced by Soviet, North Vietnamese, and Chinese Communists. Most joined the pro-Western Royal Laotian Government forces, which received military, economic and technical support from the CIA.

When the Americans came to Laos, many Laotians went to work for them. We always listened to people who had an education. If they said we should fight, we were afraid not to fight. My husband worked for the International Volunteer Service, sending supplies to different parts of Laos. I was working as a nurse's aid in a hospital in Laos.

A few months after we were married, I was pregnant, and

my husband had to go away to get training. I had to live alone, and I was frightened. We heard that the Communists were coming to the city, Xiengkhouang. We heard the big machine guns—boom, boom—so far away. My father sent my mother to get me. She walked five miles by herself through the jungle. She said, "You must leave and come back home with me. Your husband will not be able to come back for you. The city is cut off." So I packed some things and went with her. We walked all night to get to our village.

The next morning the Communists took over the city. They set up tanks and machine guns. Our troops had just a few guns that didn't work. The Communists started firing to scare the Hmong and Laotian soldiers. My father and brothers were in the army, and they escaped into the mountains and set up camp there.

I lived with my grandmother for eight months in the jungle. We lived in a small house my father built for us. I went back home to get food. With my big stomach, it was hard to walk in the mountains. Other Hmong families were hiding in the jungle, but we didn't live all together because then the Communists would find us.

My son was born in the mountains. My husband knew where we were, and he had the Americans send a helicopter for us. Then we lived in the city for a few years. More children were born. The fighting was going on all around us and it was dangerous. That was a sad time for my family. My older brother who was loved by everyone in the community was killed. He was blown up by an enemy mine.

The Americans gave me training and made me manager of a hospital in the mountains near my parents' village. This hospital was built by the United States government. I worked there for twelve years. My mother helped take care of my children. Sometimes we had a baby-sitter living with us. Sometimes the children stayed with my husband.

Choua Thoa

I rode in the helicopters with the medics. We went out into the fields to give emergency aid to the wounded. We had to go very close to enemy lines. The Communists were advancing in the countryside. They kept coming, like ants. You'd look down from the helicopters and see these deep black holes made by the American bombs; they were bombing the enemy. They destroyed crops and animals. You'd see trees without leaves.

When the Communists caught an American bomber pilot, they'd say, "You made this hole. You fill the hole." And the pilot would have to take a shovel and work to fill the hole with dirt. He would shovel and shovel. No end to it.

Some of the Hmong people were so frightened of the Communists, they hid in those bomb holes. And they hid in caves in the mountains. They came out at night to find food. They had skin disease and malnutrition.

The bombing went on every day. Many Hmong tried swimming across the Mekong River to Thailand. Some went on foot through the jungle, but it was dangerous and many people died. We started an airlift of refugees to Thailand. We went into the fields and carried the wounded into the airplane. You'd try to keep people from bleeding to death. You'd try to give them courage.

You know, when I was a little girl once I looked up and saw an airplane over our village and I thought, "When I grow up I would like to ride one of those airplanes to work." Now I was doing it. People were dying in my arms, and it made me very sad.

In the hospital, sometimes we worked sixteen hours a day. You couldn't stop. You just kept moving. So many people depended on you. When I had a day off, I did my embroidery. You could hear the Communists shooting just half a mile away. You could smell the smoke. But I went on sewing. It made me feel peaceful.

Then the shooting came very close, and we had to evacuate the patients. The medic and I carried them into the airplane. They were taken to the capital city. We waited in the mountains. We watched the hospital go up in flames. The airplane came back and took us to the capital. They picked up my mother and children and brought them to the city.

The next morning, I went to the officials of the Public Health Service* and said, "I'm resigning. I'm leaving the country. Please sign this paper." They said, "You can't leave Laos. We will keep you here." I went to the American Embassy, and they arranged for me to go in a car to Thailand with my mother and children.

I had saved some money, and when we got to the Thai border, the guards said they would kill us if we didn't pay them. So we gave them all the money we had. In the refugee camp, conditions were very bad. All the children were hungry. So little space. Nothing to do. But the women did their embroidery there. They made skirts and belts and hats and baby-carriers.

People talked in the camps of coming to America, and they were frightened. They said in America there is a big giant that comes at night and sucks your blood. I told them: "That's not true. We all die sometime. You only die when your time comes. Then you go home. Nobody lives forever."

We stayed in the camp for nine months. My husband found us there. Finally, we all came to America. We came to St. Paul because we had some relatives here. It was winter in Minnesota. There were no leaves on the trees. It was so cold I couldn't believe it. Then it started snowing and snowing, and I loved to shovel the snow. Pretty soon everything turned green and it was very beautiful.

*Under U.S. supervision.

146

Choua Thoa

At first, everyone was good to us. We opened our house to anyone in the neighborhood. You always do that in Laos. But some people started coming all the time and taking our food. We didn't have enough money to buy food for them and for our family. We didn't know what to do. Finally, my sponsor helped us to get rid of them.

We got together with our relatives and we bought a car. I was lucky to get a job right away working for the Hmong community. The refugees have so many problems when they come here, and because I knew English I was able to help them. You know, at home if someone has a problem, everybody helps. But here, the people feel they are alone. They have all lost family members in the war. They do not have the shaman to help them when they are sick. They do not know the language. Everything is new and confusing.

Some Hmong men come to this country and it's very sad, they die in their sleep. Nobody knows why. We believe that the soul of a person is sorry about leaving the country, leaving relatives behind. And the soul says to the person, "No, I will not stay. I will leave you."*

There are so many pressures on Hmong men in this country. In Laos, the man was a farmer, a soldier, he could be a shaman or community leader. Here, he may not be able to find a job, and then he is nothing. He cannot take care of his family. In this new country, the men are scared. They see that their wives are free, that their wives can divorce them if they want to.

The man is often afraid to show emotion. He is afraid to talk to his wife, or to the social worker. He says he will kill anyone who separates him from his wife. Still, even if the men have lost their power, they can go to school and learn.

*Some observers have attributed this sudden death syndrome among Laotian males to the Communists' spraying of poisonous chemicals called "yellow rain" on Laos in retaliation for the Hmongs' aid to the United States during the war.

Many of them get job training and find a job and get confidence. They make a new start in life. This makes me proud. But now jobs are hard to find.

My husband is not living with us. I work to support our six children. I take classes at the university when I can. I do my embroidery. I like to experiment with different styles and designs. We Hmong are changing and adapting. We are learning to use colors the Americans like. We are trying to get support from private foundations for this work so that some of the Hmong women can stay home and do their sewing.

There are not many Hmong artists. Why not? To be an artist you need time to dream, and our people are too busy working.

My oldest daughter does beautiful embroidery. My younger daughter only sews if a button falls off. She says it's not worth it to spend three weeks making one piece which sells for $10.00. She would rather go to work.

I sew for myself and for my family and friends. I love to do it. I sew costumes for the children to wear in festivals. I encourage other Hmong women to do the sewing so we won't lose our art form.

Our children are important to us. We want them to be happy. Now in America they go to school and they study hard, they learn Western ways. They learn new things. In the future we hope they will have good jobs, and will be respected.

I keep a diary for my children in the Laotian language. Three of them can read it. I put my thoughts and feelings into it, my sadness.

There is no more country for the Hmong. Now we must be Americans. What else can we do? Maybe in ten years our children will graduate from college and will write the story of the Hmong for their grandchildren. Maybe they will point to our art work with pride. That way, something of our culture will be passed on.

148

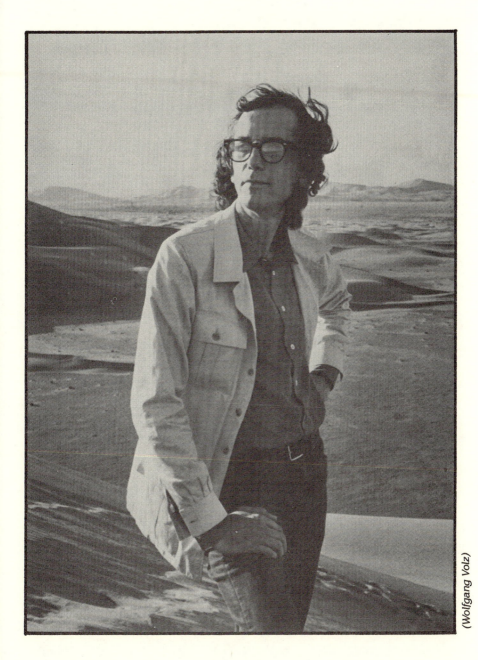

(Wolfgang Volz)

Christo
Sculptor from Bulgaria

"My art is public art."

An established artist in Europe, Bulgarian-born Christo Java-cheff emigrated to New York City in 1964, dropped his last name, and quickly became a controversial figure. Some call him a stunt man, "the Evel Knieval of modern art." Others consider him a genius with a grand poetic vision who has changed the definition of modern art.

He has wrapped a fountain and a medieval tower with plastic fabric, he has wrapped a one-mile stretch of coastline in Australia, and the facade of Chicago's Museum of Contemporary Art. Across a valley in Rifle, Colorado, he has draped an orange curtain of woven nylon fabric.

One critic terms his work "pure art on the scale of the great wonders of the world." Another dubs Christo's grandiose projects "monuments to nothingness."

Interview, October 24, 1981

Christo

On September 10, 1976, Christo's *Running Fence* was installed across twenty-four miles of California ranch country. The "fence" was a great white ribbon of white nylon fabric strung between steel poles, which extended from the freeway to the ocean, passing through farmland, disappearing over hilltops, snaking down to the Pacific Ocean. Discussing the event with Christo five and a half years later, I am struck by his restless energy as he speaks in his thick Bulgarian accent, searching for just the right English word to express his ideas with precision.

> The evening before, we finished unfurling the nylon panels, and ran them down a steep cliff to the water. We pulled the last panel out to a raft anchored offshore. I stood there on a rock shouting directions to the marine engineer and the workers. Television and film crews were climbing from rock to rock, trying to record the procedure. Museum directors, gallery owners, and art critics from the States and Europe were there.

His face with its angular features is animated as he recaptures the excitement of that event.

> The next morning, thousands of people drove by in cars. The fence was visible to sightseers on the beach two miles away. I loved the way the fabric shimmered in the wind, in the morning mists. It caught and reflected the changing light, it responded to the colors and contours of the landscape.

How did the project come about?

> For four years, my wife Jeanne-Claude and I prepared the way. We began with a proposal. I made elaborate studies and more studies, sketches and scale models. We attended 18 public hearings to overcome strict California zoning

151

laws, and the opposition of community members. We knew
we had to win over the ranchers. Jeanne-Claude visited
them in their farmhouses, she drank coffee with them,
talked about milking cows, and offered them compensation
for the use of their land. Most important, she told them that
the fence would be a beautiful thing.

We wanted to keep ranch life going smoothly, so we
asked the ranchers to help build the fence. We knew they
would be conscientious about closing the gates, not mixing
the cows of Mr. Canfield with Mr. Thompson's bulls. The
ranchers know the land, the bumps in the hills.

So many obstacles. There was almost a civil war between
land developers supporting the project and local residents
who were afraid we would spoil the terrain. There was
opposition from local artists—I don't know why. City offi-
cials were worried about traffic control. Councilmen met
and made speeches for and against the project. This all gave
the *Running Fence* an air of credibility. Because every
senator, congressman, and councilman was darn sure I
would do everything possible to build my *Running Fence,*
they went through all the slow, tedious government pro-
cesses to evaluate it. I'm proud to say that this is the only
work of art which ever produced an environmental impact
report 450 pages long, written by 15 scientists at a cost of
$39,000—which I paid for.

Having overcome most of the legal hurdles, Christo carried out his
plan to extend the fence to the ocean, despite the refusal of the Coastal
Commission to grant him a permit. He was accused of taking the law
into his own hands.

This illegality is built into the American system. I work
within the system. I test the system. I tease the society to see
how it responds. So much energy is expended. People gain
an understanding of how their society works. This is what

makes it exciting to live in America. I challenge. If I lose, I pay the consequences.

He lost, and the ensuing legal judgment against him cost him $20,000. Total cost of the project, $3 million, which the Christos are still working to pay off.

> The *Running Fence* grew and evolved like a child, beyond anything I could imagine. It built its own reality. For me it was a celebration of the landscape. It gave shape to the wind. It went over the hills like a ribbon of light, and into the sea. Seven hundred thousand spectators viewed it. It was in place only two weeks, then we removed it. This impermanence is part of my aesthetic. Once disassembled, it cannot be seen or repeated. It exists only in the photos and films that recorded it and in the memory of the spectators.

Listening to Christo, one gets caught up in his idealism. His interest in breaking down aesthetic and political barriers is not startling, considering the fact that he spent the first twenty-two years of his life in Communist countries.

> I was born in 1935 in Gabrovo, a city in the Balkans, not far from Sofia, the capital of Bulgaria. My father is a scientist involved in chemistry and physics, and he ran a laboratory. In the late 1930s, we were surrounded by friends in the literary, musical, and art worlds.
>
> I have vivid memories of World War II. Sofia and the surrounding areas were bombarded by American planes in 1943, and the destruction was terrible. I was quite young, but I remember the fear and confusion of those times. The schools were closed. Our lives were in danger. We evacuated our city and moved into a little house in the mountains until the end of the war.
>
> All during those years, even though it was wartime, I

153

remember our family was very close. I don't remember any friction between the generations such as you have here. It would have been unthinkable to defy our parents. I suppose because we lived through such chaotic times, we were unified by the daily miseries of life.

All during the war years, although schooling was sporadic, we managed to continue our creative lives. From the age of six, I had private tutors in drawing, painting, and architecture. I drew and drew, probably as a release from the terrible reality of wartime.

In 1944 the Soviets invaded Bulgaria and the pro-German government was ousted. In 1946 the Soviets established the People's Republic of Bulgaria. Industry and personal property were nationalized, farms were collectivized.

Our family had been well off, but when the Communists came to power we lost everything. It was Christmas 1947. We were living in our home in Gabrovo near my father's factory. Civilians came with guns, banged on the door, and told us we had to leave our home. Each of us could take one suitcase. They pushed us out on the street. We managed to find a small house to live in.

The government fired my father from his job. Then, realizing they couldn't run the factory without him, they asked him to stay on. The late 1940s—that was the worst period of the Cold/War. Stalin's influence over the Bulgarian Communist party was tremendous. There were arrests and purges. Many people were destroyed.

I know about the repression firsthand. My father was accused of sabotage at the factory. There was no investigation. They simply arrested him and threw him into prison. I remember it was written on the wall of our home: "Here lives an enemy of the people." I was pushed out of school because I was the son of "an enemy of the people." Once again, I had private tutors.

154

Christo

My father was transferred from one prison to another. For four years, we lived with the knowledge that he might be tortured or killed. There were reports that he was to be executed. Members of Bulgaria's intellectual community who felt he was unjustly persecuted lobbied to save his life.

The years 1947-52—a terrifying period for me. I was a teenager, very sensitive, excited about art, theater, ideas. But there was this radical revolutionary spirit in the country. Everything Russian was considered superior, everything Western, was forbidden. We were cut off from the rest of the world.

Then in 1953 Stalin died, and my father was liberated from prison. They said they were sorry about all those accusations. He was rehabilitated. They needed him to run the factory. We moved to the town of Plovdiv, where my family lives still.

I was aware of the terrible corruption in the government of Bulgaria. Throughout the country there was an atmosphere of authoritarianism and intolerance. When I was permitted to attend school, I was reproached because I was from a Capitalist family. Everyone who had connections with the old regime was suspect.

At the age of seventeen, I wanted to enter the Art Academy in Sofia. Preference was given to sons of Communist party members. Fortunately, I passed the exams and was admitted. The curriculum was programmed by the government. We studied Marxism—that's when I became interested in how governments work. The faculty was very narrow-minded. They had a conservative academic conception of art. They fed us a steady diet of old masters. Everything from Van Gogh on was considered decadent. Art books were censored by the government. It was as if Picasso, Braque, and Klee never existed.

The academy rewarded young artists for doing official art in the style of Socialist Realism. Paintings of farmers smiling, workers marching, all this idealized art. If you

didn't show interest in this, you were subjected to intense pressures from the faculty. Also the Union of Young Communists served as watchdogs at all the universities, and reported anyone who deviated. If your work reflected Western art traditions, you could be accused of sabotaging the regime. I had to be careful.

My brother worked in the theater, and through him I met actors, directors, and scenic designers. I met dissident artists who had fled the Soviet Union because of the chaos following the revolution. I was exposed to the avant-garde in theater and art. I saw photos of the work of the Russian modernist school of the 1920's. I knew about Meyerhold and the Constructivists. I saw avant-garde films. Everything experimental interested me. At the academy, I was of course considered eccentric.

One aspect of my training proved to be very useful to me. In the 1950s, Bulgaria's borders were closed. But the train, the Orient Express, passed through the Bulgarian countryside traveling from Paris to Istanbul. The Communists wanted to make a good impression on Western travelers. So they arranged for students from the art academy to visit the cooperative farms. We would talk with the farmers, and tell them how to "clean up" the countryside—arrange their tractors in a line at the end of the day, neatly stack the hay so it would be visible from the railroad cars. Travelers would see that Bulgarian agriculture was efficient. I disliked this work, but in retrospect, I gained a sense of perspective, an awareness of space and distance which I have utilized in my work.

At the Art Academy I was critical, I was outspoken. My family worried that I was jeopardizing my future. I was suffocating. I felt that Bulgaria was a dead end for me artistically. In 1956, I applied for permission to visit my uncle in Prague. Impatient to get there, I borrowed the

156

money to go by plane. Three days after I arrived in Czechos-
lovakia, the revolution broke out in Hungary—causing
turmoil in all Communist countries. The Soviets crushed
the rebellion.

I was determined not to return to Bulgaria. I remained in
Prague, studying theater direction and stage design at the
Burian Theater. To survive in Prague, I painted portraits.

Every day, people were escaping to the West. I had a
chance to escape to Vienna. With a doctor and his family I
hid in a sealed railroad car that was taking medical supplies
to Vienna. We paid a customs official not to betray us to the
police.

On arrival in Vienna, we were supposed to go to the
refugee camp, but I knew that one could be confined there
for months. So I left my suitcase on the train—I didn't want
to look like a refugee—and hailed a cab, although I had no
money. He took me to the home of a man my father had
known years ago, and I was lucky. The man was still there,
and he paid the cab. The next day I registered at the
Academy of Fine Arts.

With my student card, I was able to go to the police and
renounce my Bulgarian citizenship. I became a political
refugee with United Nations status, and now had traveling
documents.

My escape had repercussions in Bulgaria. My parents
were obliged to say that they had opposed my plans to
escape and that they had renounced me. I had to sever my
connections with them so they would not be harassed.

In Vienna I did odd jobs. I parked cars, washed dishes,
and painted more portraits until I had saved enough money
to go to Paris. Paris—I lived in a small loft seven floors up
on the Rue de Saint Senoch—and began wrapping dis-
carded objects. I had no money for materials, so I used
bottles and tin cans. I wrapped a chair and contrasted it

with an unwrapped chair. I wrapped telephones and street signs. Pretty soon the room was full. Then I wrapped automobiles, motorcycles, and storefronts.

Were these wrappings a satirical comment on the prevalence of commercial packaging in modern society?

(His eyes twinkling.) I just thought that people like to unwrap packages.

I was interested in concealed forms and obstructed objects. I was transforming ordinary objects into dynamic forms.

Everything was happening in Paris in the 1960s. I met international artists, members of the nouveau réaliste group who used the images of the popular culture in their work. I met innovative composers like David Tudor and John Cage and the video artist Nam Peik. I had my first one-man exhibit on a waterfront. There was a wrapped automobile and a large roll of paper stacked 20 feet high, wrapped in tarpaulin and rope, which I called "Dockside Packages."

In August 1961, the East Germans constructed the Berlin Wall separating the Eastern and Western sectors of the city.

I was horrified that a barricade could divide this great city. With some friends I erected my own "iron curtain" consisting of 204 oil drums. For three hours, this 14-foot high structure blocked the Rue Visconti, a little narrow street on the Left Bank of Paris. Traffic had to be rerouted. Local residents were irritated and threw water at us from apartment windows. I had not been able to obtain a permit, and I thought the police would throw me in jail, but this was Paris. Nothing happened.

158

Christo

Christo attracted considerable attention when he sheathed a nude woman in plastic.

> I used opaque material because it must be solid on the outside. The important thing is to see nothing. The ambiguity is the image. I was interested in the surface of things, the contour of the form.

For the most part refusing to interpret his work, Christo left himself open to the onslaught of critics who alternately praised and vilified him. In 1964, he moved to New York City, which was becoming the center of the avant-garde movement. His projects took on broader dimensions. They include the wrapping of the Pont Neuf bridge in Paris, construction of a massive pyramid-like "Mastaba" made of oil drums for the oil sheikdoms, and a giant sausage-shaped inflatable sculpture suspended high above the ground. In 1973, Christo lay the groundwork for his most ambitious project, the wrapping of the German Reichstag.

> Why the Reichstag? It is the former headquarters of the Weimar Republic and of the parliaments of the Second and Third Reich. It is a powerful structure for the German people who have lived through two world wars and political terrorism. In 1933 and 1945 the building was almost destroyed. In 1960 it was rebuilt, a symbol of hope for a reunited Germany.
>
> The Reichstag is the building closest to the Berlin Wall, the place where East and West meet. It is under the jurisdiction of the British, the French, the Americans, the Soviets, as well as the East and West German governments. To wrap it, I must have the permission of all these powers. I am eager to engage in a dialogue between East and West, to bring about a new interpretation of my work.
>
> For nine years, my wife and I have been involved in this

project. At first, the Germans didn't want to talk about it—it was like putting a knife in an old wound. The Soviets were suspicious of the Western powers' involvement. The Western powers were afraid the Soviets would exploit the project to cut off access to East Berlin. Then both sides softened. We meet with members of the German art establishment, with government officials, with bankers, and industrialists. We listen to speeches for and against the project; we make speeches. We hope to have permission soon.

I thrive on complexity. There is no parachute taking me to a project; I put together many elements, working in slow motion over the years, building an identity between myself and the site, the people, the situation. If somebody says to me, "Christo, we have everything for you: a park, a lake, go ahead," I say "No. I do not work that way." There's no challenge.

Sometimes a project does not materialize. After so much groundwork, it's like a cold shower to my ego. But after a while, I move on to other things.

I never accept commissions. All of my projects my wife and I finance ourselves through the sale of my drawings, collages, and scale models to international art collectors. So the people who believe in the work make it possible.

My art is public art. I believe that any work of art is in a sense social comment. All our actions have political implications. The artist must be responsible. When we drill holes in mountains, we are careful to see that the landscape is restored to its former state. It is my job to enhance the environment, not damage it.

In 1980, Christo announced plans for a new project for New York City's Central Park. Entitled *The Gates,* it calls for the construction of 11,000 tubular steel frames to be planted 9 feet apart along 26 miles of walkways, with a golden banner hung from each frame, at a cost of $5

million to be financed by the artist. The proposal has brought opposition from community leaders.

> City politicians are afraid we'll set a dangerous precedent—
> next, someone will want to paint the rocks pink. Harlem
> blacks come to the meetings, and they say, "We need jobs,
> man, not golden banners." I tell them that construction of
> *The Gates* will create jobs. And I tell them it will be like a
> walk through a marvelous golden corridor with the fabric
> playing above your head, inviting you to watch the open
> space. The banners will touch at the slightest breeze, creating a continuous golden chain.
>
> People ask me, "Aren't you depressed when you have to
> deal with bureaucracy and red tape?" "I enjoy it," I answer.
> All the meetings, the reports, the facts and figures, the
> speeches—all the energy the work generates. The people
> get together and they discuss garbage collection. And then
> they discuss a work of art. It's like poetry.

What if this project is turned down?

> Well, the park will be there for many years. And I am in
> good health.
>
> I came here as an immigrant, and I learned the way the
> American system, the way the whole big machine works.
> This I use in my art. To challenge the American social
> structure and make it work, this I learned in America.
>
> Some people say I make theater art. But no. There is no
> element of make-believe. Everything really happens. My art
> is rooted in the everyday lives of the people.

Does your art have a function?

> It has no purpose other than its own existence. Each project
> is an exploration involving a new land, a new language, a

161

new concept. The work is so large, it affects so many people on so many levels that any interpretation is valid.

You know, people used to say I am not an artist. Now they at least admit I am an artist. (Laughs.) But they ask me to do the project somewhere else.

(Eeva-Inkeri: Copyright © by Christo/C.V.J. Corp.)

Christo's *The Gates*, project for New York City's Central Park. Charcoal and pencil drawing by Christo

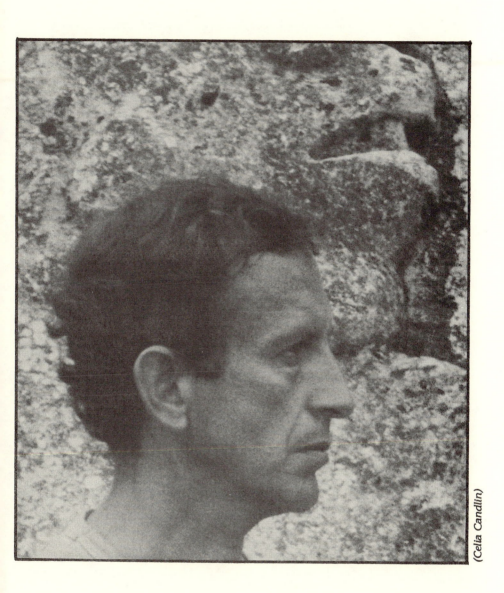

(Celia Candlin)

Mario Toral
Painter from Chile

"I felt the ruptures in Chile as blows to my own body."

Born in Santiago, Chile, in 1934, he studied at L'Ecole des Beaux-Arts in Paris, and came to this country in 1973 for an exhibit of his work. He lives in New York City and shows his work all over the world.

A warm and effusive man, Toral talks and laughs easily, eyes flashing, hands speaking, tracing ideas in the air. His studio is decorated with a profusion of hanging plants, books, and momentos: an African drum, a Russian icon, a Hindu bullhead, and wall-to-wall paintings.

Toral's canvasses are filled with sculptural forms and sensual imagery: the female torso, breasts, and limbs suspended in space, blending with the natural environment. Of his paintings the poet Pablo Neruda wrote:

> *He soars through subterranean caverns, reaching at last the Towers of Babel . . .*
> *These statues, these women of Babel glow, stone captives of the tinted air.*
> *There to remain until, born anew, Toral soars in new flight, abandoning them.*
> *Then they will close their lids and await him singing.*

Interview, November 17, 1980

Mario Toral

The fragrant, the silent, the tangled Chilean forest. . . . My feet sink down into the dead leaves, a fragile twig crackles . . . a bird from the cold jungle passes over, flaps its wings and stops in the sunless branches. And then, from its hideaway, it sings like an oboe . . .

I have come out of that landscape, that mud, that silence, to roam, to go singing through the world . . .

<div align="right">

Pablo Neruda, Memoirs

</div>

My friend Pablo Neruda, he sang in his poems of his love affair with Chile. He sang of our mountains and rivers, our political struggles, our folk heroes, our sense of humor, and our dreams. Whenever I think of Chile I think of him. He died a few days after the coup. At his death, Chile cried.

I was young in Chile. The country was in bloom. I remember the Alleys of Poplars. I remember the seashore, the desert sun and, in the distance, the peaks of the Cordilera Mountains crowned with snow.

My earlier paintings were sensual and lyrical, depicting men and women embracing in erotic encounters. I was interested in the mystery of life and creation. My subject was the human landscape.

I lived in Chile until I was sixteen, in a rambling old house on Molina Street in Santiago. My father was a peasant who had come from a small Spanish village and made good in Chile. He had a shoe factory, he called them "American choezz." He and I didn't understand each other. Then one Christmas Eve, they brought his dead body home. Maybe one day I would have come to understand him, but now it was too late.

I was always playing on the rooftops, defying the cries of my mother: "Chiquillo (little one), you'll crack your head," and those of our neighbors: "There goes that crazy kid again, breaking the tiles."

From the rooftops you could observe the life in the patios below. I watched a girl scrubbing laundry on a board.

While she worked, her breasts rose and fell. This disturbed me, but I didn't know why.

In school, I liked zoology because we drew animals. But I hated drawing class because you had to draw everything with a ruler. I drew trees and hillsides. I drew a dancer kneeling on one knee, flinging her head, arms and hair behind her. I loved to draw because I could be alone with my dreams.

I met a man who was a primitive painter. His name was Don Augustin Calvo. He ran a grocery store on our block. Behind the counter of the store he painted the things he sold: a bottle of oil, nuts, tomatoes. I watched him transforming these commonplace objects into image and color, and I began to see painting as a way of transforming the real world into another reality.

When I was sixteen I left Chile and traveled to Buenos Aires. I had no money, and spent my days scrambling for survival, sleeping in railway stations and in freight cars. Once I was asleep in one, using my only pair of shoes as a pillow. The train began to move. I jumped out and fell to the ground. Hell, I had left my shoes on the train.

In Buenos Aires, I worked as a waiter, a carpenter's apprentice, docker, and car washer. Every day was an event. I traveled through Brazil, sleeping in cheap hotels and— one unforgettable night—in an orange grove by the light of the moon. I worked on cotton plantations. Then on to Uruguay. In Montevideo, I found a job painting plaster figurines, and saved enough money to enter night classes at the School of Fine Arts.

At last, a chance to paint all day long. At night, endless discussions about artists. Someone would attack Botticelli, someone would defend him. I championed Goya and Picasso. The discussions were so heated, we almost came to blows.

I remember a self-portrait I did from that period. The face

166

was divided into two halves, one violet, the other yellow. The violet part was ethereal, the yellow reminded one of someone suffering from jaundice—but it looked "modern." When the school director saw it, he said, "Toral, we don't paint like this in our school." Later at the cafe we said, "This guy doesn't know anything about art."

We read the diaries of Delacroix and Gauguin. We painted in the countryside at night with candles in our hat lighting up our canvasses, like Van Gogh—but the wax dripped onto the paints and the candles blew out. I left Uruguay and a few years later, the repression started. Many of my friends who were outspoken on political matters went to jail.

I went back to Brazil. In San Paulo, I saw the originals of paintings I had seen only in books displayed at the Biennial. Picasso's *Guernica* and the dense, solid colors of Juan Gris left me breathless.

I lived in a narrow cellar without windows. I painted sitting on the bed, using a chair for an easel. Soon the canvasses began covering the walls, and piling up under the bed. I found the courage to take my paintings to the director of the Museum of Modern Art, and he arranged for a one-man show. Other shows followed. I found a job designing textiles. My boss gave me a large bonus—and on impulse, I resigned so I could spend all my time painting.

I was ready for Paris, the city that had always been my goal. There, I studied at the School of Fine Arts, doing paintings and engravings. Sometimes the sculptor Giacometti would come to the studio and give his opinion of our work. We met Jean Cocteau at showings of his plays and films. I visited the zoo where Rousseau painted his jungle animals. I made a pilgrimage to Van Gogh's tomb.

I was restless again, so I hitchhiked to Trieste, Istanbul, Athens, and Jerusalem, and I spent three months on a kibbutz. Then back to Paris. I made 40 engravings in

memory of America: her monuments, winds, and stones. I call the series *Totems*. The forms are deeply etched in stone. Stone—a symbol of being, and of continuity.

I felt the need to return to my own land, to touch my roots and my mountains, to take what I had learned and somehow give it back to my country.

So after fourteen years I returned to Chile. I came back by way of Argentina, taking the long train ride across the southern cone. It takes at least twenty-six hours to cross from Buenos Aires to Santiago. You enter Chile through its stone steppes, the back door of the Andes. This is austere country. You see peasants, cactus, and stones, stones, stones.

I was thirty when I returned, my shoulders had broadened, but still my mother greeted me with a kiss and said, "That little one. He's just the same."

In Chile, I continued my *Totems* series and it evolved. Ancient presences etched in stone—sometimes they seem to rise out of the stone.

My return was an awakening. I had seen much of the outside world. I was less of a dreamer than before. When you walked the streets of Santiago, you'd see the starved faces of the street children, little beggars with empty bellies. In the slums, you'd see people living in the mud, eight people crowded into one room.

The artists and intellectuals met in the cafes at night. We talked of the injustices we saw in our country. A few people, many of them foreign investors, made large profits from the riches in our copper mines. They paid workers almost nothing.

Then in the late 1960s, a powerful movement swept through the country to improve the lives of the Chilean workers. Its leader was a man named Allende.

In 1970, Salvador Allende, head of the Unidad Popular Government, became the first Marxist chosen by popular vote to head the govern-

ment of a Western democracy. In an attempt to establish Socialism by peaceful means, he nationalized Chile's mines, redistributed land, and instituted a social welfare program.

I never belonged to any political party. But I could see that Allende was committed to improving the lives of ordinary people, to giving them a sense of their own worth and dignity.

Allende's priorities were food and medical care. Milk was given to every child, powdered milk was distributed to pregnant women. He started a program of maternity leave for factory workers. Production increased, more people had jobs, and the economy improved.

Allende aroused our national pride. You know in Chile, like everywhere else, foreign things were admired--Coca Cola, blue jeans, American television, and discos. But Allende was surrounded by people who believed in the richness of Chilean culture and folklore, and in the innate creativity of the people.

During this period, I was working with Neruda, illustrating his poetry. One book was called *Twenty Poems of Love and a Song of Despair*. What a big heart this man had. He liked to gather his friends together. Once he gave each of us a book of his poems which he had wrapped in paper decorated with leaves and shells. Once he came to a party with a huge football made of wood, another time with a massive shoe made specially for him. There was this child-like quality, a gift for laughing at himself and life.

Allende's government had tremendous popular support. But the upper classes started plotting when they began losing their benefits. The opposition to Allende came from corporations with investments in Chile, from the right wing, and the American press. They undermined Allende's government with a campaign of lies. There was sabotage— power plants were destroyed, transportation was paralyzed.

The reactionaries said that the chaos, which they had created, justified the coup.

In September 1973, the military junta seized power in Chile. Although the Chilean press reported Allende's suicide, supporters alleged that he had been murdered. The junta suspended civil liberties, academic freedom, and many of Allende's reforms. A few years later, the U.S. Senate admitted that funds and support for the coup had been provided by the CIA.

With the coup, the old order returned.

I was then in Washington, D.C., for an exhibition of my paintings, and I decided not to return to Chile.

I cannot live in a society where a people's culture is subjugated to the power of the state. I cannot live in a country where there is censorship, where for speaking out against the government you can be awakened at two o'clock in the morning and taken to jail or disappear, and friends, family, and lawyers who support you are threatened with punishment.

This sort of thing goes on all over Latin America today. A throne of bayonets is not comfortable. Sooner or later it will crumble because the dictator gives the people nothing to believe in.

I felt the ruptures in Chile as blows to my own body. I had a feeling of urgency, a sense that I had to work fast, that I might die before finishing my own work. My paintings became more and more agitated, reflecting my indignation. In the work I did at that time, you see images of conflict and struggle. You see the human form distorted, limbs torn and dismembered. There is a sense of the grotesque. There is violence, torment. It is the world of Goya, a world at war. If you are angry, you cannot think cold-bloodedly. The drawings are emotional, visceral.

I believe in life as a positive force. I depict the human body interacting with the landscape, the sea, the rhythm of

170

the waves. There is continuity, flowing movement. I use warm colors like Venetian red suggesting the blood of life—and the blood spilled in war. Images of life and death are inseparable. I'm fascinated by the process of transformation: flesh becomes skin becomes cloth becomes petals becomes shells becomes stone. The images are a sort of shorthand for regenerative change.

I reveal myself as more naked and vulnerable than ever before. I believe there is nothing new under the sun. I have found massive figures like those in my *Totems* series in the bas reliefs of the Mayan ruins. My *Towers of Babel* hint at the threadbare fragments of Inca weavings.

This is a consumer society. Here on 14th Street in New York City you can see all the goods displayed on the sidewalk: clothing, cheap plastic toys, man-size teddy bears. People work all week; then on the weekend, they spend all their money on things that will fall apart. You know, it's true all over the world. People buy things to fill the void in their lives.

I have this neighbor—his apartment has a gray carpet, gray furniture, gray walls, and all these modern appliances. It's sterile, like a hospital. Once I saw an onion out of place in his aluminum kitchen cabinet. (Laughs.) It was a relief.

New York is full of paradoxes. It is the center of one of the world's great powers, but its buildings are deteriorating, there is incredible noise, you are preyed on by hoodlums. On the same day you can go to a museum and enjoy an exquisite Vermeer, and minutes later be mugged in Central Park.

The city is democratic. So many minorities and nationalities are at home here. Rich people ride the subways and rub shoulders with poor people. They share everything—even the garbage. You can see the extremes of grandeur and misery—the jet set and the slum dwellers living side by side.

In New York you can create your own style. You can be yourself.

171

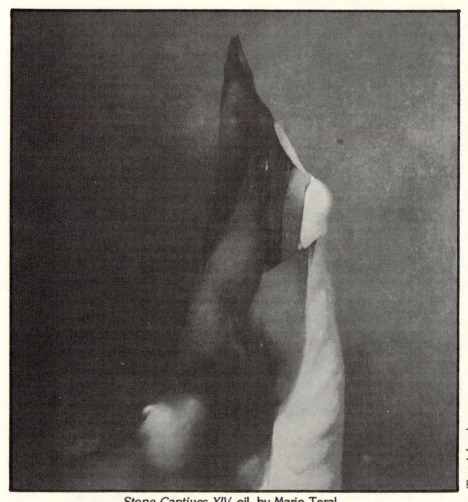

Stone Captives XIV, oil, by Mario Toral.

(Eeva-Inkeru)

172

More than 2,500 people have been killed in rightist-leftist violence over the past two years and the toll is growing . . .
 The New York Times, *February 17, 1980*

Turkish novelist and journalist Yashar Kemal, who was imprisoned by the Fascist junta in 1971, explains in an interview with Herbert Mitgang, why he has left his native land.

Now Turkey is again under martial law, and a number of prominent liberal professors and writers are in danger. Some have been assassinated. Ceyhun Can, a poet and lawyer, was murdered in Adana, my homeland. Abdi Ipekci, editor of the Istanbul daily Milliyet . . . was killed. The police found a list of Turkish writers marked for liquidation by a fascist gang in Istanbul. My name was included . . .

I'm not afraid of prison but I don't want to be killed accidentally on some street corner. I have many things to write yet . . .
 The New York Times Book Review, *April 27, 1980*

173

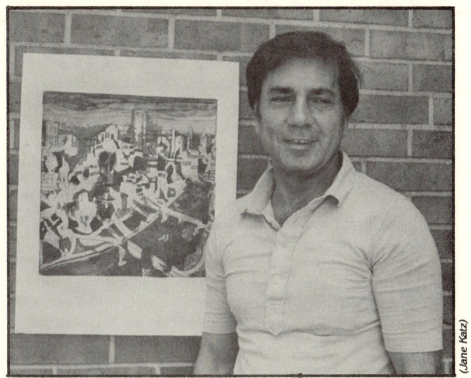

Gunduz Golonu with print, *Minneapolis Skyline*

(Jane Katz)

Gunduz Golonu
Print-maker from Turkey

"In America, I am reborn."

The work of Turkish artist Gunduz Golonu has a timeless quality, for it blends ancient Islamic art traditions with contemporary art techniques. Trained in Istanbul, sent to Paris in 1967 on a Turkish government scholarship, Golonu learned the intricate color viscosity print-making process. Returning to Istanbul, he served as professor at the Academy of Fine Arts. His work has been exhibited in Istanbul, Paris, Brazil, Egypt, England, and the United States.

In 1979, Golonu emigrated with his family to this country, where he has served as artist-in-residence at Midwestern universities and on the West Coast. Having learned English only since coming to this country, he speaks haltingly, tracing his ideas in the air with an artist's expressive hands, frequently calling on his wife Yildiz, an artist in her own right, to supply the elusive English expressions. He speaks passionately of Turkey, the country he still loves, and of the bewildering circumstances surrounding his departure.

<div align="right">Interview. January 19 and 26, 1980</div>

I am living now in America, in exile. I am lucky to be here, lucky to be alive. But many times I ask myself, why am I here?

Silence then, the depths in his eyes conveying more than words can.

It is hard to talk in English, hard to find the right words. People are not patient. They want answers and you feel you do not satisfy them. So I do not speak much. I paint.

Silence again. He is hesitant to venture into uncharted territory. But questions about his early life release a wellspring of memories, and he sallies forth.

My childhood, I remember very well. I was born in 1937 in Canakkale. This is a small city in Anatolia [Turkey]. It is on a channel which connects the Marmara Sea with the Aegean.

I remember mountains. And sunlight on deep blue waters. Clarity. Every kind of fish in the water. When I fish, and the fish touches my line, I feel the vibration, movement, life. I feel a connection with the fish.

I remember donkeys and camels, caravans going to market. The houses whitewashed, with tile roofs. Ancient temples with stone columns. Mosques, minarets. Everybody in our town was fisherman or farmer. My relatives had gardens and fruit trees—mulberries, apricots. Many vineyards. I loved to watch the Greeks make wine; they dance on the grapes, crushing them with their feet in rhythm. The whole district smelled of wine.

My father, he worked as official of the Department of Agriculture. He traveled all over to villages and cities. I remember, before my mother and father divorced, when I was five years old, the first fighting between them was because of me. I wanted a pencil. My mother says no. I

wanted to draw. I didn't see any pictures in the house, but pictures came to my mind. I found somewhere a pencil and I drew on the wall. But I wasn't punished. My father was very quiet with me. He always wanted to be a painter, and he hoped I would be one.

After they divorced, I lived with my father in a little village, Imroz, near the Dardanelles. Evenings, we went to a coffee shop in the village square. No women there; they stay at home. My father brought me paper, and I made a copy of a picture hanging on the wall. A landscape. I was so excited.

In school when I was six, I made a reproduction of a Dutch painting. I remember the figure of a train and the port of Holland. I reproduced it very seriously. The students and teacher praised it, and, after that, I never stopped drawing.

Then I went to live with my grandparents in my mother's village, Canakkale. They were old people, very religious. My grandfather worked in the mosque. I went to school, but I could not study. I play, I fight, I dream all the time—impossible things. So funny. My father used to show me pictures of Ottoman Turks fighting battles with swords and shields and horses. "Look, these are your ancestors," he said. Then when I was angry with someone, I would sit in the class and think, "My great-grandfather's army will come and help me defeat him." I felt very powerful—like Superman!

My father moved to Istanbul, and he brought me to my aunt's house. He said to her, "Here's the dreamer. He's nine years old. He doesn't study. He plays all day. If we send him to school, he will be all right. If not, he will be a gangster— he will need a horse and sword." And he left me there. My aunt disciplined me, very serious. I must be in by five-thirty: "Stay in the house and do your homework." But I didn't study. I just sat there, dreaming.

Gunduz Golonu

My father came sometimes and took me to museums. We saw paintings and sculpture. I remember wonderful Greek and Roman statues—their heads had been knocked off. The early Christians turned against their gods and destroyed their idols. The first iconoclasts. All over our city, these beautiful statues still stand, all without heads. We went to palaces and churches, we saw mosaics of the Greek, Roman, and Byzantine periods. Colors like jewels: lapiz lazuli blue, pomegranite red.

Once, I found a piece of stone on the street—limestone, very soft. It resembled a human head. I wanted to do sculpture, but I had no material for carving. So I used a knife. I found a saw and hammer. I cut the piece, gouged out eyes with the hammer. When I thought it resembled a human head, I buried it under the ground hoping that one day it would be discovered by archaeologists.

Whenever I tried to do art I was disappointed, for I had not the materials.

The next year, I went to live with another aunt on the Dardanelles. I went to secondary school. My friend was beaten by the teacher, so I made no trouble. Again, I wasn't studying. Oh, the landscape of the Dardanelles. I was in a dream.

I used to sit on the grass watching the men making pottery. It was for their own use. They used a wheel and put their pots in the sun to dry. They glazed them, painted on them designs of fishing boats, sultan's palaces, flowers and birds. Beautiful. A man would work one month to make one cup, then reproduce it by hand. Now the people make pottery very quickly, just to make money. It is not good quality. And they are just as poor as before.

So much of the old culture is lost. People are not interested in the past.

In our village, I did not see sculpture. But one day in a shop, I found a copy of the head of *Venus de Milo*, and I

179

went crazy. In high school we had plaster. I tried to model this head, but the plaster dried very quickly before I could give shape to it. Another disappointment.

After high school, my father sent me to the Turkish Academy of Fine Arts in Istanbul, a great center of art. I liked to draw the human figure. But in our Moslem religion, drawing the human figure is not permitted. Our sect, the Sunni Moslems, is very conservative. We picture abstract shapes, decoration. No figure, no. Artist must not try to be creator. That is for God. But at the Academy, there was a nude model every day. This was revolutionary.

Artists at the Turkish Academy of Fine Arts were influenced by Western art, especially the Parisian abstract school. Following the revolution led by Ataturk in the 1920s and 1930s, Turkey was modernized. Ottoman culture was suppressed. Religious fanatics were hanged or expelled. Women began to throw off their veils and to come out of the kitchen.

But to cut all ties with the past, this was extreme. My professor at the University of Istanbul said, "Go back to your sources. Look at the Ottoman miniature paintings. Look at the patterns and details, the leaves on the trees. This I did. I liked the geometric order of figures, the colors, light and dark values arranged according to a pattern. On this foundation, I felt that I could build anything.

Now, a visual feast as we look at reproductions of miniature paintings of life in the Ottoman Empire. There are colorful depictions of life in the Sultan's court: daily rituals and ceremonies, processions, military exploits, as well as interpretations of Islamic legends. I ask about the absence of women. "They are off in the palace doing their embroidery," Gunduz says.

So I had this wonderful tradition. I wanted to establish

180

continuity. But these paintings are of another time. My problem was to find a new kind of expression of my own day to give to the people. In Paris, I studied with Stanley William Hayter, and I learned the color viscosity process. I etch designs on copper and zinc plates. I apply all the colors at the same time. Because of the oils and the inks, the colors do not mix.

You want to know about my style? I will show you my work.

On a table, Gunduz spreads out his prints: his impressions of mythological mountains high in the sky, bird's eye views of the Black Sea, the Aegean and the Bosphorus, of Troy and Byzantium. The colors are luminous. The shapes evoke images of another time and place, yet are tied to this world.

In many of these works, the motifs come from the Ottoman miniatures. I look to nature from far away, from above, as if from an airplane. The vertical lines suggest lines of figures in miniatures. Arcs suggest domes and minarets. Hints of mosaic patterns of Arabic calligraphy, but this is often unconscious. This one, Istanbul. Many cultures, old world and new, come together. Mosques, palaces, monuments, Turkish baths, winding streets, village squares. Byzantine, Greek and Ottoman styles all mixed together. The texture of the city is chaotic. The colors: sienna brown, citron yellow, vermillion red, Prussian blue.

In my recent work, I blend colors to create new colors. You see geometric shapes, abstract forms in motion. Everything in space has movement. An artist must seek new shape and composition.

I visit galleries, and I find new ideas. Frank Stella, he works with liquid acrylic, poured acrylic. Many shapes and colors. He catches the nature of the material. The sculptor George Segal, he is my favorite. With plaster he builds the

human—it has no color—and he builds around the body the environment. Contrast, contradiction. Interest in relationships. This is life.

Taking something ordinary and making of it an object of art, this is creative. Picasso drew a woman's face with two noses. A new way of seeing. It is a question of courage. Because your artists do not have old tradition, they are free. They create out of their imagination. Everything comes from within themselves.

In Turkey today, old and new exist side by side. In Istanbul, you see automobiles and donkeys. Migrating tribes come to the city riding their donkeys, wearing headdresses and elaborate dresses they weave themselves, just like their ancestors a thousand years ago. They sew mirrors on their dresses in a pattern. They carry all their goods in carpets on the donkey. In beautiful designs on the carpets they explain who they are, their family and social position in the tribe. But in the city they become slum dwellers. They live in shacks and are not respected. They give up their old traditions. It is a tragedy. Their art will die out.

Anyone who is different in Turkey has a hard time. Homosexuals especially are not accepted. They do not dare to admit what they are. In the villages, women still work in the fields. They are beaten by their husbands. In the cities near universities, it is better—they are getting education and jobs. My wife, Yildiz, is an artist. In Turkey, she helped me with my work. Now she wants to work, to be independent. This is good.

The Koran sanctions polygamy, although this practice is not legal today in Turkey. According to the holy book of Islamic law, a man was permitted to have four wives if he was able to provide for them. I ask Gunduz how a modern Turkish man feels about this.

Naturally, I would like to have a harem. (Laughs.)

The Turkish people are devoted to Islam. Before they build a school, they build a mosque. And many pray to Allah five times a day. We do not. Our religion does not have much ceremony. We believe the spirituality is inside you. It is unfortunate—politicians of the Middle East use religion to gain power. But the Moslem religion is of the spirit world. It should not be mixed with politics.

In Turkey, our summer home had an olive grove. Every morning we had breakfast of apricots and figs in our garden. In Istanbul, we had an apartment with a terrace overlooking the Bosphorus. But all around us, much poverty. Turkey has no industry, no economy. Agriculture, yes, but even the fertilizers are imported. The people have nothing, but always they hope for better life. So easily stirred up by politicians—one day, the left, next day, the right. Many groups fight for power.

In Istanbul, it was not safe. Terrorists attack writers and university professors. People are put in prison because they say what they think. I was not political, but people knew that I had friends in America. In Turkey, there was much bad feeling against America.

We were packed, we were leaving soon for the United States. I hoped to find work here. A man telephoned our apartment many times, and when my wife answered, he said that I would be killed. She was frightened and did not want me to go out. One afternoon, a man forced his way inside. A big man. I never saw him before. He pushed my little girl out of the way, and she started to cry. I said, "Don't touch her again." He turned on me in anger and rushed at me with his knife, stabbing me many times in the chest. I didn't feel anything, but I was bleeding. He ran out, and my wife called the ambulance. The police investigated and they found the man, but he went free.

I believe the attack was planned. By whom? I do not know.

The knife went deep into my lungs, and I was in hospital for many months. The doctors feared for my life, but I never believed in death. As soon as I was able to travel, we left at night, taking very few things with us, and took a plane to the United States. Friends helped us survive, helped me to find work. I am grateful.

I love my country, but I will not go back—they would kill me. I close the book on that part of my life. In Turkey, I lost everything.

In America, I am reborn.

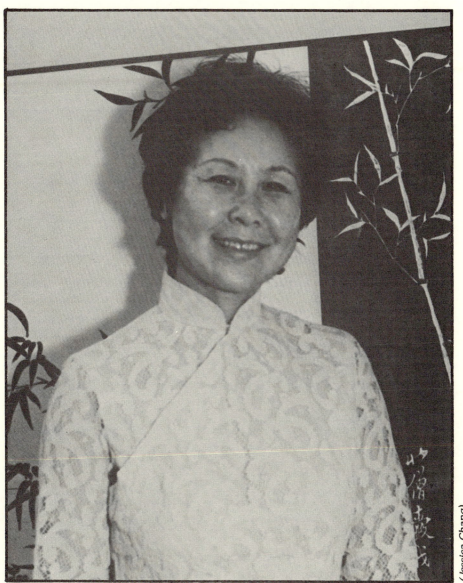

(Jessica Chang)

Lucy Liu with ink drawing, *Universal Peace*

Lucy Liu
Painter from China

"The world was upside down."

We drink tea in her colorful studio home in Seattle. In a corner of the room, an orange tree blooms. On the wall hangs a beach relic, an aged, curved, barnacle-encrusted tree branch. On a table, a cluster of dahlias waits to be sketched. In an elegant rosewood chest are displayed ancient stone incense burners and jade carvings.

Surrounding us are Lucy Liu's art works: ink rubbings, silk screen prints, stone cuts, traditional brush paintings of landscapes, flowers, and birds. Her work is fresh and original, combining oriental motifs with contemporary styles and techniques.

Lucy is warm, earthy, and pragmatic. She has lived through pain and has emerged with her sense of humor intact. She speaks with profound emotion of the obliteration of arts and traditions during China's Cultural Revolution.

<div align="right">Interview, August 21-22, 1981</div>

My parents were engaged when they were just five years old. The grandparents arranged the marriage. Family members had a big celebration. My mother told me she peeked out of the window, and saw this little boy with a long pigtail playing with the other kids, and she knew he was to be her husband. She was shy. The other kids laughed at her. They were engaged for twelve years, and they could not talk to each other during that time.

My mom was educated in Chinese classics. She was very smart. She studied five years with a tutor, then it just stopped. In those days, they didn't want a woman to know too much, for she might begin to question. People would say, "A woman is more virtuous without knowledge." That was an old saying which, fortunately, my parents didn't believe in.

But all the Chinese girls learned sewing and embroidery, cooking, and other things to prepare for marriage. A woman was expected to stay home and take care of her husband. You were taught that according to Chinese philosophy, first you obey your father, then your husband. My mom did that. I believed in it when I was little. When I got older, I thought it was unfair.

My parents were just seventeen when they were married, and my mom was really afraid of men. But my dad was very gentle. You know, we had this old saying: "When you go to bed at night, you're husband and wife. When you wake up in the morning, you're friends." You express your emotion in bed—but only there. During the day, you treat each other with dignity and respect. Of course, with all the relatives around all the time, you had to be reserved.

We had a big family, and all the generations lived together in one house. This caused lots of problems. For example, when my mother was married, she brought my father a large dowry, and his brothers' wives were jealous of her. When my father's father died, they blamed my mother; they said she brought the family bad luck.

The women had to get up early, prepare tea and meals for the older people and serve them. You were taught to respect the old people, to take care of them. Now it's changing. The kids go off on their own and neglect their parents. It started with the Cultural Revolution, this discarding of the old traditions.

My father was a kind of philosopher. His family was wealthy. His father was a doctor. He was used to being taken care of. My mom urged him to make a living, and he became a veterinarian, practicing medicine using the old folk medicines and remedies.

I was born in 1927 in Mukden, Manchuria. My upbringing was in some ways traditional. I learned to play the *ku-ch-'in* [zither] and to do calligraphy. We made much of our own clothing. Mother followed a lot of the old Buddhist customs. We burned incense to the gods. She believed that the god of earth protects all living things. When my brother and I fought and made trouble, she'd make us kneel in front of the "kitchen god," a paper statue, and she'd ask him to forgive us. But pretty soon we'd forget and go on fighting. I never did believe in all those superstitions.

In school, I could pass without studying. But at home I was very ambitious. I wrote poetry and stories. I read a book about Madame Curie and I wanted to be a scientist. I was a dreamer—I wanted to be a doctor, a writer, a painter. I was drawing and painting all the time.

I didn't talk much, but I was a leader. I always had ideas and energy. I didn't like doing the delicate things a typical Chinese girl did. I was more like a boy. If we went out in a rowboat, I would row.

The Japanese occupied Manchuria in 1931. They appointed the last ruler of the Manchu Dynasty Chief of State, but his was a puppet regime, under Japanese control, and lacked popular support.

We hated the Japanese. They really looked down on the Chinese people. They paid Chinese to spy on their own people. They took our food, all the soybeans and white rice, they left us the worm-eaten crops. They destroyed old temples. You had no space in Manchuria. One of my brothers ran away and joined the underground working against the Japanese. Most of the educated young people did.

I wasn't interested in politics. My life was so full. When I was seventeen, I was working in a bank, I was taking a painting class, and I had a radio program two evenings a week. I sang folk and popular songs. My picture was in the newspaper. People used to come up and ask for my autograph on the street. This bothered me, so I took the bus.

I wrote some songs. Once I wrote a play.

Then I met my husband. He was in the Kuomintang Air Force. Very cool. Didn't pay much attention to me. But when I was sick in the hospital for two months he came to see me, and I was so grateful, I wanted to repay him. When he asked me to marry him, I accepted. We got engaged. I didn't feel right about it. I didn't love him. I couldn't sleep at night. But breaking an engagement, this is so embarrassing for a Chinese family.

We got married, and went to live near his base in Taiwan. My husband was a stupid man, and very selfish. When I tried to talk to him, he just criticized me. But my training was old-fashioned. You don't walk out so easily. That was the 1950s, and divorce was considered immoral. I felt ashamed to leave him. You just bear it.

When I was pregnant with my first child, I was so lonely I wanted to go home to my family. But that was impossible. The Communists were in Manchuria. The world was upside down.

I tried to kill myself, but I couldn't go through with it. I tried to have an abortion; I went to see a doctor, but I was very sick with malaria, and he said it was too dangerous. I

had the baby. She almost suffocated in childbirth, but she lived.

My husband and I were still living together, but he was running around with other women. He didn't provide for us. When my little girl was three, I put her in a nursery and went to work as a kindergarten teacher at the Air Force base. Then two more children were born. I bought a bike. I put one child in front, one in back, and went to work. The youngest stayed at home. Neighbors looked in on him. I would come home and feed him at lunchtime.

After a few years, my husband and I separated. I kept on working to support the family. I wrote some articles for a magazine. I went to college and studied Chinese and English literature, and Chinese brush painting.

In 1972, I was working in Taiwan with a professor from the University of California. We were researching Chinese folklore in the countryside. He arranged for me to come to Berkeley the next year. My husband agreed to a divorce. I had saved some money, so I took my three children and came to the United States.

I was working in Berkeley, and going to school. It was so hard. I was embarrassed because my English was very bad. And I worried that if I got sick, I would not be able to support my children. I felt so lonely for my family in China. All the years I was in Taiwan, I sent them money, but I could not get out of Taiwan after the Communists took over. My parents wrote to me—official letters. They wrote that they had a good life under the Communists. But I knew things were bad.

Finally in 1977 the political situation improved and I was allowed to visit China.* It took four months to get a visa. When I got to Mukden, my father was dead, my

*China's Cultural Revolution lasted 10 years, ending in 1976 with the death of Mao (Mao Zedung).

mother was dying, the house was almost empty. My mother told me all the things that had happened to them during the Cultural Revolution. It hurt me so much, I went to bed for days and could not get up.

So many of my old friends and relatives were gone. My mother told me they had been killed by the Communists. People who had been educated were now doing farm labor and factory work. Their children were growing up without any knowledge of their heritage.

My mother told me that during the Cultural Revolution, there were five ways to get in trouble with the Communists. If you had property, they said you were a Capitalist. If you were middle class, they said you were subconsciously anti-Communist. If you had a car and nice clothes, that meant you liked luxury. If you were educated, especially if you were a professional, they would denounce you.

Members of my family were hard workers, but they had all the things the Communists said were evil. The kids were insulted when they went to school, so they didn't want to go. The Communists took most of our property. They let my parents keep the house.

The Communists didn't know anything about farming. They bungled the agricultural reform, and the harvests were terrible. They took away the people's animals, and the people starved. My mother told me that they ate grass and bark from the trees.

My mother was a smart lady, and she knew how to survive. She was good to people, and no one reported her to the Communists. She read Mao's *Little Red Book* and used it to teach all the neighborhood children. But my father had a hard time. He had joined the Kuomingtang during the Japanese occupation, and the Communists never forgave him for it. They criticized him because I had been living in Taiwan. They said I was a spy for the Kuomintang. A lot of stories.

You know, in our country it was a tradition for young people to work for their parents and to take care of them. But the Communists discouraged this. We had no health insurance or social security, so a lot of old people lived in terrible poverty. Some became beggars. Many committed suicide.

My aunt was accused of being a spy for the Kuomintang, and the Red Guards came to the house. They forced her to kneel on a brick for hours while they questioned her. The pain was so great that finally she confessed. A few days later, she had a heart attack and died.

My brother, the one who had run away to join the underground, came back to Mukden and the Communists put him in prison. Then Communist officials called in his wife. "Take his clothes home. He will not be going home," they said. The family never saw him again.

My older brother had an argument with a man he was working with. That man reported my brother to the Communists, and he was poisoned.

My parents felt so helpless. They had worked so hard just to survive. Their two sons were dead, and I was gone. My mother had eleven children to look after: grandchildren and the children of relatives. All those mouths to feed. They had financial troubles.

Then the burnings started. My family received a message, "Tomorrow the Red Guards are coming to search your house. You have twenty-four hours' notice. Burn everything, all the books and art, or you will be in trouble." So my parents built a fire in the yard, and they burned my mother's embroidery, all the old classical books, even a translation of *Romeo and Juliet* that my mother loved. They burned all the drawings and paintings I had done since I was a little girl.

Just one thing my father tried to save—an old-fashioned book of herbal medicines his father had left him. My

mother hid it under her pillow. But then the Red Guards came, a group of neighborhood kids, and they found the book. My father begged them to let him keep it, but they refused.

We had a beautiful ceramic vase from the Ming Dynasty. My mom used to save coins in it. The Red Guards made my mother smash it. They laughed and said, "Does it hurt?" She had to pretend that it didn't.

My father felt that he wasn't head of his family. He was insulted by neighborhood kids. And he worried about what had happened to two of his friends, an old man and his wife. The Red Guards forced them to stand up on a table outside on the street, and to wear paper caps with words written on them: cow, snake, ghost, devil. This meant that they were less than human. People crowded around, yelling, spitting at them, the kids threw stones. The old man came to our house and said to my father, "It is terrible to be shamed like this. Your son sees you. Your grandson and other relatives throw stones. I want to die," he said.

Oh, I shouldn't talk about the Communists.

She has told more than she intended to tell. Old wounds are opened, and she cries. She is silent for a while, then resumes her story.

A few nights later, my mother was busy making shoes. Embroidered shoes? No, no. Embroidery is for Capitalists. (Laughs.) Plain cotton shoes. My father left the house without saying anything to her. He was afraid the Red Guards were going to come for him. He went into the barn and hung himself with his belt.

My mother told me that she had his body removed. She had to tell people that he was a coward, and she was glad to be rid of him. She had to preserve that lie to survive.

I stayed in Mukden for six months, until my mother died, and then I returned to America. I moved to Seattle. I got a

master's degree in teaching, and I taught in a community college. I was supporting myself and the three children. I did traditional Chinese brush painting. I had exhibits, and people bought my paintings.

You know, people said I should stick to one thing. I was painting fish, and they called me the fish painter. Then I started painting flowers and they said my work was too sweet. Pretty soon I started painting what I like—combining the old way with the new, Eastern techniques and Western ideas. I used traditional materials, but I developed my own style.

In China, an artist does one thing. You are a landscape painter or a flower painter. But here you experiment. You use your imagination. You can do anything. You transform a human being into a tree. It's good for your art.

When I first came to America, I was shocked by all the freedom. In Berkeley, you'd see women wearing tight clothes and miniskirts on the street. Nobody shouted at them. On Telegraph Avenue, you'd see men with bald heads wearing Buddhist clothes. You'd see men with beards and hair down to their shoulders. In China, they would be harassed by the police.

And all the sexual freedom. In China, love and sex are considered unrevolutionary. People will talk about you and report you if you do anything. It's a giant security system. You have to be secretive. You have to hide. Taiwan is more open than mainland China because of the American influence. People do everything there that you do here, but they don't talk about it.

In China, and even in Taiwan, if you're warm and friendly with men, people will say you're easy to get, and men may try to rape you. In Taiwan, because I was around Americans so much, I was friendly with the men I worked with, and some people said I was being seductive.

194

Lucy Liu

Here, you can be honest, you can be natural. People leave you alone. You have privacy.

But there is one thing about Americans I cannot get used to. The way they treat old people. I feel so sorry for them. They spend their lives bringing you up. Then they are ignored, pushed aside. The kids talk back to them.

My son and his wife live with me. He's an engineer. They clean and do the lawn work. I pay the mortgage and cook for them. We combine the Chinese and American style. I told my son to go and live by himself. But he feels ashamed to leave his mother alone. He told his wife, "No matter what my mother has done, I should take care of her." (Laughs.) That makes me wonder what I did wrong.

I'm happy now. I have my family and lots of friends. I have a good education. I love to teach. I love to paint. I am writing a book about Chinese brush painting. I want to do everything. I'm still very ambitious. I suppose I'm very Chinese.

East and West, ink drawing by Lucy Liu.

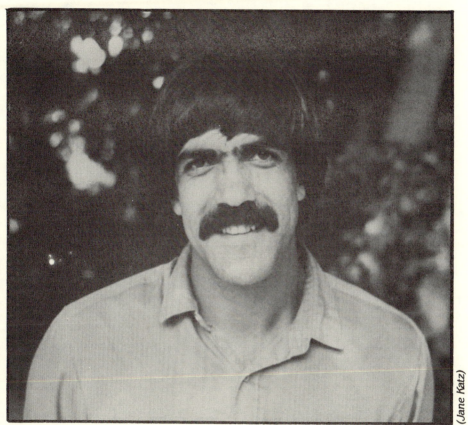

Aziz Mujadedy
Painter from Afghanistan

"We have always liked to be free."

Aziz Mujadedy is a member of a family well known in Afghanistan for dissent against the political regimes of the last two decades. He came to this country in 1975 on a student visa, and, because of political turmoil at home, he cannot return. "I would be killed," he says.

In Afghanistan, Mujadedy painted scenes of everyday life in the countryside, recording a way of life unchanged through the ages. Without any training or exposure to art movements, he developed his own individualistic style, gradually moving from realism to surrealism. His colorful and often startling images, executed with meticulous attention to detail in paintings, charcoal drawings, and political cartoons, are sardonic comments on society.

He is tall and swarthy, his rugged build contrasting with his gentle manner. He speaks softly, searching for the right words to tell the story of his beleaguered nation. About his future as an artist in this country he is optimistic. His humor is whimsical, his laugh robust. But his eyes reveal the sadness of being in exile.

Interview, July 18, 1980

Aziz Mujadedy

My name is Aziz Mujadedy. I was born in 1953 in Kabul, the capital of Afghanistan. My family is middle class. We are religious people; we are Moslems. Before the Russian invasion there were thousands of members of the Mujadedy family living in Kabul and in other cities and villages in Afghanistan. But so many have been imprisoned or killed or have fled the country. Now I think that there are not more than 100 members of my family living in Afghanistan.

I do not want to talk too much about my family for I will seem proud. But a little, this is OK.

One of my uncles was a Professor of Logic and Parsi* Literature at the University of Kabul. He wrote books on Afghan literature. In the 1960s, he was president of the Office of Education. At that time, the government received some support from the United States. President John Kennedy invited my uncle to visit the White House.

My mother I love and respect very much. My father speaks five languages. He educated himself. When he was young there was no university, so he had to read and study by himself. He was hired by the Office of Education to write an encyclopedia. He completed most of the books, and then they transferred him to another job, said he was getting too famous. This hurt my father very much. Now he is retired.

I grew up in Kabul. We traveled to the villages to visit our relatives. There are wild flowers and fruit trees, wonderful grapes and melons. Most of the people are farmers and sheepherders. They live in stone and adobe houses. Each house has a hujrah, a separate room for sleeping and entertaining guests. It is our custom to take off our shoes in the doorway. Then we sit for many hours in the hujrah, drinking from big pots of black and green tea, listening to the old men tell stories. Old people are respected in our country.

*Descendants of the Persians.

From the villages you can see the dry, sandy mountains. There are animals, pheasants, gazelles, and other wild birds there. Springs run down the mountainside. At the top, the peaks are covered with snow. It is very beautiful.

But today on the mountain ridges, you can see the tents and bunkers of government troops that have been sent in to put down the rebellion.

We went to weddings in the villages. Hundreds of people come, no one is turned away. The women wear dresses with full sleeves and jewelry they have made themselves. Some still wear the chaderi, a long dress that covers them from head to toe—you can see only the eyes. The men wear baggy pants with a long blouse like pajamas, and turbans. They wear a bandolier across their chest to show their bullets. This is a symbol of national pride. They are defenders of their nation. The men dance the attan, a circle dance. They clap hands, turn, sing and yell while musicians play the dol, a sheepskin drum. Very exciting, much spirit.

The cooking goes on for days. The women cook *kabli palau*, a main dish. First you cook the rice, then you drain it. You fry raisins and nuts in oil, then add this to the rice. Lamb, chicken, or beef you cook separately with onion. When the meat is soft, you mix it all together and bake it in an oven for twenty minutes. It is very good.

At picnics, the men cook sherba, a stew made of meat and potatoes and vegetables, in a big pot over a wood fire. The people eat it with bread with their hands. But you must wash in the river first. That is civilized.

When I was in high school I started drawing and painting. I was out of school for one year because of hepatitis, and I did a lot of drawing. I had to express myself. Art is a way of talking, another language to express your feelings, your way of looking at things. Some people become writers; I became an artist. I had no training. There were no art schools to go to. People in the villages made jewelry and

200

carpets, but I did not know any painters. I did not go to any museums. I had a museum in my head. I painted the faces of the people, nomads, caravans in the desert, the mountains. I painted my image of the holy world in bright colors—blues and purples. My father taught me if you think too much about God you will go crazy. The search for God I expressed in my paintings.

I put my culture into my paintings. I sold some; most I gave away. Those paintings, they belong to my country.

After high school, I did not know what I wanted to do with my life. I had no direction. If you are poor and you don't know the right people in Afghanistan, you cannot get into the university, and you cannot get a job. Thousands of kids just hang around on streetcorners with nothing to do. I was one of them.

I lived at home with my parents so I did not need much money. I began to be very serious about my painting. I was not so interested in technique. Subject matter was the most important thing. To paint what I saw or imagined. Materials were expensive, but we had junkyards, what you call flea markets and I went to them and bought paint and brushes, and sometimes clay for sculpture.

As I got older, my way of painting changed. I began to paint the strange images that were in my head. My dreams. Surrealistic. It was not like anything I had seen before. Sometimes I thought I should go to the university to study, but how can you study art? It comes from your own mind. It has its own logic. If you have something to express, you just do it.

One painting I did in Afghanistan I call *The University*. There are separate rooms, with all kinds of strange different people wandering by themselves. They are lost. It is as if they are in prison, and trying to get out. They are searching for something, but they are not sure what it is.

Sometimes I see this universe as a prison.

For maybe as long as twenty years, my family has been against the government of Afghanistan. When I was young, there was a king. Always I heard stories of how the king cared only for himself. He had big banquets for parliament members, fed them a good dinner and then told them what laws he wanted them to pass. The country did not grow economically. There was terrible unemployment and poverty. So much corruption. Without paying someone a bribe it was hard to get a job, a driver's license, or official papers. Nothing worked well in the country.

One time, during a drought—our people were starving—food shipments came from the United States and other countries and were delivered to the border. But the food was sold by government officials in Pakistan. It never reached the hungry people. My father was working for our government then, and he asked for an investigation, but nothing happened.

In 1973, a cousin of the King, Muhammad Daoud, made a coup against the government and took power. He promised to bring "democracy" but he was no better than the king. Anyone who was against the government was put into prison. And the jails are horrible places. There is torture. I remember going to the funeral of one of my relatives who was a political prisoner. They brought in his body, and there were chains on his legs.

The people of Afghanistan, we have always liked to be free, not to be controlled by anyone. When the Russians tried to gain power in our country in the nineteenth century, and the British tried to take us over, we went to war and threw them out. The government of Mohammad Daoud tried to build highways and subways leading to our villages. The tribal leaders met in the marraka, the tribal meeting. They put down their guns, they sat cross-legged in a circle and talked over the problem. They said, "These roads are dangerous for us. The government will use them

to control us. They will try to change our culture. They will make us go into the army. We do not need to join the army. Always we have fought to protect our country." And when work started on the roads and subways, there was sabotage. The people attacked the road crews and equipment and the work had to stop.

Many people said that the Daoud regime had financial support from the Soviet Union. One of my relatives who was a university student made a speech in the big mosque in Kabul. He said that our nation was in danger from the Marxists. He said that the religion of Islam was in danger. They put him in prison for making that speech.

Religion is woven into the fabric of daily life in this nation of 18 million people, which is 99 percent Moslem with the Sunni and Shi'ite sects predominant. The word Moslem means "one who submits." Moslems are taught to follow the teachings of the Koran, their holy book, to worship a single, all-powerful God whom they call Allah, and to emulate the exemplary deeds of Mohammed, the prophet of Allah.

There are maybe as many as 70 million Moslems in the Socialist states. The Islamic movement is growing more powerful. This frightens the government, and so they try to weaken the influence of the mullahs, the religious leaders.

The mullahs said we should unite, we should fight a jihad, a holy war against the Marxists. They said it is right to die for your faith and your country. You must believe in your cause, they said.

But the Afghan tribal leaders fight each other for power. Sometimes a mullah will offer weapons and other bribes to any tribesman who will follow him to attack a fort. "Loot, love, and land"; these, the people say, are the cause of trouble. While the mullahs were busy fighting each other, the Marxists came to power.

Mujadedy left the country in 1975. In April 1978, the Daoud regime was overthrown in a bloody coup, and replaced by a Marxist regime. The revolutionary government proposed reforms which threatened the autonomy of tribal and religious leaders, who then intensified their rebellion. For failing to subdue the Islamic revolt, this and another Marxist regime were overthrown and a puppet government was installed by the Soviets. Soon, heavy artillery and tanks were rolling into Kabul, and thousands of Soviet troops took positions throughout the countryside.

One of my relatives was a professor of Islamic Culture and Philosophy at a University in Egypt, but he came back to Afghanistan to lead one of the rebel groups. The word passed very quickly. The people were angry about the invasion, and they risked their lives to follow him. The rebels took over the city of Herat for two days, but the government bombed the city. Homes and schools and beautiful old mosques were destroyed. Then they dropped parachute troops from big helicopters. Hundreds of Russian tanks moved to the hillsides and shelled the villages. Many of the rebels were killed. Many went to prison. Some were lucky and escaped. From their base in Peshawar—this is just across the border in Pakistan—they go on fighting.

The rebels—they are called *mujahids* (crusaders). They come from all over, and from all classes: farmers and sheepherders, teachers and doctors. Young boys fight and old men with beards. They wear their black turbans, and their bandoliers across the chest. They fight with anything they can find: swords, axes, daggers, World War I rifles, a few helicopters, and armored cars they take from the Russians. Some of the mujahids live in villages. Some live in dugout bunkers outside of Kabul. Their life is hard. They are often cold and hungry. They do not have good training for fighting, not good equipment. Sometimes when they are attacked, they do not have bullets for their guns and cannot

return the fire. But the mujahids do whatever they can. They attack government tanks with Molotov cocktails. They ambush convoys and block roads so that government supplies cannot get through.

The rebel leaders sometimes turn against each other. When they are not unified, they are not strong. When they see their companions killed, it is hard to go on fighting. They know if they are captured they will be tortured. Last year, a relative of mine, just sixteen years old, sent me his picture with all his fingernails removed. They put him in jail and forced strips of wood under his nails. His father and uncles were put in prison, and nobody heard from them again.

It is dangerous to be a member of the Mujadedy family.

When there is a general strike, the people come out into the streets: students, government workers, ordinary people. They carry signs: "Russians go home," or "God is one." Just a few months ago there was a general strike in Kabul. My sister was a student at Rabia Balkhi, an all-girls' school named after a great Afghan woman poet. Almost the entire school marched in the streets to protest the invasion. My sister took a risk to write to me. "The troops fired into the crowd," she wrote. Then she said, "So many of my sisters were killed or wounded." After that, she wanted to get out of the country. Now she is in Pakistan.*

It is hard to know exactly, but I think nearly a million people have escaped from the country. The refugees leave almost everything behind them. They travel across the desert on horseback or by car. Some go on foot, a camel carries a few belongings. Sometimes you see someone escaping with just the clothes on his back. The trip across the mountains takes five days. At the border, if they are

*Mujadedy's sister came to live in the United States in 1981. She is active in the drive to win U.S. government support for the Afghan cause.

lucky the guard will take a bribe and let them through. A few get by—the Soviets cannot patrol the whole border. Those who help the refugees escape carry weapons they make themselves: rifles, machine guns, grenades.

Another time, there was a demonstration against the Soviets in Jadeh Maiwant Square in Kabul. The Soviets fired at the crowd, and many people died. The dead were buried on a hillside near their homes. On each grave they put a small, white flag. Some graves have two crossed flags, one white, one red. This means that one day the dead man's family will avenge his death.

Women, children and old people make the journey. Many die on the way from exposure or exhaustion. Those who do not die arrive hungry and cold, they do not know where to go, they are afraid of what is ahead. It is hard to help all who want to leave. My friend—members of his family had no money, no help, nothing. They just escaped any way they could, and now they are separated, living in seven different countries.

In refugee camps which extend from Peshawar in Pakistan into eastern Iran, the people live in flimsy gray tents grouped together around a river bed, or in lean-tos providing little shelter from the intense summer heat and brutally cold winters. These overcrowded camps, Aziz explains, are breeding grounds for disease and crime.

I have friends in the Bay Area who are from Afghanistan. We have started an organization, the Afghan Refugee Aid Committee. We spend most of our time raising money to send to the refugees in Pakistan. They need food, clothing, blankets, medicines, even water is hard to get. They are desperate.

My brother, my two sisters and two nephews are now in the refugee camps in Pakistan. My parents said they had a future and they should leave. One sister stayed with my

parents. My father is seventy-four, my mother is sixty. They are afraid to leave their old house in Kabul and everything they know. And they are not healthy or strong enough to make the journey. Escape is frightening for old people.

My parents used to write to me sometimes. But they didn't dare to say what they really thought. Just "Hello, we are well . . ." I have not heard from them for months. I worry about them. They live in fear of the future. They are like hostages.

I was lucky. Friends helped me to come to this country. When I first came, I did not know the language, and it was hard to talk to people. I was lonely. I did a painting I call *The Nightmare of Love.*

Another painting is of my parents, old people who are caught in wartime, separated from everyone they love.* There is one I call *The Peaceful Land*: people escape from the conflicts in this "civilized" world and hide in holes in the earth. I became an artist to express what is in my heart. People look at my work and they say, "There is a lot of anguish in your heart. The images are fearful."

Maybe it is true. I must draw and paint what I feel.

My people have lost everything. The Russians say they have come to save Afghanistan, but they are destroying my country. Every week we get reports of a village that has been bombed and left in ashes. We do not want to be saved. We want to be left alone.

I know the people. Until the last Russian leaves, they will go on fighting. This is our way.

*Early in 1982, Mujadedy received word that his mother had died. His father remains in Afghanistan.

"The runner seeks a balance. We start, but we fall down. That's the way I see our life in this world." *The Start Which Never Takes Place*, oil, by Aziz Mujadedy

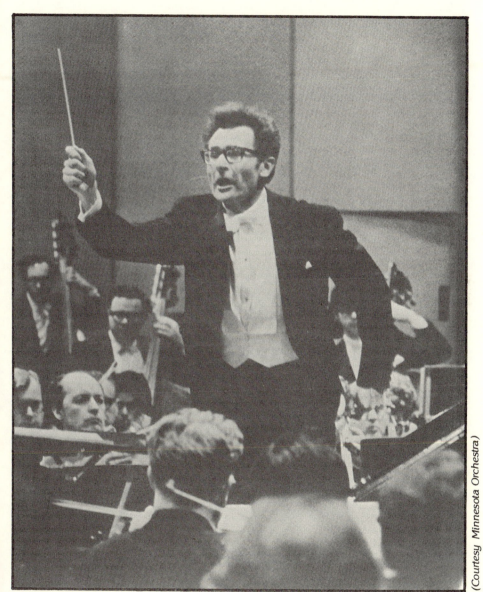

(Courtesy Minnesota Orchestra)

Stanislaw Skrowaczewski conducting the Minnesota Orchestra

Stanislaw Skrowaczewski
Composer, conductor from Poland
"The greatest adventure of my life."

He distinguished himself in his native Poland, winning prizes for composition at an early age. After World War II, he studied composition in Paris with Nadia Boulanger. His symphonic works *Music at Night, Concerto for English Horn and Orchestra,* and others are part of the repertoires of the world's major orchestras.

Following in the tradition of European conductors Mitropoulos, Ormandy, and Szell, Skrowaczewski has conducted symphonic and operatic orchestras worldwide. He served as Music Director of the Minnesota Orchestra for nineteen years.

He is lean and energetic, soft-spoken and genial, the sort of man who opens doors for women. There is no facade. There is an intensity about life and art, and a genuine passion for music. "It is my religion," he says.

<div align="right">Interview, April 19, 1982</div>

Stanislaw Skrowaczewski

In April 1981, Stanislaw Skrowaczewski's *Concerto for Clarinet* had its world premiere with the Minnesota Orchestra, conducted by the composer. The music was at times somber and dark-toned, at times light and fleeting, ending with dramatic, whirling passages. On the podium, Skrowaczewski's body was animated by the rhythm, his hands drew subtle nuances from the performers. He conducted with great precision and restraint. I asked him about the experience of conducting his own work.

> Well you know, when I write something, I really hear it—all the dynamics and sonorities. So when I conduct it for the first time, it's as if I had conducted it before. I don't like to give a very emotional performance of my own music. I'm pretty cold and perfunctory—whereas when I conduct Bruckner I really get involved emotionally. I just feel preposterous doing my own work, like an idiot behaving on the podium as if I adore my own music.

I asked Skrowaczewski about the artistic climate in Poland during his childhood.

> I was born in 1923 in Lwow, Poland, a city devoted to all art forms. There was exquisite architecture—early Renaissance buildings still intact, and Baroque churches. Before the war it was a radiant city in a valley surrounded by mountains.
>
> The fascination with music started when I was a baby crawling under the piano. My mother played Chopin, Rachmaninoff, and Grieg. Under the piano you hear the deep reverberations of the music, the keyboard ringing like bells, tones blurring. Soon, I began sitting at the piano bench and playing. I began studying at the age of four. A young child can play Haydn, Mozart, and Beethoven sonatinas.
>
> I played symphonic scores for four-hands on the piano

211

with my mother and teacher, and listened to symphonies on the radio, and loved the richness of the harmonies. I began putting musical symbols on paper. I started playing the violin and viola at the age of eight, but I was more interested in composing. I began by imitating Haydn, Mozart, and Beethoven. I wrote my first symphony at seven. In my studies, I moved quickly through the nineteenth century, and came to the postromantics.

The first time I heard a performance of Bruckner's *Seventh Symphony*, I was so excited by the music I was sick with a really high fever. My father was a brain surgeon, and he couldn't find anything wrong with me. He must have been thinking, "What kind of a crazy boy is this?" But it was a wonderful sickness brought on by the music. My horizons were opening up.

I gave my first piano recital on the radio at the age of eleven. There was some talk then of my becoming a professional pianist, but I had my doubts because I was also very interested in chemistry and physics.

I made my conducting debut at the age of thirteen. By then, I knew the whole classical repertoire, and was discovering Bartók and Stravinsky. My studies in school were very demanding, but I composed when I had time. I was interested in the process, and wanted to know how conductors developed form and achieved various effects.

In the late 1930s, Poland's security was endangered by the expansionist policies of Hitler's Third Reich. There was a German-Polish, nonaggression treaty which Hitler proceeded to violate, and in September 1939, the Nazis invaded Poland from the West.

We thought we could resist the Nazis, and my friend and I volunteered for the army. We were immediately sent to the front. I saw my friend torn up by shrapnel. I saw bombs tear huge craters in the earth and destroy homes. Our losses were devastating. The Germans kept advancing. When the Rus-

sians invaded Poland from the East, the situation became hopeless, and I went home.

The Nazis began to pull back, and Poland was partitioned into a German and Soviet sector. In Lwow, we were under Soviet rule, and soon the deportations started. It was Stalin's idea to weaken Polish nationalism by diluting the population, so thousands of Poles were deported behind the Urals, while Tartars and Kalmucks were resettled in Poland.

From our city of one half million, two hundred thousand people were deported. Not just Jews, for the intense Soviet persecution of Jews came later. Anyone could be deported, especially professionals—doctors, scientists, newspaper editors, those with the brains and the means to organize dissent. The police would come at night and force whole families into cattle cars. Friends and relatives disappeared, and we didn't understand why.

The Soviets occupied Lwow for two years, and they intruded into many aspects of our lives. But we had a lively musical life during that period. Huge numbers of Jews had come to the city, escaping from the Nazis, and many were musicians. We had four orchestras, and I played in one and sometimes had a chance to conduct.

Then in June 1941 the Germans returned and bombed Lwow. The war lasted one week. I was visiting a friend's home when a bomb struck—a wall collapsed. I was pinned under it. Both hands were broken, the nerves were damaged. My father obtained the best medical care for me, but it was clear I could never be a professional pianist. Since I was never certain I wanted this for a career, I just said to myself, "Forget it," and concentrated on conducting and composing.

There were food shortages during the Nazi occupation, but my father sometimes obtained food in exchange for medical care, so we survived. I knew that at any time I

might be deported to a labor camp. To avoid attracting the attention of the Nazis, I worked as a bricklayer. I kept out of sight as much as possible.

Concerts were permitted only for Germans. If the Nazis found six people together they would shoot them. The Nazis said Polish culture was verboten—but we Poles always had a rebellious streak. Books and music—these were things worth risking your life for. All during the war, those of us who were lucky enough to escape the bombs and concentration camps were painting, writing, composing, performing.

You know, if you are active you have a better chance of surviving any disease. So we mobilized to fight the repression as best we could.

A friend of my father had a large basement, and we met there to play chamber music. At one time, we had a thirty-piece orchestra, with a few people in the "audience." I conducted. We knew that for such violations we could all be shipped off to the camps, but we kept at it.

I was sometimes able to attend classes at the university, and this period was fantastically stimulating for me. There were just two or three students in a class, so you got personal attention. I studied philosophy, art aesthetics, and composition.

After the war was a period of intense creativity in Poland. It was as if people had survived an earthquake and were beginning life all over again.

One of the finest young postwar composers was Penderecki. He experimented with new effects with a string orchestra—all sorts of sounds produced by knocking on wood with a bow, playing behind the bridge, glissandos. He wrote a symphony with spooky effects, ending with a phenomenal explosion. He told me that after completing it he saw the analogy with the bombing of Hiroshima and gave it the title *Threnody for the Victims of Hiroshima*. It was not a political statement—good art never is. It was a

214

profound emotional response to an event that shook up the world.

In Paris right after the war, I studied composition with Nadia Boulanger. She was a phenomenon. She had a mind like a computer. You'd show her a very complicated new score, she'd page through it and in a few minutes she'd say, "Here on page 12, the development of this theme is inconsistent with what's on page 1." She'd spot anything false or superficial. She was a forceful woman, but gentle and sensitive.

I helped to found a musical group in Paris, Zodiaque, which was dubbed avant-garde because we broke new musical ground, but I don't think the label was appropriate. I always believed in building on the past, not breaking with it. John Cage was l'enfant terrible of that period. He was a catalyst for composers, questioning all musical perameters, encouraging experimentation. I thought his music alien, nonmusic, but I admired his intellect.

Within a few years after the war, our country had become a Soviet satellite. I was conducting the Breslau Philharmonic, and I had to follow strict Soviet guidelines. You'd go to see a government official for permission to play a particular work, and he'd say, "It's not my responsibility. Go and see so-and-so." They were afraid to respond. You had to deal with this faceless bureaucracy. If you showed them a composition that didn't glorify the Motherland you could go to prison, so I kept my compositions to myself.

Shostakovich came to Warsaw in 1947. I remember being struck by his warmth and enthusiasm. He returned a few years later, after he'd been viciously attacked by Soviet authorities, and he was a changed man. He didn't seem to recognize anyone. He'd answer questions—"Yes," "No"— but he was nervous, distracted, like a lunatic. They destroyed this great man. He didn't have the courage to emigrate.

In 1958—I was then conducting the Warsaw National

Symphony—I was invited to guest-conduct the Cleveland Orchestra. I spent some time watching George Szell in rehearsal. Some of the musicians hated him for he was cold and demanding and his wit could be caustic if anyone failed to do their best. But I developed enormous respect for him. Because of his exacting standards his was one of the finest orchestras in the world. When he died, a great era of conducting came to an end.

After Stalin's death, the political and artistic climate improved in Poland. I was conducting the Warsaw National Symphony, and we had relative freedom, in terms of repertoire. We played contemporary Western music. When I was invited to become Music Director of the Minneapolis Symphony Orchestra* in 1960, I accepted—not for any political reasons. It was simply an opportunity to explore new musical territory, to conduct a really outstanding orchestra.

From the beginning, I found Americans very receptive to newcomers and new ideas. And I was delighted by the support for the arts in cities like Minneapolis. You know, I think sometimes Americans romanticize about the European's devotion to the arts. People can be provincial there, as well as here. Do you think the German farmer listens to chamber music?

One thing bothered me about this country, and it still does—the constant bombardment of "music" in public places—stores, banks, restaurants. Not to mention all the TV and radio commercials. There's no escaping from it. It dulls our musical senses. I think it calls for an amendment to the constitution.

The first time I went on tour with the Minneapolis Symphony, I was so impressed by the organization. Everything went like clockwork. Every musician showed up and

*Now known as the Minnesota Orchestra.

216

came in on time. And I thought, "This must be American efficiency."

Occasionally I have this horrible dream that I am appearing before an orchestra to conduct a piece I do not know. It is a nightmare. Well, once I was conducting in Minneapolis in front of an open pit, 10 or 12 feet deep. I lifted my baton to conduct Ravel's *Daphnis and Chloe,* which begins very softly—and the trumpets started blaring; they were playing "Happy Birthday." I had forgotten it was my birthday. I was so shocked I almost fell into the pit.

Another time we were playing Mozart's *Hafner Symphony* in a lovely little chapel in a small town in Ohio. I was delighted with the acoustics. We were playing the second movement—soft and lyrical. Suddenly, a loud voice burst forth through a speaker right over our heads: "Will the owner of the green Cadillac parked at the rear entrance please move it?" At first we could not understand the words, and we were stunned. It was as if someone had announced an air raid, and I felt as if I were back in wartime Poland. Once I regained my composure, we returned to Mozart.

After nineteen years with the orchestra, I resigned to become a free lance conductor. Now I conduct all over the world.

Will you return to Poland to conduct during this time of political upheaval?

Well for one thing, they wouldn't invite me now. Secondly, I wouldn't conduct there now for I would seem to be sanctioning the Soviet repression. A year ago, I hoped that the government would achieve some accommodation with Solidarity. When you impose unjust measures on a people, you invite rebellion.

As an artist, have you ever had to make any compromises?

217

(Incredulous.) Oh no. Why? Why? Absolutely not. It would be impossible, I think. If I don't like something, I don't perform it. It doesn't pay, because sooner or later it's obvious that you're dishonest.

When I am not conducting, I devote myself to composing. The crucial thing is to start. If the start is right, the work develops. The music and form are born in a flash of imagination. You wait for the flash. (Laughs.) I hope it comes this summer when I have time to compose.

Are you identified with any school or style of composition?

There are so many trends in composition today: neo-romantic, neo-classical, tonal, atonal. Everything is accepted, and this is fortunate. What matters is not a composer's style but whether or not he or she has imagination.

For a while, you know, it was fashionable to approach the writing of music like mathematics—everything was organized into sequences, with the pitch, color and dynamics serialized. A work might look very impressive on paper, intricate and logical, but it was often empty. The beauty of the sound wasn't taken into account.

For me there is no avant-garde; there is art. I build a succession of notes and chords. The inspiration comes from Mozart, Beethoven, Bruckner, Bartok—the masters. Also from Schoenberg and Shostakovich, and from contemporary composers. But the influences are indirect. As an artist, you develop your own personal musical language.

When I was conducting full-time, I could hardly ever compose. Oh, you jot down a few phrases on airplanes and in hotel rooms. But this was not satisfying.

Now there are periods when I can devote myself to composition. This is like a second youth. It is the greatest adventure of my life.

No one entered into esthetic discussions with them (forbidden com-
posers) or asked them to explain themselves. Someone came for
them at night, that's all. . . .

Awaiting executions is a theme that has tormented me all my life.
Many pages of my music are devoted to it. The majority of my
symphonies are tombstones. . . .

Dmitri Shostakovich, Testimony: The
Memoirs of Dmitri Shostakovich

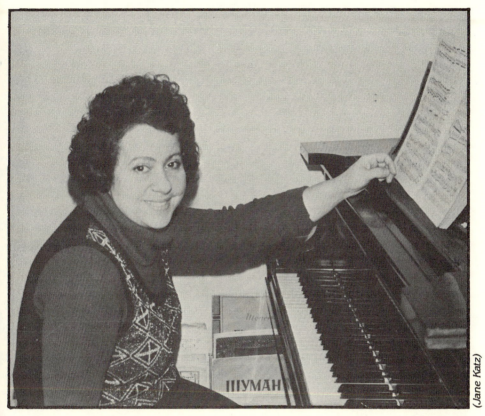

(Jane Katz)

Nina Lelchuk
Pianist from Russia

"I was always waiting for a phone call."

The publication of the memoirs of the Russian composer Dmitri Shostakovich in 1979 and the defection to the West of his son and grandson in 1981 drew attention to the paradoxical position of the artist in a nation which prides itself on its cultural traditions but villifies those who create original work.

Pianist Nina Lelchuk won early honors in Russia for the emotional depth and artistry of her playing. She won international piano competitions and was acclaimed throughout Europe. But the intervention of Soviet party functionaries in the realm of music affected her career. Seeking artistic freedom, she emigrated to the United States in 1979 and is now winning rave notices for her playing.

<div align="right">Interview, November 13-14, 1980</div>

Nina Lelchuk

Center stage in Ms. Lelchuk's New York City apartment are a grand
piano and a massive collection of piano scores. Providing the sound
track for this interview is her golden retriever, Bimke. He barks.
"Tische! [be quiet]" Ms. Lelchuk says in Russian. "He understands
Russian, you know," and the dog retreats. Soon he returns, sniffs, and
barks again. Unruffled, Ms. Lelchuk reminisces about an early expe-
rience as a music student in Moscow.

I attended a special school for gifted children. When I was
ten, I was invited to play in a special concert at the Bolshoi
Theater. It was during the 11th Congress of Young Com-
munists. This was a very big honor. The principal of the
school told me I was to wear a white apron over my brown
uniform and to play a waltz by Tschaikovsky.

It was springtime in 1949. My mother came early with me
to the theater to fix my hair. Soldiers were at the door. They
shouted at her: "Get out of here," and she had to leave. I
began to cry. I was very frightened. Before the concert, I was
watched continually. Someone instructed me that before I
began to play I must bow to the box on the left, where the
Czar used to sit. When I finished playing, people ap-
plauded, and I bowed again. When I looked at that box, I
saw a familiar face. It was Joseph Stalin. I remember I was
very surprised. I'd always thought of him as big and power-
ful. But there he was—a very small man with a mustache
and red hair and a pockmarked face.

I graduated from the Moscow Conservatory and began
teaching there. Maxim Shostakovich, the son of the com-
poser, was my student, and through him I met Dmitri
Shostakovich. Once I played for him, his *Prelude and
Fugue* which is marked allegro. I slowed it down, and he
was very courteous; he said that each musician finds his
own tempo. I asked why he had called for such fast tempo
and he said, "Well, I don't have time to practice the piano.
So when I play a new composition, it's easier for me to play

223

it fast. The mistakes aren't so obvious." I really admired his honesty.

Shostakovich was a very nervous man. When he spoke with you, he wasn't still for a moment. He'd scratch his head, he'd scratch his left ear with his right hand, and he'd transfer this nervous impulse to you so you'd begin to scratch. Nothing was simple for him. He was a complicated man, and a genius. I didn't know then how deeply troubled he was. He hid his dislike of the Soviet system—until it all poured out in his memoirs published after his death.

I remember hearing about an incident that occurred at the Moscow Conservatory two months before the premiere of Shostakovich's *Fourteenth Symphony* in 1970. There was a showing of the work for the Union of Soviet Composers. The composer addressed the group. He said that death had been on his mind while he was composing this symphony. He said that when death comes, you had better be prepared—better not to have too many bad deeds to regret.

In the audience was a Communist official who had been a bitter opponent of Shostakovich during the Stalinist years. Apparently the man was very sick, but he told his companion he didn't want to leave the hall for fear it would look like a protest against the music. He sat there and left just before the end. After the concert, they found him lying on a bench outside the hall, dead. An ironic climax to the music.

In those days, of course, Shostakovich had been rehabilitated, and was much admired. But I grew up during the 1940s and early 50s when Shostakovich was an outcast. He was attacked in all the newspapers, accused of being anti-Soviet. Stalin was pretty simplistic about music. He rarely attended concerts—he'd killed so many people, he was probably afraid to come out of hiding. He feared any form of individualism in the arts. When Stalin heard Shostako-

vich's innovative opera *Lady Macbeth of Mtsensk* he was outraged. *Pravda* called it a "muddle instead of music" and the opera vanished.

In 1948, the Central Committee of the Communist Party issued a resolution attacking Shostakovich, Prokofiev, Khachaturian, and other composers whose "formalist perversions and anti-democratic tendencies in music, alien to the Soviet people and its artistic tastes, are particularly glaring."

I was quite young, I think I was in the fourth grade. I remember our teacher read this resolution to us. I didn't understand it, of course. She said that the music of these composers didn't reflect the Russian soul. Then an article appeared in *Pravda* attacking all the composers who were writing abstract music. The Soviet official who wrote the article said these composers were more concerned with form than with the good of society. He said they were writing noise, not music. Then he wrote, "Our country needs music that is optimistic, that belongs to the people."

In class we had to study this article. Our teacher played a recording of a Prokofiev opera *The Nose* based on a story by Gogol, and she said it was "noise." We had been brought up on Bach, Beethoven, and Chopin. How could we question this judgment?

Not long after this article appeared in *Pravda*, Prokofiev went into seclusion. He suffered from poor health. He died of a brain hemorrhage on the day of Stalin's death.

This was a terrible time for Shostakovich. People called him a traitor, they threw stones at the house. Maxim told me that in school he was accused of being "the son of an enemy of the people."

I could not understand this persecution of a composer. How could anyone find a symphony, a group of sounds so threatening?

Shostakovich wanted to live, and so he wrote officially approved music. He wrote symphonies in memory of Lenin and The October Revolution. He wrote an oratorio dedicated to "the forest of the future." He lived a double life. The irony and agony in his music were subtly disguised. In his last years, Shostakovich was praised for his "service to the state." But he felt that he had betrayed himself.

You know, Lenin's generation, the first government of the Soviet Union, was made up of men who were young, intellectual, and idealistic. But in Stalin's time the sons of workers and peasants came to power. They were party "hacks," so you say? They didn't know anything about our great cultural treasures. Many of these people are still in power. They are not literate; they are shallow. There is no idealism any more.

Khrushchev disassociated himself from Stalin's brutality. You could speak a little more freely. People returned from jail. But still you had to be careful.

A composer could be in favor one day and in disgrace the next. There was a time when Rachmaninoff was banned, then Scriabin, then the composer Medtner. There was a special meeting of Communist officials devoted to the playing of Medtner. He was called a "cosmopolite" (citizen of the world)—that was an insult. He was called a Zionist. Anti-Semitism has always been potent in Russia. The officials plug it in, turn it on and off. Anyone who played Medtner's music was denounced.

Those party officials didn't know anything about music. I never saw them at concerts. But still they felt they could tell the great composers how to write music. They'd say, "We need music that will help us build Communism." Nonsense!

I was so impressed when I heard on the Voice of America that President Carter used to listen to Brahms, Schubert, and Beethoven while he was working in the White House.

Nina Lelchuk

I was never a political person. I taught my classes at the Conservatory. I played my concerts. I did read Solzhenitsyn in secret—friends passed copies around. When I read the *Gulag Archipelago,* I could picture the misery of the people in the Gulag. I was so upset, I couldn't sleep for days. You had this feeling it could happen to you.

A friend of mine, a colleague at the conservatory, mailed her brother, a soldier, a copy of *A Dog's Heart* by the banned writer Bulgakov. A few days later, the KGB searched her apartment, turned everything upside down looking for other banned books. She was fired from her job at the conservatory, and the party held a special meeting to denounce her.

I began to have my own troubles with the officials. Vladimir Ashkenazy and I had been friends from childhood. He is a remarkable man—modest and shy, a determined and honest artist. Well, his wife left Russia to visit her parents in England. She was in her eighth month of pregnancy. She became very ill, and Vladimir obtained permission to take their son and visit her. After two weeks she was still in the hospital, and the officials told him to return to Russia. He would not. He defected at that point, and I respected him for it. His wife came first.

But in Russia they called him a traitor, and they wanted me to denounce him publicly. Of course I refused, and they said they couldn't trust me, that I might do the same thing.

In 1961, the Tschaikovsky Piano Competition was held in Moscow, and I became friendly with some of the American musicians. One of them, Susan Starr, played a Rachmaninoff work for my class. I accompanied her, we talked about the music and I gave her some pointers.

Within an hour, the president of the conservatory knew about it, and called me into his office. He was furious. "Why do you help our enemies? They are competing against our musicians. This is unpatriotic."

He warned me not to do this again. He was a dangerous

227

man, a real Hitler and paranoid about Jews. Next to Jews he hated Armenians because his wife had had an affair with an Armenian.

In 1966, the American pianist Misha Dichter came to Moscow to play in the Tschaikovsky Competition. He came with his parents who spoke Russian, and we became friends. I listened to his rehearsal and gave him some suggestions. Again the president called me in and screamed at me. "You are a professor at the Moscow Conservatory, and again, you are helping our enemies."

I said to him, "How are they enemies? Why do you invite them to take part in this competition if they are enemies?" He never forgave me.

The first Tschaikovsky Competition had been won by an American, Van Cliburn. The next year, an Englishman shared the top prize with Vladimir Ashkenazy who defected. So this year, they were absolutely determined that a Russian would win. They gave the prize to a Russian, and Misha Dichter took second place. Well, many people said Misha should have won—and I had helped Misha, so you can imagine the furor.

The president was vindictive. He closed doors to me professionally. He made sure that I was not allowed to play concerts outside the Soviet Union. Of course, this damaged my career. Over the years, the pressures built up. I was always waiting for a phone call.

Someone would call up and say, "Ms. Lelchuk, why didn't you attend the trade union meeting? Why don't you attend our Communist party meetings?" "Because I'm not a member," I'd answer. And they'd say, "It's your obligation. Everyone has to participate."

My husband and I decided to emigrate to the United States. He left his job at the Institute of Theoretical Physics so they could not say that he was a security risk, and began teaching at the Polytechnic Institute in Moscow.

Nina Lelchuk

To get permission to leave, you had to have an invitation from Israel, but we could not write letters to friends there, for the KGB opened letters. You could lose your job or apartment just for applying for a passport. How did we get permission to leave? If you want something, you find a way. Nothing is impossible. We sent messages with Americans who came to Russia. Eventually, the invitation came from Israel, and we got our passports.

We had everything packed. They came to the apartment and searched all our belongings. They read our personal letters. We were not allowed to take with us personal photos or manuscripts. They took away almost all our money and anything of value. At the airport, another search, this time of your whole body. Some people had to remove all their clothes. It was humiliating. We flew to Vienna. There, we had a choice of going either to Israel or to the United States.

Why were you permitted to leave Russia, when so many were refused?

I don't understand it. There's no logic to Soviet policy. Of course, this was the period of detente, when so many talented artists left the country.

We took a big risk leaving Russia. There we had good jobs, two apartments, a country house, two cars. We had friends and family. We said goodbye to all that. We were poor when we came here, and didn't know if we would find work. We lived in a tiny apartment in New York City without a piano, and I had to go to a friend's apartment to practice. When my husband found a job, we bought a piano, and I began teaching and performing.

My son Dimitri was ten when we emigrated, and he cried because he didn't know English. But he became an American very quickly. He found an old typewriter someone had thrown out, he fixed it up and practiced his writing. He wrote some stories, he drew pictures, and put together a

little book. Then he and a friend set up a stand on the street and sold it for five dollars. Good for him. Here, if you're alert, you find the resources and get ahead.

This would never happen in Russia. Russians convince themselves they are not materialistic. The government has created an image of "the person of the Soviet tomorrow." He doesn't think about himself or his family. He only cares for his government and the society. Well, if Russians love their country so much, why do so many of them want to leave?

Today in Russia, the atmosphere is freer for musicians than before. Many are influenced by Western composers like Schoenberg, Webern, Stockhausen, and John Cage. Occasionally there are performances of new music, but still there are pressures to conform.

The Sixth All-Union Congress of Composers met in Moscow in the fall of 1979 to set down official guidelines for Soviet composers. Tikhon Khrennikov, First Secretary of the Composers' Union, criticized the younger generation of composers for their infatuation with "Western bourgeois" techniques of composition—serialism, electronics—that appeal to an artistic elite rather than to the "broad masses." On Khrennikov's "blacklist" were seven "avant-garde" composers, chastized for insufficient attention to melody and pandering to the West.

You know, I'm not anti-Russian. I had a wonderful education there; the Moscow Conservatory is the best in the world. I developed my career there. But it is impossible to breathe in Russia.

In a way I was always an outsider. I always played better in other countries. Now I feel free to express my feelings. A musician communicates very directly with an audience. I am playing better than ever before. I feel as if I were born here.

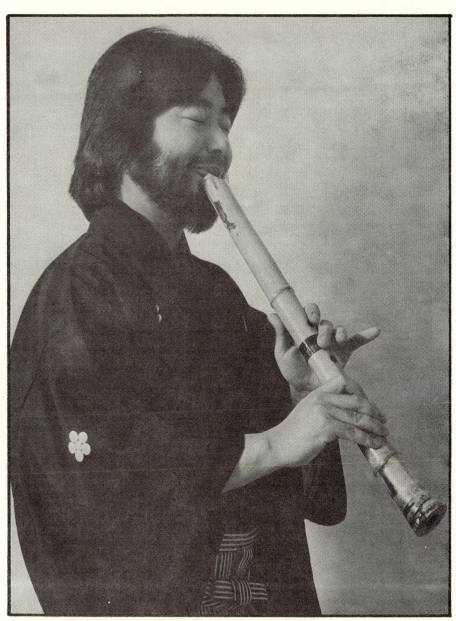

(Audrey Kanako)

Masayuki Koga
Shakuhachi player from Japan

"I am the sound."

Koga is a skilled and subtle musician, a student of many musical forms: Japanese folk music, Western classical music, and jazz. In his native Japan, he was considered one of the foremost players of the shakuhachi, the popular bamboo flute.

Koga found himself philosophically opposed to the climate of pragmatism and commercialism which prevailed in post-World War II Japan; his quiet rebellion led to his emigration to the United States in 1972.

In performance, Koga sits cross-legged on a cushion, his body immobile except for slight head motions, and plays a gentle lullaby, or a song of deer calling to each other in the hills. His lips barely touch the flute. He begins with hushed tones, then the melody evolves—pure, mellow tones contrasting with brilliant ones. One note is held, suspended in time, then gradually fades out to a whimper. The plaintive sounds echo in the silence.

<div align="right">Interview, March 18-20, 1980</div>

Masayuki Koga

In Japan, I did not have many friends. I was different. I thought of coming to America. Why not? Must I be put in a drawer because of my skin color? I am a space age man—I belong everywhere. This earth resembles a human face, I thought. Japan is one pimple, America is another. I will just be moving from pimple to pimple.

I had fear of coming to a new country. When I first came to Market Street in San Francisco, I couldn't understand even "hello." I looked up the word in the dictionary, but then it was too late to answer, so I kept my mouth shut. I felt things, but I cannot describe. I struggled with the language, I still do. When someone said something I did not understand, I was embarrassed. Then I learned to deal with my embarrassment.

When I first came here in 1972, I didn't like to go to parties—such a big headache. I could not listen to rock music. Western music, it seemed empty to me. The sound stays in this world. When I heard rock music, I would leave.

Very early in the morning, I went to Golden Gate Park to practice the shakuhachi. If an airplane passed by or a car engine screeched, I would hate it. Then I realized I was small-minded. I came to accept the noise.

I am not a Zen Buddhist. But I grew up in religious atmosphere. Buddhism is life. In our home, we had two shrines—Buddhist and Shinto. Both are methods of arriving at understanding of the universe. Both help us to reach the universal God. When we speak of God, we do not mean big man with a white beard. No, God is the entire universe. It includes everything. Good and bad, darkness and light, animals, humans, even noise, everything is part of the God. This life is so complicated—so many contradictions. You must accept your life as it is. You must strive to be perfect.

I was born in Omuta City on Kyushu Island in Southwest Japan. It was beautiful. Mountains and white clouds, clear air. I was very young when World War II started. My

233

father was trained as a soldier and went to war. He believed it was his duty to fight and die for the emperor. He left my mother and three children behind. When the bombs fell on our city, we ran off to the mountains. My mother hired farmers to build a small house for us. They were suspicious and unfriendly, maybe because it was wartime, and they did not have enough to eat.

I don't remember the bombing of Hiroshima, but my friend saw the mushroom cloud, and his father died in the explosion. My aunt lived 150 miles away from the explosion, but still she suffered from the radiation, and she became sterile. Many people did not know the meaning of the war. It was government policy to make the people believe the emperor's way was right. But when the people saw their city bombed, they hated the emperor. My father returned after the war, and he said that now that the Americans were victorious, we should respect them. He said, "What happened, this is past. One must make the best of it."

My father thought of himself as the spirit of the Samurai. He believed in the Samurai code. He taught us: "Whatever you do, fulfill your obligations. You must never owe anything to anyone. You must be number one. You must not fail." He hated cowardice. Better to die with honor than to live as a coward.

I remember, he always said to us: "Whatever you want to be, any job you choose, that's OK. Sweeping a building is wonderful if you enjoy it. Being president of a company is wonderful. Being satisfied—that is the important thing. That is happiness."

My father is a man of principle. When his business went bankrupt, he did not get bitter. Always he spoke his mind. He felt that the government of our city was corrupt, and he said this. When he ran for mayor, the businessmen

attacked and slandered him, and so he lost. But he never fought back.

My father is a quiet man, mysterious, angry. He believes in educating children in the Samurai way. When I did something he did not like, he would not speak—he would hit me in the face. If I asked him what I did wrong, he would say "Damare!" "Shut up!" When I heard that, I blocked. He is big and strong, with a powerful voice. I knew if I talked back to him, he would win. It was so hard for me to explain anything to him. I was afraid, emotional, not good with words. My father believed he was teaching me the right way.

He is still alive, and for me he is still the spirit of the Samurai. His spirit is strong and pure.

I never knew boys in Japan who rebelled against their father. Fighting with a father—this is war. It is shameful. If a boy did this, he would be kicked out of the house.

I used to get into fights with other boys. My older brother scolded me. He told me to run away, not to fight back. But I did not listen. I was in many fights. Now I think he was right. I should have learned to control my anger. I should have refused to fight.

It is the same on the streets and in war—the fighting is endless. Someone has to hold back and refuse to fight.

My mother was a soft and gentle woman. She played the koto, a stringed instrument, she did flower arrangements and tea ceremonies. Every Japanese woman learns these things before marriage. She stayed at home every day. She cooked and cleaned and made most of our clothing. She never said she loved us, but she showed it in the way she cared for us, and taught us patiently how to do things.

With my father, she was patient. When he came home very late, she cooked him fresh, hot meals. She did not complain. But one time, I remember, my mother said,

"Everything I have done is for my parents, my husband, and my children. I never did anything for myself. Nothing is left over for me."

My father did not show affection to mother or to us. Actions, not words. This is the Samurai way. They never spoke in anger to each other before us. But one time, when they thought we were asleep, I heard them speak angry words to each other. Now that my parents are older and mature, they can express anger in front of others without embarrassment. Half-joking, half-serious, they express their feelings so there's no anger left inside. This is nice. I want to get old soon.

In Japan, it is very important to do the right thing. I am independent. I did not always care what others think. I was guided by old Japanese spirit. I was a young punk. I would challenge anybody.

Most boys I knew in school wanted to be a successful businessman, lawyer, or politician. My father wanted me to be a professional man. I obtained a master's degree in law from Meiji University and he was very happy. But the law was not for me. Always I played the shakuhachi.

In the seventeenth century, masterless Japanese Samurai roamed the countryside playing the shakuhachi. Forbidden to carry arms, they turned the flute into a weapon, thus defying governmental authority. The songs of these strolling musicians have come down to the modern shakuhachi player.

I studied the shakuhachi for six years with a master teacher. I became a teacher. I take advantage of the opportunity presented to me by my birth in this world.

When I was twenty-five years old, I started to make shakuhachi. I went to bamboo mountain. You have to search for the right plant, one that is a certain age, still green but slightly yellow, one that is getting old. After

much experience, you begin to see with your body where to go to find the right plant. It is intuition. You take the bamboo home, build a fire in hibachi, you hold the curved part of the bamboo over the flame to make it straight. You must have just the right number of nodes, and the right distance between them. To make a good flute, it takes skill. And good luck. And you must be a good man. This is the idea.

You ask, can a woman make a shakuhachi flute? Yes, but custom prevents this. Most of the women prefer to have man make the flute, and they can just listen. Very smart!

The bamboo comes from the earth and exists on the earth. When I play the flute I become part of the earth. When I play deeply, the shakuhachi and I become one. The sound is a part of me. I am the sound.

Before we were born, everything was whole. Then, all the elements separate. Some become the sun, some trees, some become human creatures, some animals. All life is a gradual return to the wholeness, the unity. We go into the silent world we came from.

In Japanese philosophy, one seeks to understand reality in a holistic manner, to grasp the substance of things intuitively, without thinking or explanations.

The shakuhachi player learns to play a single note well. One note expresses everything. One note is Buddha, perfect enlightenment. You inhale, and one note follows another. Pure tone. Balance. The melody is not written down. You must feel it in your body. There is no way to translate it into language.

The shakuhachi includes everything—love, hate, beauty, ugliness, the thunderstorm, the sounds of the city. When we play it, we try to translate the spirit of human beings directly into pure sound. The spirit is free. The flute is like

my daughter. You do not hold her to yourself forever. She has her own life. The sound has to fly away toward the sky. No way to hold it.

Through the shakuhachi, I achieve self-awareness. My life is a search to recognize why I am living, to realize the silence.

Most people in Japan do not seriously think about philosophy. They are too busy thinking about money. After the war, they thought the Western powers were superior because they won the war. So the people think that making big cars, ships, and planes will make them happy. They don't care if they live long. They are ready to die.

In Japan, I was married to a musician. My wife was a great koto player. A strong person and independent. I am stubborn. We were divorced after four years. Now my girlfriend is Japanese. She is very soft and agreeable. She takes care of others before herself.

It would be nice to have children. It would be nice to have a wife who will stay at home and take care of the home and children. But now I live for the shakuhachi. She is a perfect wife. She knows everything I am thinking.

My parents taught me always to aim toward a higher goal, to have the mental preparation of a Samurai. Who knows, at any moment we might die. After death, maybe there is darkness. I don't care as long as people play the shakuhachi. That is my happiness.

I do not want to lose my identity as a Japanese. It is best to blend good things from both worlds. This I try to do.

(Jane Katz)

Mikhail Bogin
Film director from Russia

"I did not want to serve them any more."

Lenin's dictum: "The cinema, of all the arts, is the most important," is still a guiding principle of the Soviet cinema, which is viewed by government officials as a crucial tool for manipulating public opinion.

Bogin was admired in Russia for his award-winning films. *A Ballad of Love* (released in Russia as *The Two*) won the Golden Prize at the Moscow International Film Festival and Grand Prize at the Cannes Festival of Youth. *In Search of a Person* won Grand Prize at the International Film Festival in Varna.

But for Bogin, art and ideology are incompatible. Finding government pressures to conform to the Soviet mold intolerable, he emigrated to the United States in 1975. His first American film *A Private Life*, which won first prize at the 1981 American Film Festival, has been praised for its sensitive portrayal of two aging emigrés who deal with dislocation and try to find love in a new land.

Interview, July 2-3, 1982

Mikhail Bogin

He is warm, down-to-earth, approachable. I begin by taking pictures of Bogin. Although face-to-face with an intrusive Rolleiflex, he is relaxed and talks easily.

In Russia, the movie theaters are always full. People love American films. They want view of another world. But the Russian government is afraid people will be seduced. They call Hollywood "factory of dreams." They show only the most superficial American films, like *The Sound of Music*. Films that show what America is really like, these are kept under guard in an armory. Only government officials and film specialists can see.

The government does not like films of sex or violence, conflict or struggle. You are supposed to struggle only for the Motherland.

I'll tell you why so many Russian films are very sophisticated visually. Filmmakers must be cleverer than the censors. The government controls every step of production from script writing to filming and editing. A good director uses innovative camera techniques, subtle visual images, ironic contrasts to convey his vision. The people are skillful at "reading" his message. The director can't rely on words, for the censors "improve" a script and turn it into something false.

It's funny, if a Russian film gets bad review, you know it's probably a good film. Contains something real and human. Probably the censor was sleeping.

I must tell you a story about the film director Eisenstein. He was a genius. He had a great sense of irony. He was honored throughout the Soviet Union. Stalin chose him to make three films on the life of Ivan the Terrible. Well, the first film showed the czar's ruthlessness—Stalin liked it. The second film showed that he had a human side. After it was finished, Stalin ordered Eisenstein to visit him at 4 A.M. (Stalin slept all day and worked all night.) I knew Eisen-

241

stein's widow, and she told me that when her husband returned early in the morning, his face was absolutely white. She said to him, "What did he say, please tell me." And Eisenstein answered, "He said it was not what he wanted."

The next issue of *Pravda* contained an attack on Eisenstein. The article said that the film was a distortion of history, that Ivan was weak, like Hamlet. We all had to read this in school. Stalin's disapproval was a death sentence. Soon after that, Eisenstein died of a heart attack. He was only 50.

There was a film on the life of Stalin, and Stalin chose the actor who would portray him. When Stalin saw the film he said, "I can believe I was that handsome, but I didn't think I was that stupid." It was ironic—Stalin wouldn't let this actor play any other roles, and he died right after Stalin died. Of boredom, I suppose.

In the Soviet Union, people live such warped lives. You cannot travel, you cannot speak out. Your every move is watched. But in the privacy of your kitchen you can gather with friends, you can speak freely about American films and books, about poetry, music, and painting. Your friends help you solve problems—no psychiatrist. You build your own little world of very special people.

I asked Bogin about the Russian's ability to retain a sense of humor in the face of adversity.

Well you know, you live in an overcrowded apartment, you have nothing in the refrigerator, there is no soup on your table. But at least you can make jokes. You have to have a sense of the absurd to survive in Russia.

I always loved America. America has much prestige in Russia. No government propaganda can destroy it. People

will pay 250 rubles—that is a month's pay—for a pair of blue jeans. That is a symbol of freedom.

When I was a kid, they shipped American equipment across the Soviet Union to Japan. I remember seeing Studebakers on the highways. Big and shiny—our cars were small—it was like exotic animal.

During World War II, Americans sent us canned meat and clothing. I was maybe in second grade, I got this blue jacket and in the pocket there was chewing gum. I thought it was great.

We learned about American history. We read *Tom Sawyer* and *Huckleberry Finn,* and Faulkner and Hemingway. We had wonderful translations—our poets could not publish their poetry, so they worked as translators to make a living. Joseph Brodsky, for example. He is a great poet, a genius. Even though he lives in exile, his country is Russian poetry—he belongs to it. It is his life, his world.

Bogin was born in 1936 in Kharkov, a city in the Ukraine. His parents were engineers.

In 1941, the Germans came, and because my family was Jewish we had to emigrate to a city in the Urals. People were starving there. To save me from that, my parents sent me to my grandmother in Siberia. She lived in a little mining town surrounded by a wild, untouchable forest. "Taiga," we called it—a jungle. You cannot imagine it. There are huge trees hundreds of years old and bears. Beautiful and mysterious. Kids got lost there. But we explored, we felt very brave and free.

After the war, I finished high school in Kharkov and then attended the Leningrad Polytechnic Institute. I studied to be engineer. You had to be student or you would go into the army. But I always loved cinema. I applied to the Institute

of Film. Out of 50 applicants, only one was selected—I was lucky. I studied directing and script writing.

In order to receive his diploma, Bogin coauthored and directed a film, *A Ballad of Love*, about the love affair between a music student and a young woman who is a deaf-mute.

This film is about two different worlds: the world of music and the world of silence. There is a wall between them. I wanted to prove it is possible to cross that wall. The film is about communication.

Does the camera make visible what we do not ordinarily see?

The camera looks into the human soul. You know, Victoria Fedorova, the actress who plays the deaf-mute (she's living in the United States now), when you meet her she is a pretty, bright woman. But on camera there is this special, spiritual quality. She cannot speak in this role, but her body speaks—she moves harmoniously, the big eyes are luminous, she is radiant.

They wouldn't let me make this film in Moscow. Russia is not supposed to have deaf-mutes, blind people, sick people. In America, it's OK. But Russia, no. So I went to Riga [Latvia]. The director of the studio there had lost his hearing, and we made the film. Then he was fired.

I went to work at the Gorky Film Studios in Moscow. Bibi Anderson came to Moscow, and I directed her in a film, *On Love*. I remember, she wanted to adopt a Russian child. "You Russians are so strong," she said. But the Minister of Education told her, "No, I'm sorry. In Russia, we have no orphans." So she went to Czechoslovakia to find a child.

Bogin's film *In Search of a Person*, coauthored by him with the poet

Agnia Barto, was released in 1973, a major event in the Moscow film world.

This success was for me hollow. I will tell you why.

The film is a documentary based on the experiences of Russians who lived through World War II. During the war, there was turmoil all over the country. It was a cauldron. People were fleeing from the Nazis. Families and whole towns were evacuated. Thousands of children got separated from their parents. Officials would find a lost child, maybe three years old, at the railroad station. They would bring him to the orphanage and question him.

"What is your name?"

"Kolya."

"Your last name?"

No answer. The child was too young, too scared, and he didn't remember. They would put down: Kolya Ivanov.

"How old are you?"

Again no answer. They would open his mouth, look at the teeth and guess at his age. They made it all up: name, age, place of birth. Everyone had to have identity papers. But they were fake. These people grew up, married, had their own families, but still they didn't know who they were. The police could not help them, nobody could help them.

Then the poet Agnia Barto started a program on Radio Moscow. She would say:

Listen to me. There is a woman I know, she lost her parents when she was three years old. She remembers that her mother had white hair, her father used to wear boots, they lived next to a river. They had a dog with one ear. Do you know this family?

And an elderly couple wrote in: "That's our little girl."

It was incredible. Thousands of letters started coming into the station, and were read on the air, and, over a period of nine years, hundreds of families were reunited.

I worked with Barto, and I read the letters. People ignored the censorship to write the most personal things— about how they saw their parents arrested, they wrote about escaping from burning buildings, wandering alone through villages. It was heartbreaking. These people had survived the war, but it was not over for them. Their identities were false—they were living a lie.

Each letter was a cry of loneliness.

Then suddenly, the radio program was cancelled. Some official told Barto, "This is the greatest country in the world. This program shows that many people are unhappy." Barto had no spine, no integrity. They didn't tell her to cut out the program, they just said, "Why so many unhappy people?" She had won plenty of recognition. She didn't want any criticism, so she did their dirty work for them. The program ended.

The Russian government deals in innuendo. People become very crafty at reading between the lines to protect themselves.

The letters kept coming in to the station. People knew I was interested, so they came to me: They brought me a cake or homemade bread and said, "Help me, help me!" I couldn't walk out on them.

I proposed to Barto that we make a film based on these letters. We wrote a script based mostly on the people's childhood. Children's memories are amazing. An empty box or a little doll can become the center of a whole drama.

I decided to go on location throughout the country, to film people telling their stories. For authenticity, the sense of real life. I began shooting in a little village. We had arranged a family reunion—a mother and daughter who

had been separated for 35 years. They talked to each other, they cried, but they didn't touch each other. They were wooden, strained. Maybe because of all those years, maybe because of the camera.

I felt it was immoral to film such personal, painful moments, so I decided to use unknown professional actors. We filmed in cities and towns all over the Soviet Union. It was going very well. Fascinating, heartbreaking stories. Each one a human drama.

Of course, there were official pressures. I knew we could not shoot stories about Jews. This was Russia. But Jews had written to us. Barto just twisted their stories, eliminating Jewish elements. For example, a man named Abramovich wrote, "I remember my mother. She was very pretty and gentle. She prepared gefilte fish; my father wore a talis [prayer shawl]." Barto would cut out "gefilte fish" and "talis."

Someone else wrote: "I remember an old house, with paint peeling from the walls. On the table there was the Talmud under a flower." Barto cut out Talmud. Those were crucial details. This was censorship. It was painful for me—I had a constant battle with Barto.

I went to Riga to visit a woman named Ehrenberg who had written a fantastic letter. I thought maybe she was German, not Jewish. She was this pathetic little grandmother, almost blind, surrounded by her grandchildren. She hugged me, kissed me, called me "father" and cried, "Help me, help me." She was holding a little red shoe.

I thought, no one can tell this story the way she does, so I invited her into the studio. I filmed her telling her story, crying. She told how in 1941 her husband left for the army, and she was left with four children. The Germans were in the next village, so they escaped on foot. It was nighttime, there was shooting all around. She was holding her baby,

and led her three-year old by the hand. They came to a river, and her five-year old girl was afraid to cross. A man said he'd help her. When they got across, the girl was missing. All she could find was a little red shoe. She said, "Can you help me find my daughter Masha?"

I thought, "This film will go all over the country. Maybe she will find her daughter." But the director of the studio saw the scene and he said, "Take it out, Mischa. She has a Jewish face." I had no choice.

Well, we finished the film, and it was big success. But for me it was a lie. I could tell only half the truth. I could film people from all over Russia, but I could say nothing about my own people. They pretended Jews didn't exist.

I make films for people. I want to spill out some love for people in my films. Making a living is secondary. I had hoped that making this film would change people's lives drastically from despair to hope. But my hands were tied. I said to myself, "What am I doing? I am old enough not to lie. It is time to think of my soul."

I decided to leave the country. I did not want to serve them any more.

How is it that your exit visa was granted within three months when others have had to wait for years, or have been refused?

I wasn't hero like Vladimir Bukovsky.* They don't care about ordinary individuals. They just want to keep people quiet. I suppose they thought if they keep me against my will, I will complain to others, maybe to the Western press, and this will create unrest. To get me to stay they promised me money, a chance to travel, everything. When I said no, they said, "You will die in the West."

When I was leaving Russia with my family, they

*Dissident writer, author of *To Build a Castle.*"

searched us. They told me to remove my shirt and shoes, to hold my hands up. It was humiliating. But I was happy because that was the end of my life as a slave.

We came to this country, to New York City. I didn't know if I would find job, if I would ever be able to make films again. But I was lucky. I found work as a teacher of film-making at New York State University. And I won a grant from the New York State Council on the Arts to make a film about elderly people in New York. You know, people live so close to each other in this big, chaotic city. Yet they can be so far apart. For the elderly it is frightening. They can be beautiful and passionate. But they are so fragile.

Last fall, there was showing of my films at Museum of Modern Art, and a man from the Russian Embassy came. He spoke to me very loud in a stupid voice. (Bogin mimics him, snarling.) "Bogin, you will die here. You will never make masterpiece in the United States."

Of course I would like to make films in Hollywood. This is every director's dream, yes? Last year, a friend of mine in Hollywood called me up and he said, "Mischa, tomorrow you will come and start work on a film. OK?" I said. "OK." I stopped what I was doing, and the next day I took a plane to Hollywood. Well, I arrive at the studio, and a young woman in a low-cut dress greets me. She is doing a dance as she leads me down the hall to meet her boss, the studio head. He's really uncomfortable, he clears his throat, he speaks in a feeble voice, but he tells me, "You know, I'm really not like this. I'm usually very energetic . . ." And I think to myself, "Does he know who he is? If I stay in Hollywood, will I lose my identity?"

I didn't have an opportunity to find out. We worked for only two weeks. I liked the script. But the producer and the writer were at war the whole time, and so they shelved the project. Too bad.

Will you try again to break into Hollywood?

This is like scaling the highest mountain. They are like czars, the men who run the industry. Mostly they want films for mass audience, with blood dripping from the screen. I want to make films about a person's inner life. In America, I will never be rich. It's OK. (He laughs.)

In Russia, if you work for studio, they give you money for film, no problem. But then they are always looking over your shoulder, meddling in something they know nothing about. Here, you are totally free to say what you want in your script, but it is almost impossible to get money to make a film. This is another form of censorship.

Bogin has come to Minnesota under the aegis of Film in the Cities to direct a film entitled *Finders Keepers*.

It is a comedy based on a true story. This farmer is deeply in debt. He is afraid he will lose his farm and his family will go hungry. He's a dreamer, always looking for a way out. One day, a car crashes near his farm, the driver goes to get help, and the farmer's dog finds a sock stuffed with $25,000 in the car. The farmer thinks it's the answer to his dreams—but not so simple in real life. It turns out to be dirty money belonging to a narcotics dealer. Of course, everybody wants to get their hands on the money, and the farmer wants to keep it.

Does he? Bogin smiles, but does not answer. I will have to see the film to find out.

I am a city boy making a film about farmers, so I went to visit farms. Such a hard life! They work from early morning to late at night—no holidays. They just milk the cows, take care of the animals, bring in the crops. I could see their love of the land and the closeness of the families.

I asked the farmers, "What do you like about your life?"

One answered, "Well, the place is homey and I like animals." Another one said, "So many people are out of work, and we're always busy." I asked a woman, and she said, "You know, that's a very interesting question. I would like to think about it. Could you come back in a few days?"

We are shooting the film on a farm. The setting is very important. It is an efficient, productive farm, but all around, nature is in decline. Tree stumps, old gnarled trees bent by the elements, foliage running wild. There is this atmosphere of decadence, as in a Turgenev novel.

What can a film director do to build atmosphere that a novelist cannot do?

I use light and shadows. We will shoot on a day that is overcast. You cannot rely on words. You must use visual images to convey your ideas. Nature has character. I combine American story and characters with Russian lyricism.

Minnesota is beautiful. When I was a boy in Russia and I read *Huckleberry Finn*, I thought it would be great adventure to travel in a raft down the Mississippi River. Now I am here, maybe I will do it, yes?

I want to know this country, its soul, its people. (His smile is as wide as the Mississippi.) It's my country now!

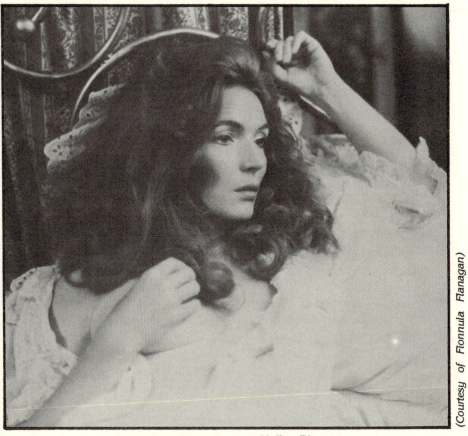

Fionnula Flanagan as Molly Bloom

Fionnula Flanagan
Actress from Ireland
"I feel a sense of being divided."

Her name is pronounced Fin-oo-la, which is Gaelic for "fair shoulders." With her flaming red hair and green eyes, she is stunning. Dublin-born, trained at the Abbey Theater, she performed on the Irish and British stage and in the film version of the James Joyce novel *Ulysses*.

On Broadway she won a Tony nomination for her performance opposite Zero Mostel in *Ulysses in Nighttown*. Television audiences have seen her as Clothile in *Rich Man, Poor Man* for which she won an Emmy, and in starring roles in *The Legend of Lizzie Borden* and *How the West Was Won*.

Her award-winning, one-woman show *James Joyce's Women* is at the same time erotic, witty, and lyrical, a striking demonstration of this actress's creativity and courage.

<div align="right">Interview, October 20-21, 1981</div>

Fionnula Flanagan

I asked Fionnula what it was like to grow up in Ireland. She laughed:

Does anyone really grow up in Ireland? I think it's one of the tragedies of Irish life—the talk, always the talk, and the pubs where the talk flourishes and nothing much happens except broken dreams.

We lived in a two-bedroom row house in a working class section of Dublin. My father was a newspaperman who had wanted to be a novelist, and James Joyce was his passion.

In Dublin, Joyce is a part of the landscape. My father was always walking us around the old city, pointing out the places that are mentioned in Joyce's novel *Ulysses*. "This is the street where Leopold and Molly Bloom lived," he'd say. I went to school on that block. Most of the landmarks within Leopold Bloom's journey—the stores, the churches, the whorehouses, and bars were still there when I was a child.

Another thing, many of the Victorian and Edwardian customs which Joyce pictures in the novel were still in practice during my childhood. For example, we had theatricals at my grandparents' home on Sunday evenings. Pale young Irish tenors would sing endless twenty-nine verse songs so boring you would die. We all knew what everybody was going to sing—you'd heard it many times, but you had to sit and listen and be very good.

Then there were the party pieces we all had to prepare. We would tell stories and illustrate them with actions. You know, the Irish oral tradition of storytelling isn't very far removed from theater.

In school we recited things by heart in Irish and English, just like a parrot. I used to recite a whole book called *The Three Tall Trees*. It began, "Hello, I'm Susan. I live in a house with three tall trees." By the time I was eleven, I had moved on to Yeats and O'Casey—he wrote in the language of my city.

My friend's father was a professional comic on the stage, and she sometimes worked in his act. She had a circular skirt with a lot of swirls and hornpipe shoes for dancing. Well, you know, that was the next best thing to a fallen woman. I thought she lived in a magical world, one I wanted to enter.

At twelve, I had my first job as a prompter for an amateur theater. They were doing *Juno and the Paycock*. Well, as prompter you have to know everybody's lines and within a few days, I knew the entire play backwards and forwards, and was just dying for somebody to drop a line so I could jump in and prompt, but nobody did.

There were wonderful roles for women. We never had censorship in theater in Ireland. I played intense tragic women, and marvelous comic roles. Irish humor is a way of looking at the absurdity of the human condition. The Irish have wandered all over the globe. They have suffered from poverty, from religious and political persecution. When people are poor and deprived, in order not to fall into total despair they develop a sense of humor. God knows it's true of actors.

I studied at the Abbey Theater, and went on from there to do professional theater and television in Ireland and England and a role in the film *Ulysses*.

I came to Broadway in 1968 in a Brian Friel play called *Lovers*. Art Carney costarred. We toured this country, and that was my introduction to America. It took me aback. Here, people seem to have no taboos about talking about personal things such as money. Someone would say, "How much rent do you pay for your apartment?" Back home, talking about money is considered vulgar.

The commercialism was hard to get used to, but of course I realized that here a performer could be out of work for three years. You had to learn to market and exploit your

256

talents. Here you have every opportunity to do so inventively.

Besides, commercialism is prevalent throughout the world. I mean, in Alaska, you gain status if you have a fine dogsled and a team. What good would a Lincoln Continental be when you're up to your ears in snow? So it's all relative.

In 1976, Flanagan played a highly sensual Irishwoman in the TV miniseries *Rich Man, Poor Man.*

After that, people sent me religious pamphlets and letters offering to save my soul. Where were these people when I was an out-of-work actress and they could have saved my soul by buying me dinner?

As an actress in America, I learned very quickly about survival. Here, entertainment is a highly competitive industry, more so than in Ireland. Vast amounts of money are invested, and the stakes are very high. It makes things like rejection keener. There's the constant search for new faces and ideas. This puts a great strain on the creative artist. If you can survive that, you can survive almost anything.

I hadn't really intended to stay here, but I fell in love and got married, and then I fell in love with America. I liked its vastness, and the candor of the people—the way you could ask a question and get a straight answer, the way people would come right out and say what they were thinking.

Americans are open to new ideas. They're not bound by the traditions of old institutions, which is what I think often hampers the European life style. I was attracted by the adventurousness of American actors—they are willing to try anything. And by the American school of acting which I think is first rate.

257

Well, even after I'd planted roots here, I had one foot in Ireland. The way to resolve that sense of being split in two was to bring James Joyce to American audiences. So naturally I was elated when Burgess Meredith asked me to play Molly Bloom in a show he was directing on Broadway, *Ulysses in Nighttown*. Zero Mostel played Leopold Bloom.

This play, based on a scene in the novel *Ulysses*, follows Leopold Bloom on a trip through Dublin's brothel district. And it includes the final scene from the book, Molly Bloom's bedroom soliloquy. This created quite a stir because I played most of it in the nude. The language is very explicit.

It was wonderful playing with Zero Mostel. His timing was impeccable. He was probably one of the world's great mimes. He was clever and inventive and funny and outrageous. He was also extremely shy, and I think he guarded his inner soul very well. He was always "on," always performing. That was how he kept people at bay. You never knew what he was really thinking.

Nighttown did very well. And it just intensified my obsession with Joyce, so I decided to create a one-woman vehicle for myself which I called *James Joyce's Women*. You know, women were of great importance in Joyce's world. Without them, neither he nor his works would have survived. Often obscure figures in the background of his life, he placed them center stage in his books, lighting up all around them with flashes of insight.

I researched and edited and put together a script for *James Joyce's Women*. In the production, I weave back and forth from literature to real life, becoming Joyce's fictional women and the women who sustained him in his life.

One of the characters I portray is Nora, his wife, whom he met and married when she was just an unschooled chambermaid of nineteen and he was a nervous, young,

strutting poet of twenty-two. They eloped to the Continent, had a child, eventually married, lived in gruelling poverty, and overcame tremendous obstacles.

Another character in the play is a Dublin washerwoman who elevates the pastime of gossiping to an art form in a scene from the novel *Finnegan's Wake*. She recounts the scandalous life and times of the infamous River Liffey which Joyce personalizes in the novel. Woven into the tapestry of the scene are the names of 250 rivers and puns on words in eleven languages. Much of it doesn't seem to make sense because of its extraordinary complexity, but it does, of course. Nora, Joyce's wife, said of *Finnegan's Wake*:

> *That was the book . . . Jim told me, it will keep the professors puzzling for years. Everybody else, too, with those jawbreaker words.*

Joyce said it is the "music" that is important, "the sound of the river."

James Joyce's Women ends with Molly Bloom's soliloquy from *Ulysses*. You see Molly sitting on a chamber pot. "I'd rather not make an all-night sitting of this affair," she says. "They ought to make chamber pots a natural size so a woman could sit on it properly." Of course I left that in. It's not romantic—but it's real. Some of the great philosophical thinking of this world has, I'm sure, been done on chamber pots.

You see Molly lying in bed, naked, alone with her thoughts. She's totally honest and vulnerable. She ruminates about her husband, about her children, about her son who died very young, about her neighbors, about local political activity, about the Prince of Wales, about scandals in the newspaper. She spent that afternoon with her lover, and she muses about that, she thinks about past lovers and about the shape and presence of her body.

The scene ends with Molly's recollection of her husband's proposal to her, sixteen years before. The words, the thoughts tumble forth in a stream of consciousness:

And I thought well as well him as another and then I asked him with my eyes to ask again yes and then he asked me would I yes to say yes my mountain flower and first I put my arms around him yes and drew him down to me so he could feel my breasts all perfume yes and his heart was going like mad and yes I said yes I will Yes.[1]

The scene is daring and erotic, the language is rich, imaginative, exhilarating. It is an affirmation, a celebration of life.

Joyce was able to portray Molly as a many-sided woman who is funny and earthy and sensual and petty and bitchy and generous and motherly, loving and ignorant and everything—because he allowed her to be human. She has all the flaws and all the dignity of a woman.

Joyce had this extraordinary gift for getting inside another human being's mind. I think he actually listened to women talk, listened to them with great interest and sensitivity, and he wrote it down. I don't think any writer before or since has portrayed a woman with such truthfulness or generosity.

Now, whether you play this scene clothed or in the nude is a matter of personal choice. I felt that the nudity was right for that character at that moment. When people are completely alone, they are totally simple and natural. There's no elaborate ritual attached to removing your clothes. In this scene, Molly is absorbed in the presence of her body, and the nudity makes sense.

When I did the play in Australia, the press really went to town on the nude scene, and it was pretty revolting. They

have a huge gutter press there, rather like the British, and they made it sound as if the nude scene was the whole play.

When I played it on Broadway, a few people were outraged, but the reviews were wonderful. They responded to the play as a work of literature and theater, not just to its sexuality.

I think American journalism is rather sophisticated. I don't think you have the same degree of prudery here as in Australia and England. Sex scandals toppled several British governments. I don't think that would happen here. I don't think Americans are so very eager to have the sex life of their public figures flaunted in the public arena. On the other hand, the sins that cause a public outcry in America are the abuses of money and power.

One thing that bothers me about Americans is the unrealistic way they look at the Irish. You know, romantic Ireland's dead and gone, although people are always trying to bring it back. Especially in Hollywood.

A lot of people were influenced by the old ethnic stereotypes in films. There was the Irish lass, usually pictured as a maid who said "sure and begorra" and said a lot of prayers and wrung her hands all the time. The Irish man was usually pictured as a drunken, brawling, honey-tongued poet or a parish priest who broke into song at the first sound of a street fight.

Our language is very rich in poetry, song and story, and we have a strong dramatic tradition. I wanted to show the best that is Irish. I wanted to present something truthful, not the mists of the past.

I assure you, there was nothing very romantic about the Ireland I grew up in in the 1950s, with economic slump and vast unemployment, expensive education that the masses could not afford and limited career opportunities for young people. Then, and even now, you have a small group of

haves and a large group of have-nots who see themselves as having no future. Unfortunately, the unrest in the north developed into armed conflict. It's absolutely tragic, and I don't see any end to it.

I admit I'm rather ambivalent about Ireland. I love Dublin, the city I grew up in, but I'm frustrated when I'm there, for so much of the life revolves around the pursuit and enjoyment of alcohol.

Last year, I performed in *A Streetcar Named Desire* at the Dublin Theater. It's a long play, so we cut it down to three hours, to run from eight o'clock to eleven. You wouldn't believe the pressures that were brought to bear on us to bring the curtain down earlier so people could get to the bars, but we didn't give in. Well, right in the middle of the most dramatic scenes, people were walking out. It was unnerving.

When I visit Ireland, the response is always a bit amusing. People are proud of me and glad to see me, but it's as if I've stepped out of a fairy tale. You know—Hollywood actress with a big house, swimming pool, and all that. If you go away and are successful, they view you with some suspicion.

There are things about Ireland I miss. The countryside in the west of Ireland is wild and craggy and rocky and barren, with lakes and rivers and streams everywhere. The light is gorgeous. It changes all the time.

But I don't think I could live in Ireland now. You outgrow a place, and it's hard to go back.

James Joyce lived much of his life in exile from Ireland. I, too, think of myself as living in exile, although it's my choice. I feel a sense of being divided—I live with that all the time. Much of my work in theater is an attempt to reconcile the different parts of myself—to reach back to my origins, to what I represent, to what perhaps I may never go back to.

Fionnula Flanagan

I suppose when you live as I do, moving about, home is wherever you are, wherever you feel most comfortable. Well, now I feel I'm a part of the American landscape.

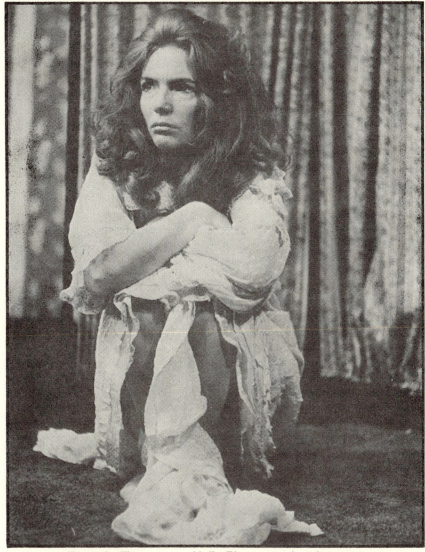

Fionnula Flanagan as Molly Bloom on chamber pot

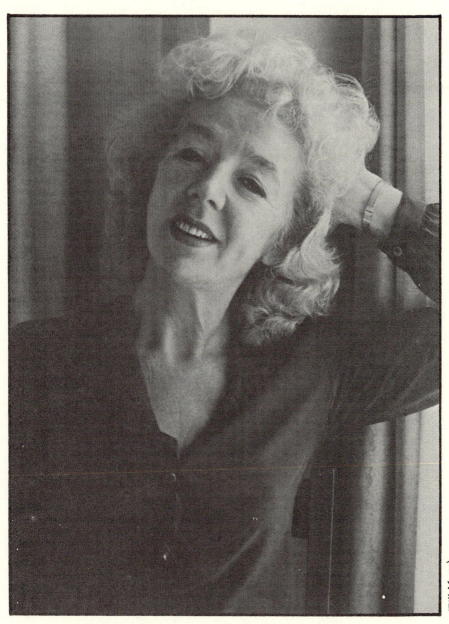

(Bill Macy)

Martha Schlamme
Actress, singer from Austria

"I was a child of war."

She is tenacious about life. As a child in Austria in the years prior to World War II, she witnessed the gathering Nazi storm, fled to England, and survived. In 1949, she emigrated to the United States.

When she was still quite young, she won recognition for her singing and dramatic talent. She built a repertoire of international folk songs and German theater songs by two other exiles, Bertolt Brecht and Kurt Weill. With a few words and an unpretentious melody, she fills an empty stage. In addition to her one-woman show, *The World of Kurt Weill,* she has collaborated with Alvin Epstein on another Weill program, *Whores, Wars and Tin Pan Alley* and the Broadway hit *A Kurt Weill Cabaret.* Among her theater credits are appearances at the Long Wharf Theater in New Haven, Guthrie Theater in Minneapolis, and Stratford Festival in Ontario.

Offstage, Martha loves to play games: "In my childhood, there was no time to play." She stars in Ping-Pong: "I think my marriages failed because I beat my husbands at Ping Pong."

Interview, August 14-15, 1979

266

Martha Schlamme

We meet in Aspen, a little town tucked into the mountains of Colorado, where musicians from all over the world come, as to a shrine, for sunlight, scenery, and music making. Martha is there to teach acting to opera students, to direct an opera, and to perform. We stroll past art galleries, ethnic restaurants, and street-corner musicians, and Martha reminisces:

These wonderful students. They are so young, and so full of enthusiasm. I feel motherly towards them. Hopefully, they will not have to go through all the terrible things that I went through. At their age, I was hiding in basements, I was crossing borders. I was a child of war—a troubled child and then a troubled young woman.

I first began to sing on my grandfather's knee, and my few happy memories of childhood are connected with him. He was a Hasidic Jew, a deeply religious man with a long white beard. I'd sit on his knee and hold his shaking hand and sing for him, and he would say, "What a shame she's a girl. If she were a boy, she could be a *hazzan* [cantor]." He went every day to the little synagogue near our house to pray and read the Torah. On Shabbat evenings, he would sing Yiddish songs—he had a wonderful voice—and, I remember, many people would come to hear him sing. We all sang. When we broke the Sabbath on Saturday night, we danced. That was where it all began for me, my love for my heritage.

My grandparents had fled from persecution, from the pogroms in Russia and Poland. They settled in Vienna in 1921 and thanked God for saving their lives. My grandfather was a very gentle man. While he was in synagogue puzzling over the Talmud, my grandmother was at home making matzoh balls, running the household, keeping the whole structure together.

A Jewish wife was supposed to be obedient, to do her duty to God and her husband in silence. But my grand-

mother was a wild fury. She kept her head covered as they
did in Eastern Europe, but in other ways she was a liberated
woman. She knew there was more to life than breeding and
bearing children. She wanted to have an existence of her
own. She even wanted to have fun in bed. She raged at
grandfather: "I've had nine children, and still I'm a virgin."
My grandfather took it all silently. He didn't understand,
and I didn't understand, then, that she was simply shouting
for life!

Dinner with Martha in a dimly lit Viennese restaurant, with students
playing Mozart quartets in the background. Martha's honey-colored
hair frames her face; the candlelight highlights her warm smile and
laugh wrinkles. In this setting of old-world ambience, over weiner
schnitzel and spritzers, Martha continues her story.

My grandparents and my parents ran a kosher restaurant in
Vienna. Since the men were usually in the synagogue, the
women did most of the work. I felt very left out. I loved my
parents, and they loved me, but the restaurant took all their
time and energy. My mother was loving and warm. I could
tell her anything. But she wasn't available when I needed
her. I have a memory of tying my nightgown to my moth-
er's nightgown at night because I thought then maybe she
wouldn't leave me. One of the leitmotifs of my childhood
is, "Not now, darling, later." I asked mother a thousand
times a day if she loved me. If you feel loved, you don't need
to ask.

I wasn't happy with the way I looked. Mother was a
beautiful woman, and I was jealous of her looks. What I
didn't see then was that she had her own struggle. My father
cared about nothing except the arrival of sundown when he
could leave and go to the synagogue. He had no earthly
ambitions. He thanked God for life. If you asked him,
"Where was your God when the other six million Jews

were being carted off to the gas chambers?" he'd say, "It is not for us to question God." His world was the Talmud. My mother longed for flowers.

In the restaurant, they asked me to sing for the guests. I knew folk songs in different languages—in Vienna you hear languages from all over. I had a pretty and clear voice, although I didn't think of myself as a singer, and they put me up on the table when I was three or four years old. If I sang a folk song about an old man and a boy, I would characterize them—they'd have different voices and personalities. Storytelling was the important thing. Children do this very naturally. Everyone would applaud, you'd get a candy, a kiss from someone, and then they'd forget about you.

All through my childhood, I felt very alone, except when I was entertaining people. That feeling carried over into adulthood, the feeling that unless you sing or entertain people, they won't pay the slightest attention to you. Even today when I'm invited to dinner, I don't feel anymore that that's all I'm there for, but still I end up telling stories. Those childhood experiences stay with you, although you work very hard all your life to erase them.

The years preceding World War II were perilous ones for Jews. Hitler was revving up his Fascist machinery. Austria was annexed by the Germans in 1938. In the schools and on the streets, Jews were singled out for ridicule. Haunted by memories of the pogroms, Martha's family felt increasingly menaced.

Once, a group of children surrounded my grandfather and tried to cut off his beard. My mother was given a bucket and was ordered to scrub the sidewalk, while a crowd gathered and jeered. Those were terrible times. We lived above a courtyard and just below us was the little synagogue. And

one time, in the middle of the night, the SS came and raided it; they took all the books out of the synagogue and built a fire and burned them in the courtyard. They pulled people out of their homes; some were never heard from again. They stopped because there were some non-Jews in the building who refused to vacate it. They risked their lives for us. There were some acts of heroism that I have never forgotten.

Then one day my father was picked up on the street by the Nazis and was sent to a labor camp. We thought we'd never see him again, and our world fell apart.

Sometimes I feel that I'm walking under a cloud of protection. Somehow, we all survived. My father sent us a message that we couldn't do anything for anybody while we were in Austria. It was a foolish sort of courage, he felt, to remain. With his limited understanding of the political situation, he said that if we stayed, we would all perish. So we stood on line night after night in front of the police station—it was dangerous on the streets—and mother finally obtained a permit to go to England to do domestic work. That was the only way you could get out of Austria. But she wasn't permitted to take me with her, so, trusting in God, she shipped me off to her sister in France. My aunt had married a Frenchman, a gentile. That was a terrible shame for an Orthodox Jewish family, and most of the family went into mourning. Ironically, it was this non-Jew, my uncle, who saved all of our lives. It's all very complicated— hard to tell it with weiner schnitzel in your mouth.

Something else I must tell you. My French cousins married Corsicans, and then my uncle went into mourning. What are they, Corsicans? Horse thieves? (Laughs.) Well, as it turned out, one of those Corsicans was an electrician and one was a doctor—that made them respectable—so everything was all right. But, I mean, the prejudice is just endless.

Martha Schlamme

It seems to me that in my childhood I was always in motion, never settled in one place.

My mother was a tiny, fragile woman, but she fought for survival. She managed to obtain a job for me to work in England. And then, by some miracle, she found a position for my father and obtained his release from the labor camp. It was early in the Nazi era—they weren't fully organized yet. The war broke out, and the British were not prepared; they never believed it would happen, and they panicked. They interned all Germans, and other "suspicious aliens." You should have seen the complexion of that internment camp: there were Hasidic Jews, nuns, atheists, Communists, Fascists, everything thrown together. The camp was on the Isle of Man. It was on the ocean, with mountains, and very beautiful. We were fed well, and treated humanely by the British. In that atmosphere of bombing and fear during the war, life went on.

An Icelandic folksinger named Engel Lund visited the camp. She sang a French song, a Norwegian one, and then a Yiddish song my grandfather used to sing, and, I promise you, my heart stood still. I went backstage to speak to her, and I was so choked up, I couldn't say a word. But I knew then that I wanted to move people the way she had moved me.

The British commander heard that I could sing, and he asked me to sing for the whole camp. Then, he asked me, "Are you going to make the stage your career?" An incredible question. Here it is wartime, we're penniless refugees, we're interned, and he's thinking of a career. It was so very British. You don't stop just because there are bombs falling. That's how they won the war.

I worked in the hospital and developed a great passion for the camp doctor. He was forty-five, as old as my father, and I was fifteen. He was a handsome Italian. He played the guitar and taught me Italian songs and called me La Pri-

mavera, The Spring, and I fell madly in love with him. It was wonderful and terrible. It seemed reciprocal, but of course he had a wife, and everyone said he was Fascist. "How can he be a Fascist, when he's in love with a Jew?" I asked. We were terrified. There were moments of frantic, frustrated grabbing at love that was impossible because there was no place for us to be. The pain was quite extraordinary. You know, I remember it well.

Somehow, every time I have fallen in love since, I've had that same sense that it's impossible to have a lasting relationship.

After the war, Martha's family was released from the internment camp and resettled in London where they began life again, starting from the bottom. Martha worked as a secretary, and sang and acted with anti-Fascist youth groups.

We did the German version of *Threepenny Opera* and I played Pirate Jenny. I must have played it rather seductively, for the director came to me later and said, "Well, Martha, you'll either be a whore or a very good artist." (Laughs.) I chose the latter.

Then a few years later I performed it on London's East End. The French mime Marcel Marceau came to see me one night after the performance, and he said, "It's very good, but you can afford to be a little more vulgar." That was wonderful. I was still that very polite Jewish refugee girl from Austria. I though about it a lot. After that, my Jenny wasn't so polite. She's hard, rough around the edges— covers up her fear and loneliness.

I got married in London, just to get away from home. I couldn't bear the restrictions of a religious household. Everything was "thou shalt not." I married the first boy who came along and proposed, a refugee named Hans Schlamme, a very sweet boy. I was eighteen at the time; we

272

were both children. He had no profession, so when a chance came to come to America, we accepted it. We arrived in New York City in 1949. I auditioned for a singing job at the Village Vanguard, and that was the beginning of a concert career in this country.

Martha's career as a singer and actress flourished, but her marriage ended in divorce. In the 1950s, Martha supported left-wing causes believing, as so many idealists did then, that this was the way to achieve a more humane society. Her second marriage, to the crusading young attorney Mark Lane, began with intense emotion.

We were so very much in love, we couldn't bear to be separated. He was a very dynamic man. He was drawn to the underdog, and that appealed to me. But he was so totally absorbed in causes, he'd forget I was there, and the marriage deteriorated. Once when we were on the subway —we were trying to patch up our marriage—he was saying very loving things to me. I was very touched, and my eyes filled with tears, when onto the train walks this little boy selling newspapers. Mark hails him and buys a paper, opens it and says, "These sons of bitches. See what they're doing in—" wherever it was. Right in the middle of his declaration of love. And I realized at that moment—*that's* why I can't live with this man.

After that, there were other men. I'm very romantic. More than anything, I would like to be deeply involved with someone. Whenever I begin a relationship, there is still that little girl deep inside me asking, "Do you really love me?" I yearn to be in love again.

I've never been religious in the conventional way. Once, when I was invited to sing in a synagogue on the Sabbath, I reluctantly attended the service. There was silence, then the prayers began. They opened the Ark containing the beautiful Torah, and I burst into uncontrollable tears. I kept

visualizing scenes of people lying on the ground, scream-
ing for help. I couldn't stop crying. I felt as if I were going to
die. Finally, I regained my composure and sang for the
congregation, but I was not just another Jewish singer up
there. I was living through a memory of thousands of years.

Being a Jew is so central to my whole being. Not in a
chauvinistic sense—I don't feel "My people, right or
wrong." But my soul—at my heart I'm a Jew. It has always
meant to me that I'm part of a larger community.

I'm a chameleon. Wherever I go, I feel I belong. Every
culture, every language fascinates me. I often think, "If
only we could talk to each other."

Once, for a television documentary, I dubbed in the voice
of a Vietnamese woman who had survived the Mei Lei
massacre. First I watched while the woman told her story in
Vietnamese, with a translator. She told of being thrown
into an open grave, with her husband and uncle beside her
and her son lying on top of her, all dead. The soldiers
thought she was dead—she didn't move, didn't breathe.
Later, she climbed out. I choked up when I did that role. I
had nightmares after that. I kept seeing that woman's ema-
ciated face. It could have been anyone from Auschwitz. It's
horrendous what people do to each other.

The next evening, the Aspen Music Festival tent is filled to capacity
for Martha's one-woman show. It is pouring outside, the temperature
in the tent is 50°, but Martha walks onstage in a clinging, low-cut
gown, shivers from the cold, begins to sing, and her warmth envelops
the audience. She begins with the soft sentiment of a Jacques Brel
song: "If We Only Had Love," which she punctuates with a bemused
aside to the audience: "I never found that having a man around the
house solved all my problems." In German, in French, in Yiddish, she
sings of fidelity and infidelity, tender one minute, bawdy the next.
There are raucous songs of the street, and there is this mock-serious
English "love" ballad:

Martha Schlamme

Don't let me die an old maid,
Take me out of pity . . .
Here I am six and forty,
And never had an offer.

But it is in the songs of Kurt Weill and Bertolt Brecht, evoking pre-World War II Germany—bittersweet, blending romance and irony—that Martha reveals her dramatic intensity. After the performance, in her dressing room, she talks about her favorite Brechtian role, Jenny, the parlormaid of *Threepenny Opera*.

Jenny is angry, hungry for vengeance. She fantasizes about all the men who have humiliated her, singing,

But I'm counting your heads
While I make up the beds . . .

Then she sends them off to their deaths at sea saying, "That'll learn ya."

When I first played Jenny, I couldn't identify with anyone wanting revenge. I couldn't imagine killing anyone. Then I began to see Jenny as someone trying to wipe out evil, and I could relate to her. I put my whole life into the drama of that role. Jenny is universal. She reaches out and touches anyone who has ever experienced deprivation.

Is my show political? I suppose everything is political, even Shakespeare. It has political overtones. I was deeply scarred by discrimination and by the war. I prefer songs that have some bite. Some people, I think, feel assaulted by the music. The truth is that much of it is a comment on the tragedy of war and the insensitivity of governments.

I confess that I'm concerned about the political climate of this country—the growing tendency to repress dissent. Coming from Europe, it all sounds very familiar. Still, one can breathe freely here. I do speak out.

Now in a pensive mood.

I love the theater. But one is so vulnerable—you have to develop a certain toughness on the outside. Not so tough that you shut out feeling and experience, but enough to survive. Reviewers can be so callous. I know people who have been destroyed by a bad review. The spoken word goes by, one can almost forget it. But once you write it down, that's holy, isn't it?

There are so many roles I still want to do. I love creating characters, exploring human motivation. I love Shaw—I'm enchanted with his language. I love Chekhov most of all. I come from a Chekhovian family. When my mother had a headache, the whole family would feel it. And the yearning of the women for what they cannot have. The unfulfilled woman, tears and laughter never very far apart, the sense of the wonder and absurdity of life, with all this I am very much at home.

On stage, I sing cynical songs, and I say cynical things. I suppose it's because I'm cynical. (Laughs.) But underneath it all, I have a deep-seated faith that everything will be all right. In my soul, there is this general *weltschmerz*, if you know what I mean—the will of the world for survival. I try to communicate this to audiences.

To be Czech is . . . to be part of an ancient culture boasting the first university and the first written language in the middle of the continent and, at the same time, to be continually occupied by a foreign power. Nearly every Czech thinker has testified to the tensions of this duality . . . I think it is hardly possible for most of us in the Western world to comprehend or empathize with the Czech condition . . . We wonder why Czechs have so often chosen capitulation rather than resistance and overlook the vulnerable geography of the Bohemian citadel . . .

David Binder, *The New York Times Book Review,*
April 13, 1980

(Antonin Lhotsky)

Jan Triska
Actor from Czechoslovakia

"The American dream is tangible."

He has been hailed by *The New York Times* as "the Czech Marlon Brando." In Czechoslovakia, Triska was featured extensively in films and television dramas, and, for twenty years, was a member of the National Theater of Prague.

Triska taught himself English over a two-year period before emigrating first to Canada and then to the United States in 1978. Since then, he has played major classical roles at the New York Shakespeare Festival and the Public Theater, and in the resident companies of Canada's Shaw Festival and Minneapolis' Guthrie Theater. Film credits include *The Amateur* and the role of a Russian official in *Reds.*

Backstage at the Guthrie Theater, in a rich, resonant voice with characteristically rolled Rs, Triska becomes a man of many faces and voices as he retraces the emotionally charged events leading to his defection. In a monotone, he mimics the steely obstinacy of Czech government officials. Minutes later, his voice leaps octaves, and he laughs with delight at the prospect of a free life in this country.

Interview, February 19, 1980 and March 10, 1981

Ah, the experience of being an emigré, it is so very complicated, so painful. It is difficult to share one's inner feelings with one who has not experienced it. To leave behind your fatherland, your motherland, your history—is to leave behind a part of yourself.

Of my childhood I remember very little. My memory is somehow blurred. I was born in Prague in 1936. My father was a psychologist. He worked for the university and in government research. This was a time of great fear. Hitler's Nazi party was gaining strength, and the pressure was building throughout Europe. But my parents built a wall of love around me.

Hitler tried to annex Czechoslovakia. In 1938, the heads of state of France, Italy, and Great Britain met with the Germans and, in the infamous Munich Pact, they sold out our nation. The next year, German troops invaded the country, and that was the end of the Czechoslovakian Republic. It became the protectorate of Bohemia and Moravia, a puppet regime under German control.

I was three years old when World War II started, and I remember only fragments—the terrible roar of airplanes, the blackouts every evening, the restrictions on our activity. On our radio set there was a label written in German and Czech: "Listening to the enemy's broadcast is punishable by death." I remember that every evening my father sat with his ear glued to the set, listening to broadcasts of the BBC and the Voice of America, and we hoped there would not be a knock on our door. He had to be circumspect. He took a risk.

The Czech underground resistance to the Germans was ruthlessly crushed. My father did not speak out to oppose the Germans, and he survived. After the war, the country recovered quickly. The republic returned.

February 25, 1948—the Communists staged their coup in Prague. I was ten years old. I didn't see the tanks or hear any

shooting, but I had a strong feeling that something evil was happening. The adults around me didn't speak, but I could read it on their faces—something awesome and bewildering was engulfing them. They felt endangered down to their roots.

I admired Americans. I remember—I must have been in high school—I used to wear an American flag in my lapel. It wasn't clever; it must have been teenage naiveté. There was a teacher of the Russian language in our school, a sort of serpent, a toad. Very elegant, very sleazy. He used to march through the school with his guitar trying to win popularity by playing Soviet songs. My first day in his class, he said,

"The boy in the last row. Stand up."

And I stood up.

"Are you American? Why do you have for Christ's sake an American flag in your lapel?"

And I stumbled,

"The Americans, they are our allies. They have been all during the war."

"Take it off!" he roared.

And I did.

With the coming of the Russians, my father and his friends were paralyzed. All of a sudden, these people who deeply loved their homeland found themselves on the crossroads. They had to decide whether to stay and be silent, bow their heads, pace through the rest of their lives under the oppression they felt would come. Some collaborated to climb the ladders of their careers. Others left the country.

My father, I'm sure, didn't play the Soviets' game, and he didn't resist. He decided to raise his family and hope for better times. Actually, by the late 1950s, the regime had begun to crumble. Perhaps the Soviet politicians were tired of imposing their will on an unwilling public.

Jan Triska

1959 and the early 1960s in Czechoslovakia: a time of optimism. The Soviet regime had loosened its grip on the country and the arts were flourishing. Director Milos Forman and others were building a strong film industry; the influence of the Czech theater was felt in all the theater capitals of Europe. Writers, painters, and architects were emerging from obscurity, and were winning international recognition.

> There was such exhilaration among the artists, they shouted "Freedom" at the top of their lungs. And then, having acquired a taste for freedom, they shouted demands for more. They were intoxicated with hope.

1968, the post-Stalin era, was a time of political ferment in Czechoslovakia as the relaxation of Soviet controls continued. In March of that year, the liberal regime of Alexander Dubcek came to power and abolished political censorship. In a speech calling for public support in building a free society, Dubcek said, "Differences in public opinion must be respected. . . . Let the struggle of ideas commence."

> The nation was beginning to breathe freely. We had this marvelous sense that anything was possible. But it was careless, naive. There were sober voices crying out, "Listen, don't go so fast. Apply the brakes. Those guys in Moscow are powerful. They wouldn't hesitate a second to stifle you." But we didn't hear them. We didn't want to.
>
> Then in the Spring of 1968, *Listy*, the Czech journal of literature and politics, published an article entitled "Two Thousand Words," and this article changed the course of my life. It was a public declaration of Czech human rights, envisioning an ethical stance for Czechoslovakia. Prominent individuals from all fields had been asked to sign this manifesto, and I was honored to be among those who signed. Months passed.
>
> August 21, 1968, the dream ended. It was all over. Com-

283

munist troops invaded Prague, and there was turmoil. Dubcek was removed. Censorship was reinstated.

Now we stood where our parents had stood a generation ago. We had to decide whether or not to emigrate. Many thousands left the country.

Big Brother, of course, was anxious about our manifesto. Government agents asked all those of us who had signed to withdraw our signatures. The Soviets saw this document as a sacrilege. Again and again, officials approached me. "If you want to go on working," they said, "if you want to make films, you must withdraw. If you do not, your life will be hell."

I kept saying, "I don't necessarily subscribe to everything in the article. But I don't think that just because the direction of the wind changes, one should withdraw one's support." They pressured me, harassed me. I did not bend. I lost a lot of work in the movies and television. There was a period when I was banned in Prague—apparently the politicians considered my presence before the cameras an affront.

My closest friend was Vaclav Havel, the internationally acclaimed playwright. We had been friends since we were both students at the gymnasium. Our families were close. My wife and I often spent weekends at their country home. Havel is a man of great talent, integrity, and guts. He suffered everlasting discontent because of the state of the nation, and this discontent almost drove him out of playwrighting and into the role of angry rebel. He wrote underground articles and letters to politicians protesting the suppression of artists. He fought a lonesome fight against a powerful but unstable government. For ten years, he did not give up. This was a dilemma for me. We remained best friends. But I knew that I was in a precarious position because of this friendship. I was still acting with the National Theater. I knew that if I wanted to continue to

act, I could not afford to lose my legal status in the theater. An actor depends on public support. Well, the Secret Police knew this too, and the phone calls started.

"Hello, Mr. Triska. How are you today? My name is Captain Martinek."

"What's wrong?" I asked, hoping it was a traffic violation. His answer, I remember it well.

"Well, Mr. Triska, it is a sensitive matter."

And I had no choice but to drive downtown to meet him. He circled around.

"How are you? How is your family?" Then he came to the point. "Your career, we understand, isn't going as well as it did before. You have been banned from television and some films. We know you are a close friend of Mr. Vaclav Havel and that you and others meet frequently at his country home. These meetings are a threat to our socialist government. Listen, Mr. Triska, let's make a deal. We'll help you get back the position you had before 1968. You deserve this—we admire you as an artist." He heaped on the flattery. "You just simply supply us with information about the conversations in Mr. Havel's home."

I was horrified.

"I cannot do this," I said. "I am not endowed with the talent to lead a double life."

I wasn't a hero. I was shaking with fear. I begged him to understand I wasn't a spy.

"Well, you just think it over," he said, "and I'll call you again." He did, of course, and I explained that they had chosen someone unsuited for the part. I argued, I protested, finally I refused.

This experience left me shaken. Whenever I wanted to say something to my wife, I would lead her into the bathroom. For three years, I was haunted with the idea that my home was bugged, and my dressing room, that I was being followed. It had happened to Havel. Why not me?

My professional situation deteriorated, and so did my friendship with Havel, for he felt responsible for what was happening to me. In 1976, he wrote a beautiful play, a loose adaptation of Brecht's *Threepenny Opera*, filled with political overtones. He was banned and under the control of the Secret Police, and no theater would produce it. In a small village on the outskirts of Prague, Horni Pocernice, he found a group of factory workers who agreed to put on his play. It was sweet forbidden fruit. Everyone who had the courage from Prague's intellectual community came to the production. It was a trap, of course, for the Secret Police knows everything. Their photographers were waiting for us.

The very next morning I was fired from the theater. "I'm terribly sorry," the managing director said. "From the Central Committee of the Communist Party of Czechoslovakia I have received an order to fire you immediately."

He admitted that the reason was political and ordered me to keep this quiet. It was humiliating. I was supposed to pretend that I had decided to leave the theater at the end of the season. I was enraged, and I said: "This is illegal, to fire me without cause after twenty years as a professional actor. I will start an action. I will write to unions all over the world and tell them that I am the only actor who was ever fired for watching an amateur production. You will be ridiculed. You will be notorious all over Europe as a coward for obeying this order."

I had a false feeling that I could win. There were a few months left of the season, and during that time the affair blew over. The director told me that I could remain for another six months. If I didn't misbehave, they would give me another contract.

Then in January 1977, Havel and a group of underground writers issued another human rights manifesto. Charter 77 was published illegally all over the world. The

Secret Police really mobilized. They began to search the houses of my friends. There were frequent night raids. Many people were held for questioning, and jailed. Havel's house was surrounded, and was watched continually. We couldn't go there. To get information about him, we'd tune in the Voice of America in the Czech language from Washington, D.C.*

Once again, like our parents thirty years before, we stood on the crossroads, forced to make a decision that would affect the rest of our lives.

One day, I was sweeping the snow from the sidewalk in front of our house and the realization came to me. I was forty. I was trying to be a successful actor while my friends were in jail or facing jail terms. I just broke inside. I went in and said to my wife, Carla, "All right. Let's move. We will go somewhere else." Right away, I started to learn English from a book. A huge volume of art history was my schoolbook. I simply started at page one, and, using a dictionary, translated it word for word.

Eight months later, we signed on a package tour to Cyprus—that was the only place one could go. On the island, our passports were collected by the group leader, so we would not get away, I suppose. Without any legal papers, with two little children, we went to the police and asked for political asylum. They shouted, "No, no, no. It's a political matter!" They said they would turn us over to the Czech authorities. But a policeman sympathized with us, and with the help of United Nations officials, we were flown to Greece. We had no papers, no identity. Nothing to prove who we were. For three months, we lived in a refugee camp and then obtained papers to go to Canada.

*In October 1979, in a new Soviet crackdown on Czech dissidents, Vaclav Havel was tried and sentenced to four and a half years in jail for "subversion of the republic," a charge stemming from his participation in Charter 77.

When we arrived in Ottawa, our daughters were four and six years old, and knew no English, but we sent them on the bus to school. At the end of the first day when they did not return, I searched for them. In the distance, I saw them trudging home in the snow, and I heard them crying, "Daddy, Daddy." I ran to them and asked why they didn't take the bus home—we were three miles from the school. "We didn't speak English," the older girl answered, "and we were afraid we wouldn't be able to tell the man where to stop."

I knew then what it meant to be a stranger in a strange land. My wife and I also had to start from the beginning, but it was our choice. I forced my children to emigrate. To this day, from time to time I feel some remorse.

I remember those first painful days of school. Our little Jana came home every day from kindergarten with her lips sealed. Overwhelmed by so many new experiences, she withdrew to her bedroom and listened to Czech fairy tales on her tape recorder. Everyday. What was going on in her soul? She needed desperately to cling to something from her past. I hope that she has forgiven me.

Piece by piece, we began to rebuild our shattered world. It was insolent of me to remain in show business without knowing the language. Fortunately, there was a Czech emigré at the Canadian Film Board. I got a role in a Canadian film, playing a pilot who crash lands with an Eskimo girl in the wilderness. His nationality wasn't specified. I learned the dialogue, because I had to. Then the Romanian director André Serban—he knew of my work in Europe—asked me to come to New York City to play the devil in *The Master and Margarita* by the Russian Bulgakov. My English was very weak. I was using two dictionaries at that time. But as you well know, devils are international.

Jan Triska

I turned down two Shakespearean roles at the Stratford, Ontario, Shakespeare Festival. Why? You can't be impudent forever. I wasn't ready to play English noblemen with a Czech accent. Then I was invited to the Guthrie Theater in Minneapolis, and played Moliere in *Monsieur de Moliere* by Bulgakov. Moliere is a flawed hero—very human. He is an artist who lives under the reign of a despot. Something I could emphathize with.

I'm not a sentimentalist. Some actors pretend the theater is a temple. To me, it's not sacred. To affect an audience, you don't need to perform sorcery. But you have to work at acting. It's a moral act, like confession. You have to confess your freckles, your wrinkles, the black spots on your soul. There's no pretense. Any attempt to be more loveable, more intelligent than you are in life will fail.

I would like to be in a film directed by my friend Milos Forman. I have great respect for his work. His approach is bitterly ironic. He holds nothing sacred, least of all, himself. He's not afraid to expose people as they are. Forman has lived out the American dream. An immigrant from Czechoslovakia in 1968, he was unknown when he came here, but he was talented and determined to succeed. It was not a walk through a spring garden, I assure you.

The total lack of censorship in America is a phenomenon. So many ideas are presented. I think that the truth proves itself in time. I love this country. The idea of a melting pot for you may sound like a fairy tale. But when I walk down the streets of New York City, for me it's very real. So many cultures are here, all descended from immigrants. Whatever your previous nationality, you are melted.

In England, even after I had learned the language, they would not give me a chance to act. "We know your work, Mr. Triska," they said, "but you don't speak English." Here, I have had wonderful opportunities. It's a matter of

generosity. The American dream is tangible. You can touch it.

Sometimes I am homesick for Czechoslovakia, but I do not regret my decision to leave. There is an old Czech saying: "Only an idiot can be merry every day."

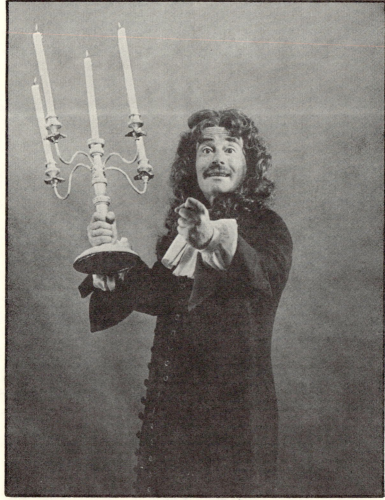

(Boyd Hagen)

Jan Triska as Molière

Remember that when you say
"I will have none of this exile and this stranger
For his face is not like my face and his speech is strange,"
You have denied America with that word.
 Stephen Vincent Benet, Western Star

Notes

Introduction

1. From an interview with the author, November 13, 1981.
2. Herbert Gold, "Vladimir Nabokov, 1899-1977," *The New York Times Book Review*, July 31, 1977.
3. Susan Schiefelbein, "Is There Life After Exile?" *Saturday Review*, September 1980.

Isaac Bashevis Singer

1. Irving Howe, *Commentary*, June 1960.
2. Isaac Bashevis Singer, *A Day of Pleasure* (New York: Farrar, Straus & Giroux, 1963), p. 5.

Yuan-tsung Chen

1. Yuan-tsung Chen, *The Dragon's Village* (New York: Pantheon Books, 1980), pp. 71-72.
2. Ibid., p. 96.

Dennis Brutus

1. Dennis Brutus, *A Simple Lust* (New York: Hill and Wang, 1963), p. 18.
2. Ibid., p. 9.
3. Dennis Brutus, *Stubborn Hope* (Washington, D.C.: Three Continents Press, 1978), p. 79.
4. Brutus, *A Simple Lust*, p. 18.

Joseph Brodsky

1. Joseph Brodsky, "Less Than One," *The New York Review of Books*, September 27, 1979.
2. Joseph Brodsky, "New Stanzas to Augusta," *Selected Poems*, trans. George L. Kline (New York: Harper & Row, 1973), p. 60.
3. Joseph Brodsky, "To Evgeny," *A Part of Speech* (New York: Farrar, Straus & Giroux, 1980), p. 86.

4. Brodsky, "Odysseum to Telemachus," *A Part of Speech*, trans. George L. Kline, p. 58.
5. Brodsky, "Six Years Later," *A Part of Speech*, trans. Richard Wilbur, p. 3.
6. Brodsky, "A Part of Speech," *A Part of Speech*, trans. by author, p. 105.

Luisa Valenzuela

1. Luisa Valenzuela, *Strange Things Happen Here*, trans. Helen Lane (New York: Harcourt Brace Jovanovich, 1979), p. 67.
2. Ibid., p. 86.
3. Ibid., pp. 194-95.

Mai Thao

1. Mai Thao, "A Blind Lighthouse," trans. Pham Xuan Vinh, copyright © 1979.

Elie Wiesel

1. Harry James Cargas, *Harry James Cargas in Conversation with Elie Wiesel* (New York: Paulist Press, 1976), p. 118.
2. Elie Wiesel, "Pilgrimage to the Country of Night," *The New York Times Magazine*, November 4, 1979, p. 36.
3. Elie Wiesel, *Night* (New York: Hill and Wang, 1960), p. 18.
4. Ibid., pp. 35-36.
5. Elie Wiesel, *A Beggar in Jerusalem* (New York: Random House, 1970), p. 208.
6. Wiesel, *Night*, p. 43.
7. Elie Wiesel, *Legends of Our Time* (New York: Holt, Rinehart and Winston, 1968), pp. 110-11, 114.
8. Wiesel, "Pilgrimage," p. 72.

Fionnula Flanagan

1. James Joyce, *Ulysses*, The Modern Library (New York: Random House, 1961), p. 783.

Selective Bibliography

Note: I have included expatriate writers, most but not all of whom live in the United States, and others who have dealt with the theme of exile. Neruda remained a Chilean citizen while living for many years in self-imposed exile. Fugard and Gordimer live in South Africa. Chin, Hwang, Kingston (Chinese-American) and Yamauchi (Japanese-American) were born in this country, but have explored the immigrant experience in their writing.

Alegria, Fernando. *The Chilean Spring.* Translated by Stephen Fredman. Pittsburgh, Pa.: Latin American Review Press, 1980.

Brodsky, Joseph. *A Part of Speech.* Translated by the author and others. New York: Farrar, Straus & Giroux, 1980.

———— *Selected Poems.* Translated by George L. Kline. New York: Harper & Row, 1973.

Brutus, Dennis. *A Simple Lust.* New York: Hill and Wang, 1963.

———— *Letters to Martha.* Exeter, New Hampshire: Heinemann Educational Books, 1968.

———— *South African Voices.* Austin: University of Texas, 1975.

———— *Stubborn Hope.* Washington, D.C.: Three Continents Press, 1978.

Bukovsky, Vladimir. *To Build a Castle: My Life as a Dissenter.* Translated by Michael Scammell. New York: Viking Press, 1979.

Chen, Jack. *The Chinese of America.* New York: Harper & Row, 1981.

Chen, Johsi. *The Execution of Mayor Yin.* Bloomington, Ind.; Indiana University Press, 1978.

Chen, Yuan-tsung. *The Dragon's Village.* New York: Pantheon Books, 1980.

Cortazar, Julio. *Hopscotch.* Translated by Gregory Rabassa. New York: Pantheon Books, 1966.

Demetz, Hana. *The House on Prague Street.* Translated by the author. New York: St. Martin's Press, 1980.

Fugard, Athol. *Tsotsi.* New York: Random House, 1980.

Goldovsky, Boris, with Curtis Cate. *My Road to Opera.* Boston: Houghton Mifflin, 1979.

Gordimer, Nadine. *A Guest of Honor.* New York: Viking Press, 1970.

——— *July's People.* New York: Viking Press, 1981.

——— *Selected Stories.* New York: Viking Press, 1976.

Hagen, Uta, with Haskel Frankel. *Respect for Acting.* New York: Macmillan, 1973.

Kingston, Maxine Hong. *China Men.* New York: Alfred A. Knopf, 1980.

——— *The Woman Warrior.* New York: Knopf, 1976.

Kosinski, Jerzy N. *The Painted Bird.* New York: Modern Library, 1970.

Krotkov, Yuri. *The Nobel Prize.* Translated by Linda Aldwinckle. New York: Simon & Schuster, 1980.

Kukumura, Akemi. *Through Harsh Winters: The Life of a Japanese Immigrant Woman.* Novato, Cal.: Chandler and Sharp Publishers Inc., 1982.

Kundera, Milan. *The Book of Laughter and Forgetting.* Translated by Michael Henry Keim. New York: Alfred A. Knopf, 1980.

Lindfors, Viveca. *Viveca, Viveca.* New York: Everest House, 1981.

Lord, Betty Bao. *Spring Moon.* New York: Harper and Row, 1981.

Lyon, James K. *Bertolt Brecht in America.* Princeton, New Jersey: Princeton University Press, 1981.

Makarova, Natalia, with Gennady Smakov. *A Dance Autobiography.* New York: Alfred A. Knopf, 1979.

Mehta, Ved. *Daddyji.* New York: Farrar, Straus & Giroux, 1972.

——— *Face to Face, An Autobiography.* Boston: Little Brown, 1957.

——— *Mamaji.* Cambridge, Eng.: Oxford University Press, 1979.

Milosz, Czeslaw. *The Captive Mind.* New York: Octagon Books, 1981.

——— *The Issa Valley.* Translated by Louis Iribarne. New York: Farrar, Straus & Giroux, 1981.

296

Bibliography

———— *Native Realm: A Search for Self-Definition.* Translated by Catherine Leach. New York: Doubleday, 1968.

Nabokov, Vladimir. *Pale Fire.* New York: Putnam, 1962.

———— *Speak, Memory, An Autobiography.* New York: Putnam, 1966.

Naipaul, V.S. *A Bend in the River.* New York: Knopf, 1979.

————*The Return of Eva Peron; with The Killings in Trinidad.* New York: Knopf, 1980.

Neruda, Pablo. *Isla Negra, A Notebook.* Translated by Alastair Reid. New York: Farrar, Straus & Giroux, 1982.

————*Memoirs.* Translated by Hardie St. Martin. New York: Farrar Straus & Giroux, 1976.

———— *Twenty Love Poems and A Song of Despair.* Translated by W.S. Merwin. London, Eng.: Cape Editions, 1969.

Pisar, Samuel. *Of Blood and Hope.* Boston: Little Brown, 1980.

Puig, Manuel. *Betrayed by Rita Hayworth.* Translated by Suzanne Levine. New York: Dutton, 1971.

———— *The Kiss of Spider Woman.* Translated by Thomas Colchie. New York: Knopf, 1979.

Rushdie, Salman. *Midnight's Children.* New York: Knopf, 1981.

Sachs, Nelly. *Oh, The Chimneys.* Translated by Michael Hamburger. New York: Farrar, Straus & Giroux, 1967.

Singer, Isaac Bashevis. *A Day of Pleasure.* Various translators. New York: Farrar, Straus & Giroux, 1963.

———— *Lost in America.* Translated by Joseph Singer. New York: Doubleday, 1981.

————*Satan in Goray.* Translated by Jacob Sloan. New York: Noonday Books, 1955.

———— *The Slave.* Translated by the author and Cecil Hemley. New York: Farrar, Straus & Giroux, 1962.

Siniavskii (Sinyavsky), Andrei. *On Trial: The Soviet State versus "Abram Tertz" and "Nikolai Arzhak."* Translated by Max Hayward. New York: Harper & Row, 1966.

————*A Voice from the Chorus.* Translated by Kyril Kitz Lyon and Max Hayward. New York: Farrar, Straus & Giroux, 1976.

Smakov, Gennady. *Baryshnikov: From Russia to the West.* New York: Farrar, Straus & Giroux, 1981.

Solzhenitsyn, Aleksandr. *One Day in the Life of Ivan Denisovich.* Translated by Ralph Parker. New York: Dutton, 1963.

_____ *The First Circle.* Translated by Thomas Whitney. New York: Harper & Row, 1968.

_____ *The Gulag Archipelago, 1918-1956,* three volumes. Translated by Thomas Whitney. New York: Harper & Row, 1974-76.

Suslov, Alexander. *Loosestrife City.* Translated by David Lapeza. Ann Arbor, Mich.: Ardis Press, 1980.

Tabori, Paul. *Anatomy of Exile.* London: Harrap Publishers, 1972.

Thao, Mai. "A Blind Lighthouse," published in *Dat Moi,* Seattle newspaper, Tet edition, 1979; and numerous novels published in Vietnam, available at Cornell University Library.

Timmerman, Jacobo. *Prisoner Without a Name, Cell Without a Number.* Translated by Tony Talbot. New York: Knopf, 1981.

Tolstoy, Alexandra, with Katherine Strelsky, ed. *Out of the Past.* New York: Columbia University Press, 1981.

Valenzuela, Luisa. *Clara.* Translated by Helen Lane. New York: Harcourt, Brace & Jovanovich, 1976.

_____ *Strange Things Happen Here.* Translated by Helen Lane. New York: Harcourt, Brace & Jovanovich, 1979.

Wiesel, Elie. *Dawn.* Translated by Frances Frenaye. New York: Hill & Wang, 1961.

_____ *Night.* Translated by Stella Rodway. New York: Hill & Wang, 1961.

_____ *Jews of Silence.* Translated by Neal Kozoday. New York: Holt, Rinehart & Winston, 1966.

_____ *The Testament.* Translated by Marion Wiesel. New York: Summit Books, 1981.

Anthologies

Chilean Writers in Exile, Eight Short Novels. Edited by Fernando Algria. Trumansburg, New York: Crossing Press, 1982.

Bibliography

Kontinent 2, journal of Soviet writers in exile, containing selections from *Kontinent* Volumes 1 and 2. Ann Arbor, Mich.: Ardis Publications, 1977.

Voices from the Holocaust. Edited by Sylvia Rothchild. New York: New American Library, 1981.

Voices Within the Ark. Edited by Howard Schwartz and Anthony Rudolf. New York: Avon Books, 1980.

Plays

Chin, Frank. *Chickencoop Chinaman.*

——— *Year of the Dragon.*

Fugard, Athol. *A Lesson From Aloes.* New York: Random House, 1981.

——— *Boesman and Lena and Other Plays.* Cambridge, Eng.: Oxford University Press, 1978.

Hwang, David Henry. *Family Devotions.*

——— *The Dance and The Railroad.*

Yamauchi, Wakako. *The Music Lessons.*

——— *The Soul Shall Dance.*

Index

Index

303

304